Wild

SEATTLE

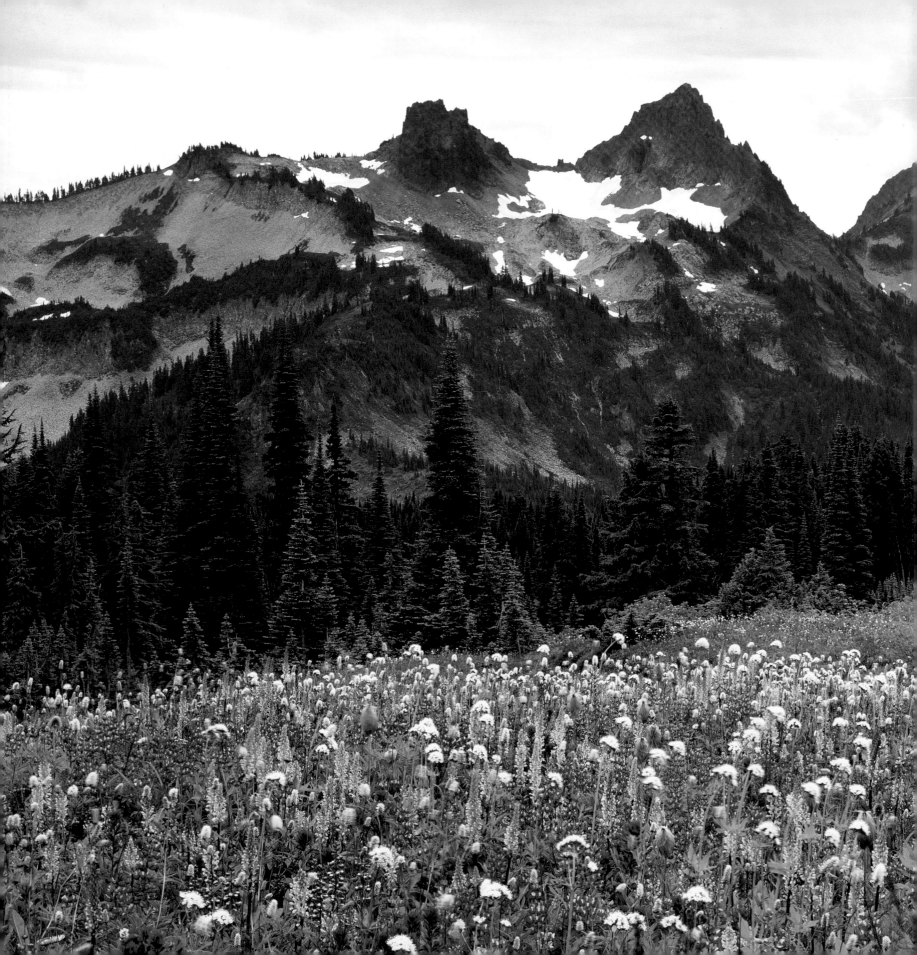

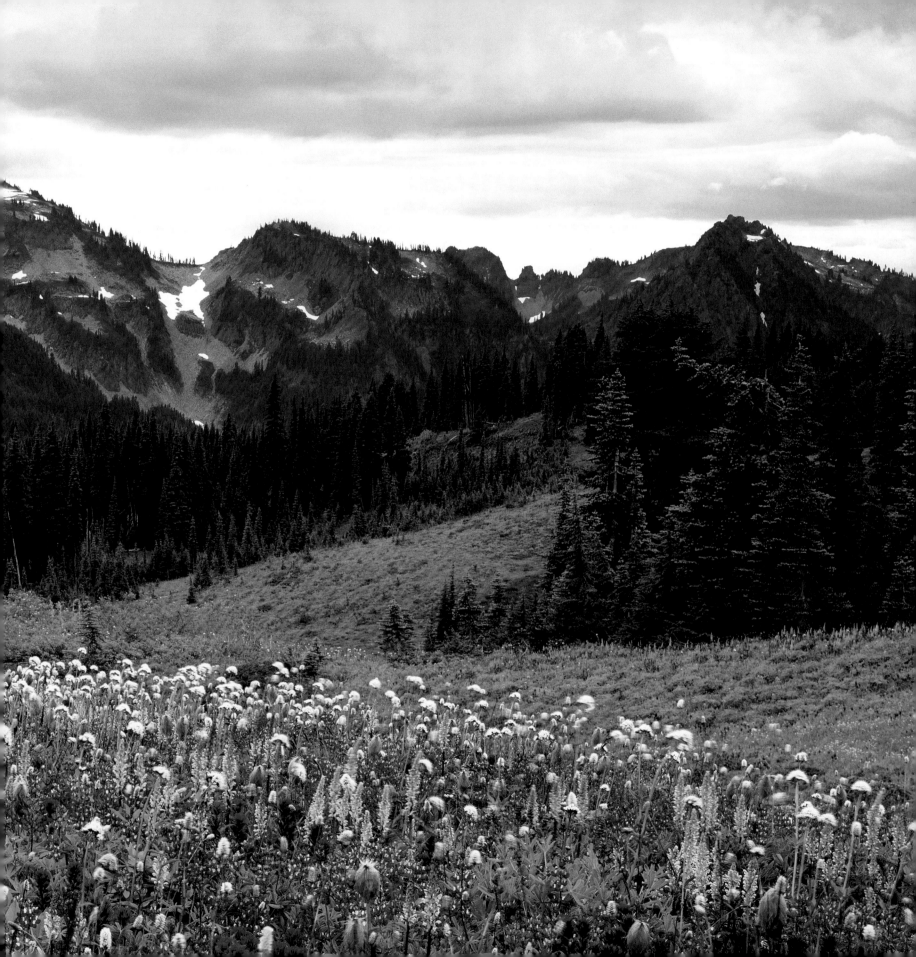

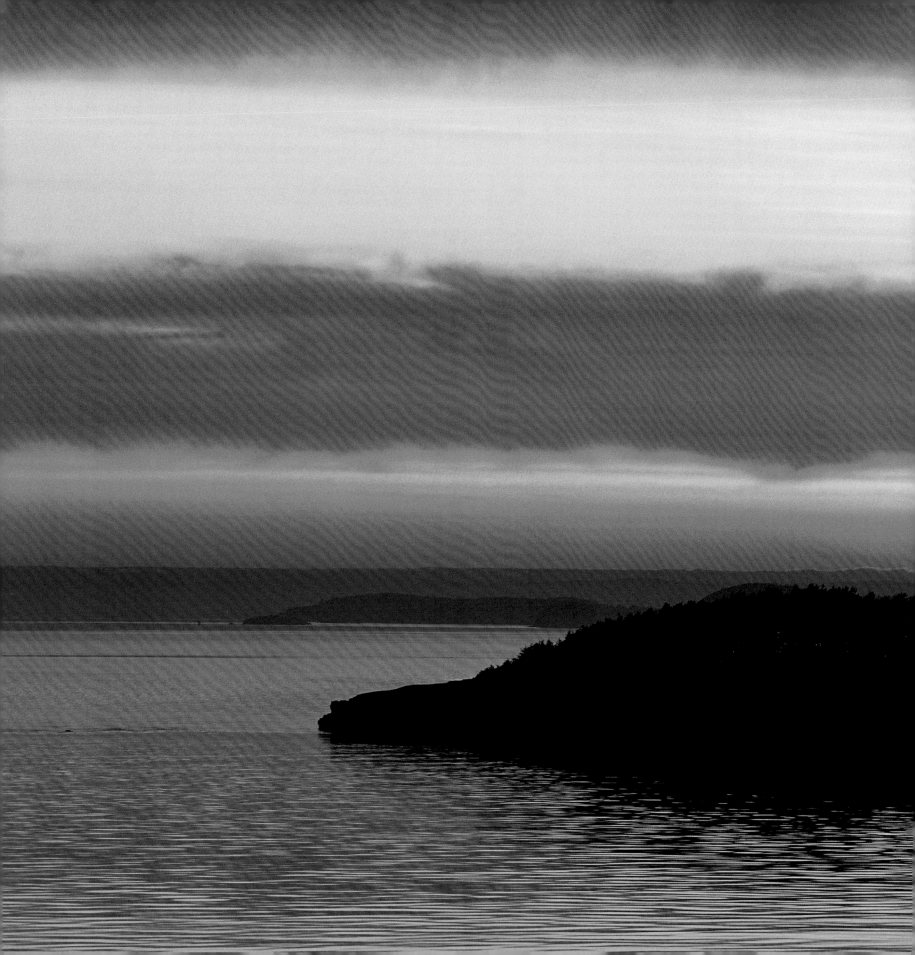

Wild SEATTLE

A CELEBRATION OF THE NATURAL AREAS IN AND AROUND THE CITY

**PHOTOGRAPHS BY TERRY DONNELLY
AND MARY LIZ AUSTIN**

TEXT BY TIMOTHY EGAN

AFTERWORD BY DOUG SCOTT

SIERRA CLUB BOOKS
SAN FRANCISCO

Published by Sierra Club Books
85 Second Street, San Francisco, CA 94105
www.sierraclub.org/books

SIERRA CLUB, SIERRA CLUB BOOKS, and the Sierra Club design logos are registered trademarks of the Sierra Club.

Printed in Canada
08 07 06 05 04
10 9 8 7 6 5 4 3 2 1

Project editor: Linda Gunnarson
Copy editor: Ellen Wheat
Book and jacket design: Blue Design (www.bluedes.com)
Map: GreenInfo Network

Library of Congress Cataloging-in-Publication Data
Donnelly, Terry, 1949-
 Wild Seattle : a celebration of the natural areas in and around the city / photographs by Terry Donnelly and Mary Liz Austin ; text by Timothy Egan ; afterword by Doug Scott.
 p. cm.
 Includes bibliographical references (p.).
 ISBN 1-57805-111-8 (alk. paper)
 1. Natural areas—Washington (State)—Seattle—Pictorial works. 2. Natural history—Washington (State)—Seattle—Pictorial works. I. Austin, Mary Liz. II. Egan, Timothy. III. Title.

QH76.5.W2D66 2004
508.797'772—dc22 2004041689

Produced and distributed by
University of California Press
Berkeley and Los Angeles, California
University of California Press, Ltd.
London, England
www.ucpress.edu

pages 2-3: *Alpine wildflower meadow, Tatoosh Range, Mount Rainier National Park*
pages 4-5: *Sunset afterglow from Deception Pass Sate Park, Whidbey Island* **page 7**: *Northern spotted owl* **pages 8-9**: *Western hemlocks, Upper Soleduck River Valley, Olympic National Park* **page 10**: *Mount Rainier and Upper Tipsoo Lake at sunrise*
pages 12-13: *Footbridge, Kubota Garden, South Seattle*

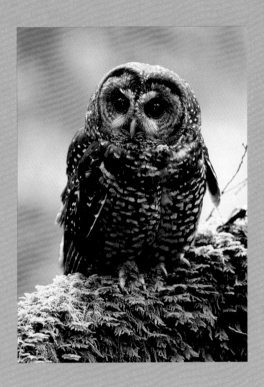

To the many individuals who have recognized the value
of wild places and who work for the preservation of
these sacred spaces. They are our heroes.

- T. D. AND M. L. A.

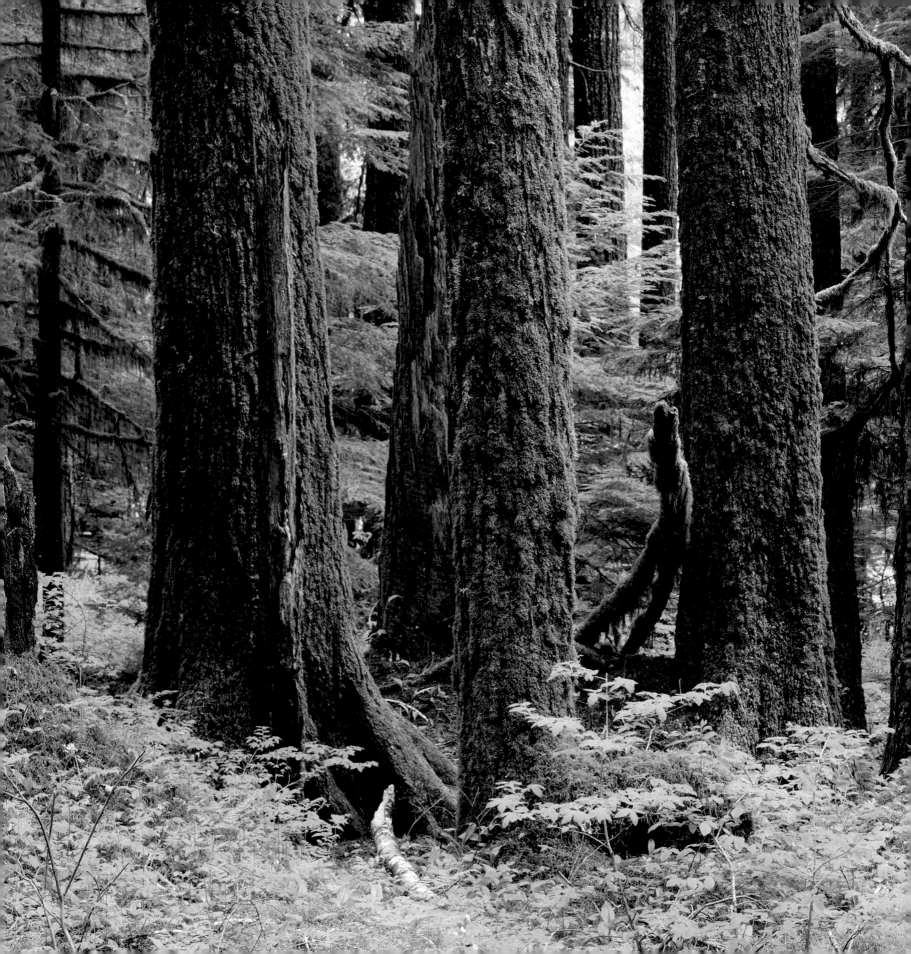

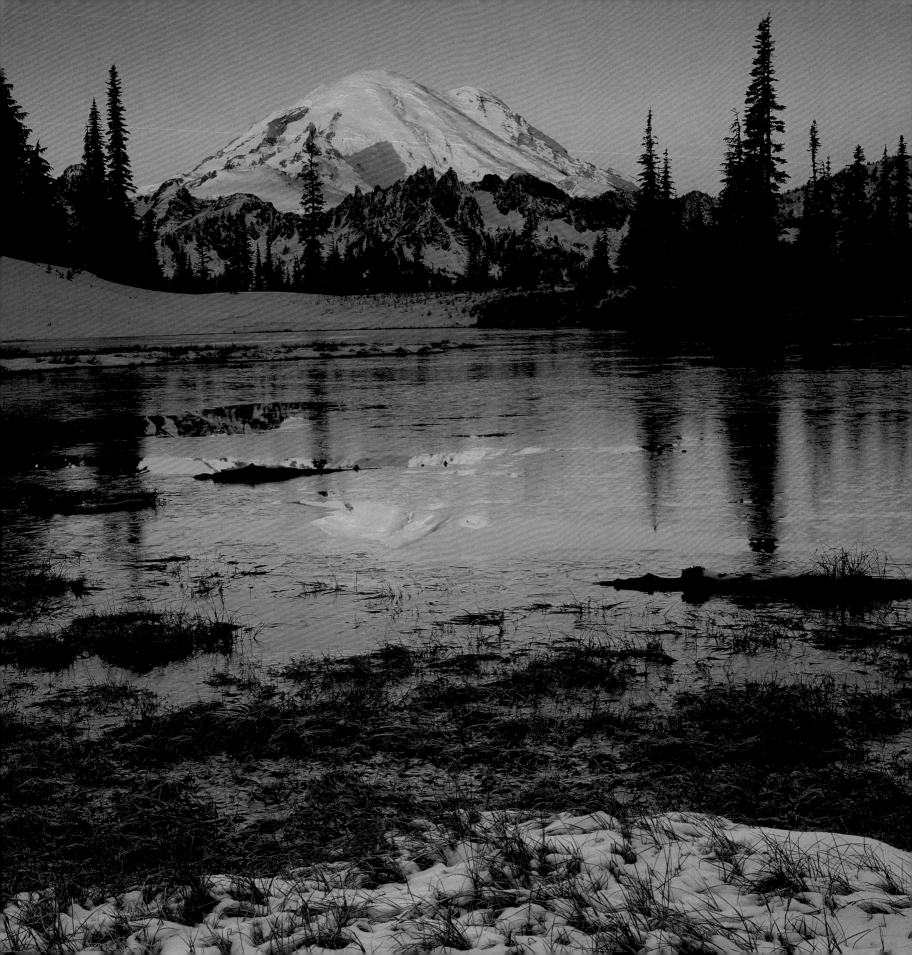

Contents

In the Arms of the Land 15

Wild in the City 33

Olympic Peninsula 65

Mount Rainier to the Nisqually 83

Cascades 101

Islands and Waterways 125

Afterword: The Long View 153

Bibliography 177

Agencies and Organizations 179

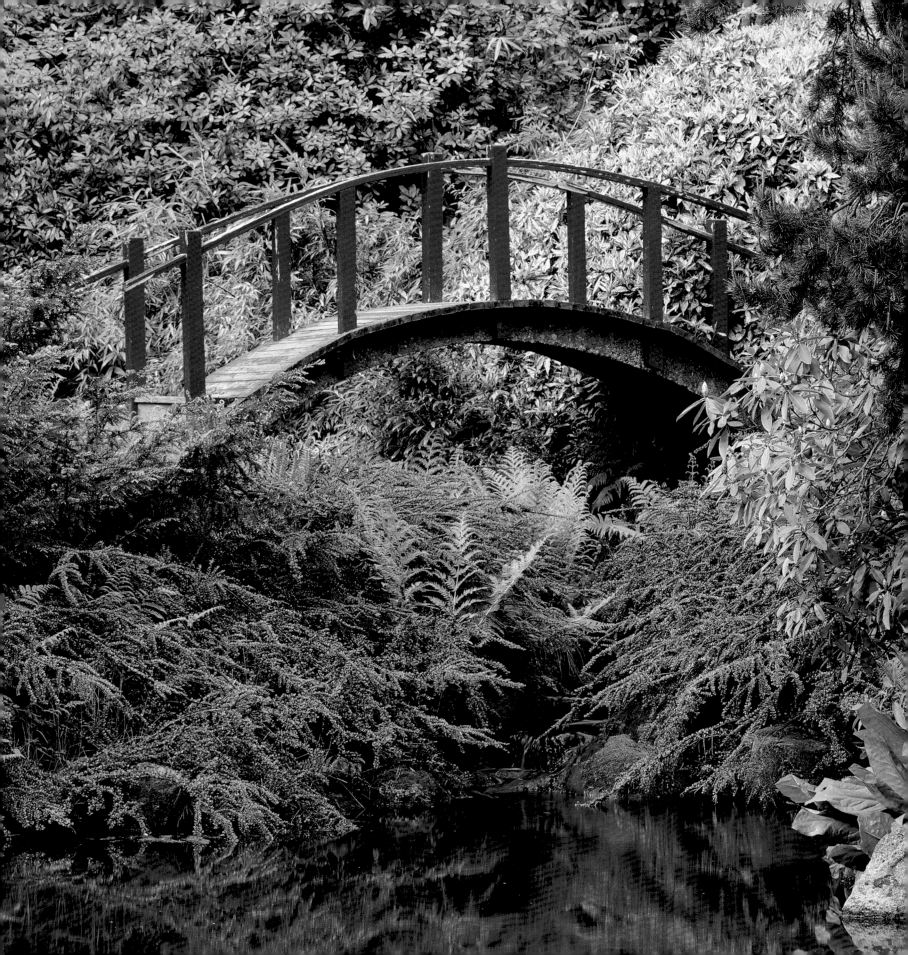

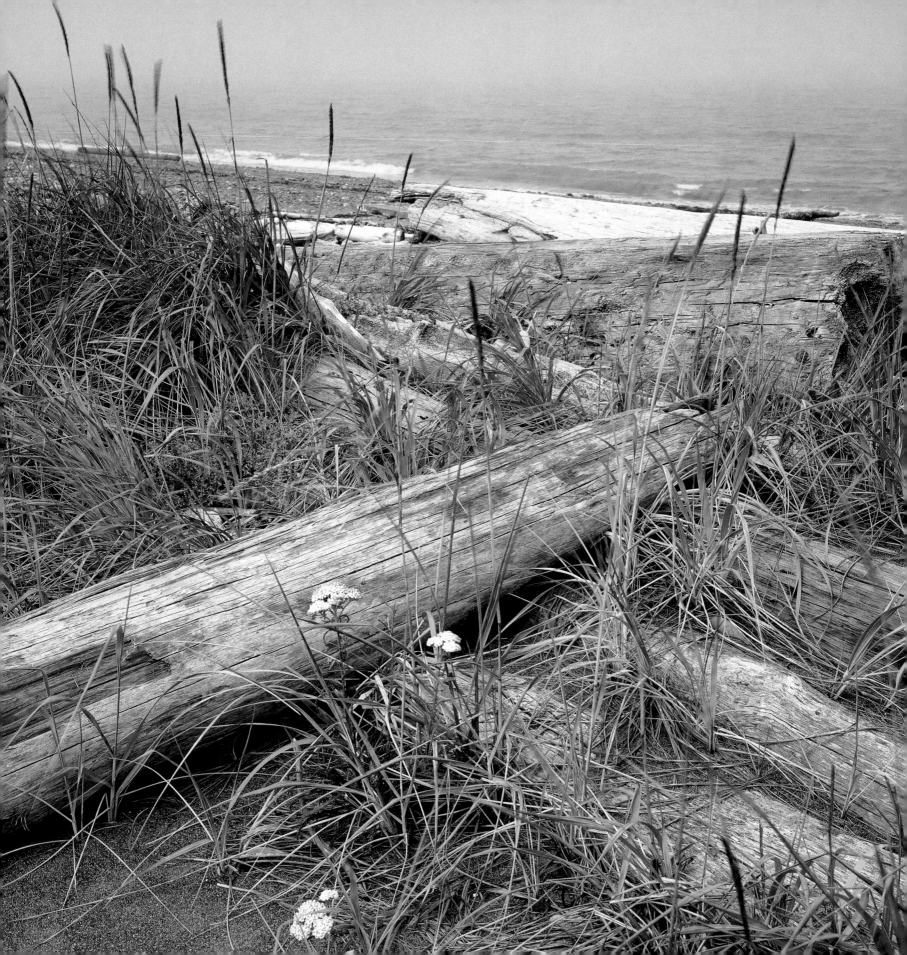

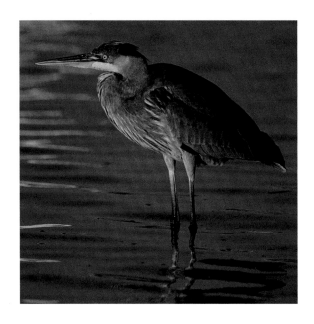

opposite: *Dune grasses and white yarrow in coastal fog, Dungeness Spit* right: *Great blue heron*

In the Arms of the Land

I REMEMBERED SEATTLE AS A TOWN SITTING ON HILLS BESIDE A MATCHLESS HARBORAGE—A LITTLE CITY OF SPACE AND TREES AND GARDENS, ITS HOUSES MATCHED TO SUCH A BACKGROUND.

-JOHN STEINBECK, *Travels with Charley*

Wild SEATTLE

Long before there was a city pressed around the inland sea, a thirty-four-year-old English explorer on board a ship named *Discovery* took a right turn at the Strait of Juan de Fuca and sailed into a place he would name for one of his officers—Peter Puget. Typical of how the English viewed the far side of the New World, George Vancouver saw the Pacific Northwest in 1792 as raw land, untamed, needing the armies of the new Industrial Age to make it livable. He had already bestowed names on harbors that conveyed despair—Cape Disappointment, for example—and on peaks,

such as Rainier, that ingratiated him with his British bene-factors. But after floating on the sound a few days, Vancouver softened and put the cultural chauvinism aside. The riot of green, the way things grew from every rock and crag, the fusion of marine life with high alpine beauty, the sweeping carpet of the native forest, the snow-white heads of the volcanoes in midsummer—it all moved Vancouver. He praised the "serenity of the climate," he was rhapsodic about the "innumerable pleasing landscapes," and he was stunned by "the abundant fertility that unassisted nature put forth." The key word there is "unassisted," a somewhat novel thought at the time.

Vancouver had little contact with the people then living prosperous lives around Puget Sound. But had he asked, he would have found that the Natives had a saying of their own, since passed on to the modern inhabitants: When the tide is out, the table is set. The Northwest Indians had such a horn of plenty that they competed to give away food in elaborate potlatches. Vancouver's passage and the Indian words-to-live-by both made roughly the same point. For once, the worlds agreed on something—the land here needs no help. The city that would take shape on Elliott Bay, its art and its obsessions, would always look to this wild land to find its personality.

In an eye blink, Seattle has gone from a mudflat village to a metropolis of more than 2 million people that may be physically unable to contain all its dreams. But it remains a city cradled, still, by the wild edge: volcanoes on one side,

the sound at the other, and a moody sky overhead. The urban attachments, as new and showy as they are, will always compete with the setting.

So it is probably true, as British expatriate writer Jonathan Raban says, that Seattle is the only city in the world that people move to in order to get closer to nature. Raban should know. After roaming the globe, he settled in Seattle fourteen years ago. It is not just bald eagles nesting in city parks, orcas swimming by a shoreline shadowed by skyscrapers, or great blue herons watching for prey in the shallows of Lake Washington. You look up or down any steep street, and there is water from the sky or in a settled basin. On clear days, you look east to the Cascade Range or west to the Olympic Mountains, and there is water again, in the form of glaciers and snow. Of all the things Seattle chauvinists such as myself like to tell visitors about our home, this one is my favorite: Ours may be the only American city where a person can look out from the urban center and see three national parks at one time—Rainier, North Cascades, and Olympic.

Of course, these gifts from nature were in place long before a group of exiles from the Midwest decided to lay an irregular plat on the hills rising from Elliott Bay in 1851. Water is the master architect of the Pacific Northwest, aided by ever-restless volcanism. The salt water that laps at the city's shores and slides around countless islands is what brought people here to begin with. Natives had been living the maritime good life for centuries. Winters were temperate, if gray. Summers dry, never humid. If the natural world

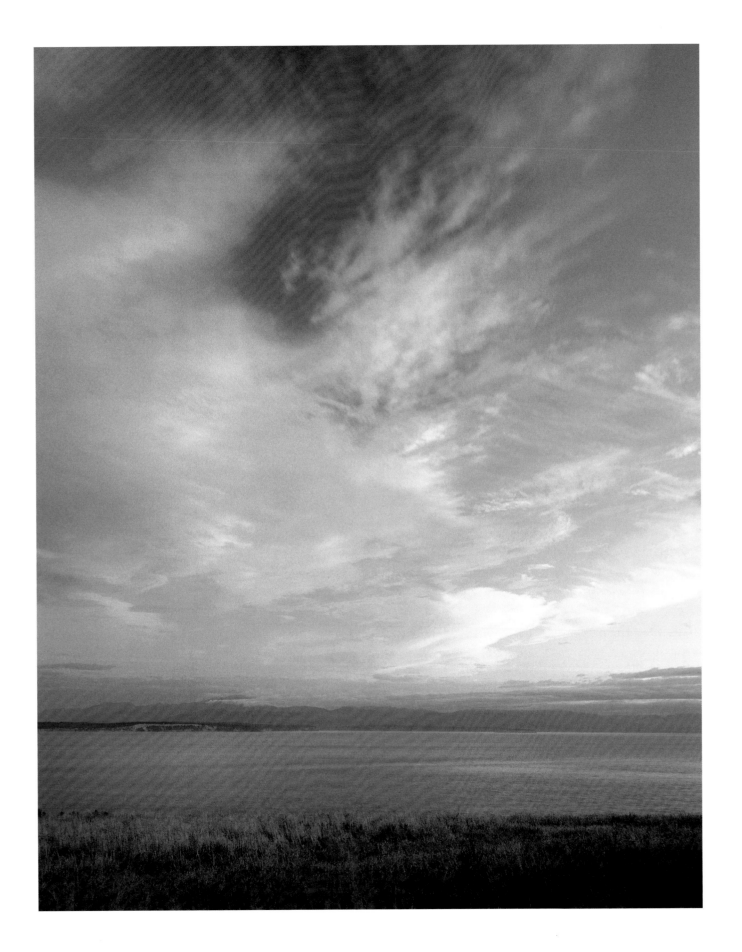

opposite: Sunset sky, Whidbey Island

was kept in decent enough shape, a year's supply of protein showed up at your doorstep in the form of salmon runs. To their doom, the Indians shared secrets of the good wet earth with the transplants from the flatlands, at one point telling a perplexed mother from Cleveland that she could supplement her baby's milk with clam broth. In return, an Indian name was bequeathed on the new settlement, and Seattle became the biggest city in the United States named for a Native American. By some accounts, Chief Seattle despised the honor.

The test for any city built amid such sublime surroundings is what it does with its natural endowment. In Seattle, at first, the new inhabitants nearly erased it. The city founders tried to level most of the signature hills. First, the thick forest was cleared, logs slid downhill and shipped away to markets without clear-grained Douglas fir and moisture-resistant cedar. Then the land itself was pulverized. They called them regrades. It was a curious form of civic plastic surgery on an epic scale. From 1876 to 1930, more than 50 million tons of original Seattle was scraped away. Day and night, the tops of the city's hills were sluiced and gouged, with downtown alone losing 107 feet of its elevation. At sea level, canals were built connecting Puget Sound, through Lake Union, to Lake Washington, and locks were put in place to allow seagoing ships to move inland. The tidelands were filled in with glacial till from the hilltops. And the Duwamish, the river that provided Chief Seattle's people with a spawning ground for one of the area's

better salmon runs, was straightened at the end; it became an industrial sewer.

But at the same time that Seattle was embarking on one of the most unusual earth-moving projects of any urban center in the country, it was looking ahead in another direction. The city hired Olmsted Brothers, a firm founded by the pioneer landscape architect Frederick Law Olmsted, to sketch a park system that would showcase the water, forest, and mountain views of Seattle. Rather than fight nature, the Olmsteds worked with it, eventually designing thirty-seven parks and a boulevard system that took in mountain views and meandered through old-growth forests and along Lake Washington's shoreline. They embraced the hills, with nary a straight line in their master plans.

Seattle has since made a tenuous peace with its setting. In Seward and Lincoln Parks, there remain trees with waists as thick as garage doors and as old as the Gutenberg Bible. Sometimes I stare out at the city and imagine it covered in this cloak of ancient green, as it looked when Vancouver first charted the Puget Sound depths. In good years, salmon return to the city's doorstep; even the Duwamish, cleaner than it was a half-century ago, provides passage to fish wanting nothing more than a chance to spawn and die. Lake Washington is swim-worthy, due to a metro-wide cleanup initiative that predated the Environmental Protection Agency. And there are those underground viewing rooms at the locks of the Lake Union ship canal, windows to seasonal salmon migrations. Blackberry bushes are ubiquitous, growing from cracks in the

sidewalk, a reminder that no amount of pavement can snuff the products of ample rain and balmy sea air. An urban growth boundary—a line designed to contain the metro area's sprawl—is in place, to keep the suburban edge from creeping up the Cascades.

What Seattle still has is the promise it offered to those early transplants: an urban milieu, with all the clank and contradictions of compact city life, but snuggled up very close to the wild. Puget Sound, after all, sits at the far edge of what Wallace Stegner called the "geography of hope." It is this dual nature that gives the city its dominant personality, the fleece-vested free spirit beneath the dutiful civic exterior. In New York, Cleveland, Chicago, or Houston, there are fine parks, but no pure wilderness areas close enough to provide quick relief from the city's raw side, or simply to define life. And with salmon coursing through waterways in the city—some of the fish have genetic links to the last Ice Age—the nature inside Seattle's urban core is not just ornamental. These fish runs, more than anything else, assure that the city's pulse is authentic, and that people are coexisting with something that predates them.

In Seattle, you learn early on that a reliable weather forecast is the presence of lenticular clouds hovering over the summit of Mount Rainier, a halo that is a harbinger of storms from the west. You learn to love winter gales for the pure brawniness of a hit from the Pacific, and the way snow geese feast on flooded fields after the harvest. You learn there is a different ecosystem in every direction: the rain forest in the west, the shrub-steppe east of the Cascades, the glacial high country of the North Cascades, and the crowd of life in the Puget Sound basin.

Most of these little spheres of wild life, to the credit of people who were thinking beyond their time, are relatively intact and open. For Seattle is surrounded not just by water and mountains, but by public land—a birthright of every American. Go south, for example: Follow the Cedar River just out of town to Maple Valley and then continue up the White River outside Enumclaw. Barely an hour's drive from the city, you find yourself in a sylvan haunt, the Mount Baker–Snoqualmie National Forest, covering an enormous expanse of the Cascades. Clear-cuts scar the foothills, a legacy of mid-nineteenth-century land grants that gave away vast swaths of the public domain to railroad companies, which then sold them to timber companies. But higher, deeper, much of the Cascades, on either side of the mountain spine, is wilderness. On the ground flows the frothy, milk-white runoff from Mount Rainier's glaciers. I threw my grandfather's ashes onto a glacier that melted into one of these torrid little streams, as he wanted. The mountain does the same thing for me that it did for him: it makes me feel significant and insignificant at the same time.

In the city, Rainier is one of those take-for-granted acquaintances that can surprise you after a long absence. For days on end in deep winter, the mountain is a rumor, at best. Then it pops out at the edge of town, its vertical ice walls holding the color of the day. On a hot summer afternoon, it

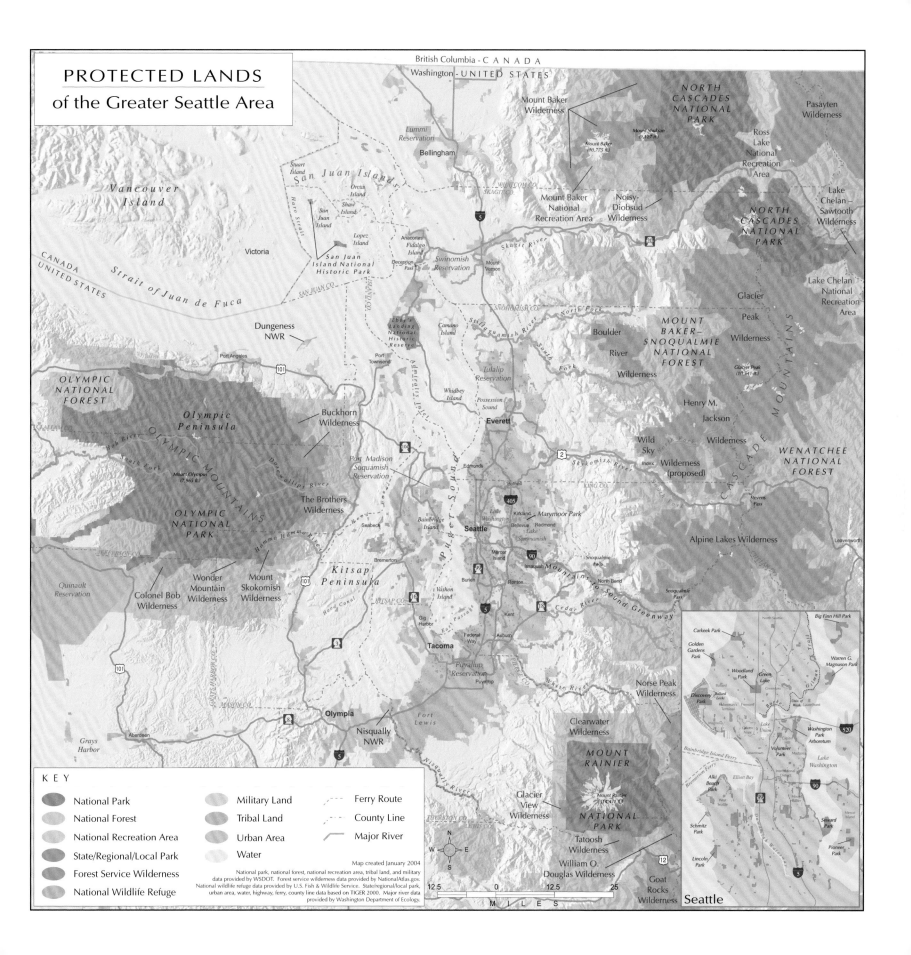

PROTECTED LANDS
of the Greater Seattle Area

British Columbia - CANADA
Washington - UNITED STATES

NORTH CASCADES NATIONAL PARK

Mount Baker Wilderness

Mount Shuksan (9,127 ft.)

Pasayten Wilderness

Lummi Reservation

Bellingham

Mount Baker (10,775 ft.)

Ross Lake National Recreation Area

Stuart Island

San Juan Islands

Orcas Island

Shaw Island

WHATCOM CO. SKAGIT CO.

Mount Baker National Recreation Area

Noisy-Diobsud Wilderness

NORTH CASCADES NATIONAL PARK

Lake Chelan – Sawtooth Wilderness

Vancouver Island

San Juan Island

Lopez Island

Anacortes Fidalgo Island

Deception Pass

Swinomish Reservation

Mount Vernon

Skagit River

Lake Chelan National Recreation Area

Victoria

San Juan Island National Historic Park

SAN JUAN CO.

ISLAND CO.

Glacier Peak

CANADA UNITED STATES

Strait of Juan de Fuca

Dungeness NWR

Ebey's Landing National Historic Reserve

SNOHOMISH CO.

Stillaguamish River

North Fork

MOUNT BAKER–SNOQUALMIE NATIONAL FOREST

Port Angeles

Port Townsend

Camano Island

South Fork

Boulder River Wilderness

Glacier Peak (10,541 ft.)

OLYMPIC NATIONAL FOREST

Tulalip Reservation

Whidbey Island

Possession Sound

Wilderness

Olympic Peninsula

Olympic Mountains

Buckhorn Wilderness

Hoh River

South Fork

Mount Olympus (7,965 ft.)

Dosewallips River

Everett

Henry M. Jackson

Wild Sky Wilderness

Edmonds

Wilderness (proposed)

WENATCHEE NATIONAL FOREST

QUEETS

OLYMPIC NATIONAL PARK

Port Madison Suquamish Reservation

Skykomish River

Index

Stevens Pass

The Brothers Wilderness

Bothell

KING CO.

JEFFERSON CO.

Hamma Hamma River

Seabeck

Bainbridge Island

Lake Washington

Kirkland Marymoor Park

Bellevue Redmond

Alpine Lakes Wilderness

Leavenworth

Quinault Reservation

Colonel Bob Wilderness

Wonder Mountain Wilderness

Mount Skokomish Wilderness

Hood Canal

Kitsap Peninsula

Bremerton

Seattle

Mercer Island

Lake Sammamish

Snoqualmie Falls

Issaquah

North Bend

Snoqualmie Pass

GRAYS HARBOR CO.

MASON CO.

KITSAP CO.

Vashon Island

Burien

Renton

Mountains-to-Sound Greenway

Grays Harbor

Aberdeen

Gig Harbor

East Passage

Federal Way

Kent

Auburn

Cedar River

Snoqualmie Pass

Tacoma

Puyallup Reservation

Puyallup

White River

Norse Peak Wilderness

Olympia

Nisqually NWR

Fort Lewis

PIERCE CO.

Clearwater Wilderness

THURSTON CO. LEWIS CO.

Nisqually River

Glacier View Wilderness

MOUNT RAINIER NATIONAL PARK

Mount Rainier (14,411 ft.)

Tatoosh Wilderness

William O. Douglas Wilderness

Goat Rocks Wilderness

KEY

- National Park
- National Forest
- National Recreation Area
- State/Regional/Local Park
- Forest Service Wilderness
- National Wildlife Refuge
- Military Land
- Tribal Land
- Urban Area
- Water
- --- Ferry Route
- --- County Line
- — Major River

Map created January 2004
National park, national forest, national recreation area, tribal land, and military data provided by WSDOT. Forest service wilderness data provided by NationalAtlas.gov. National wildlife refuge data provided by U.S. Fish & Wildlife Service. State/regional/local park, urban area, water, highway, ferry, county line data based on TIGER 2000. Major river data provided by Washington Department of Ecology.

N W E S

12.5 0 12.5 25

M I L E S

Seattle (inset)

Big Finn Hill Park

North Seattle

Carkeek Park

Golden Gardens Park

Woodland Park

Green Lake

Warren G. Magnuson Park

Ballard

Discovery Park

Ballard Locks

Fisherman's Terminal

Lake Union

Washington Park Arboretum

520

Bainbridge Island Ferry

Downtown

Volunteer Park

Lake Washington

Bremerton Ferry

Alki Beach Park

West Seattle

Elliott Bay

90

Schmitz Park

Seward Park

Mercer Island

Lincoln Park

Pioneer Park

Duwamish Waterway

Seattle

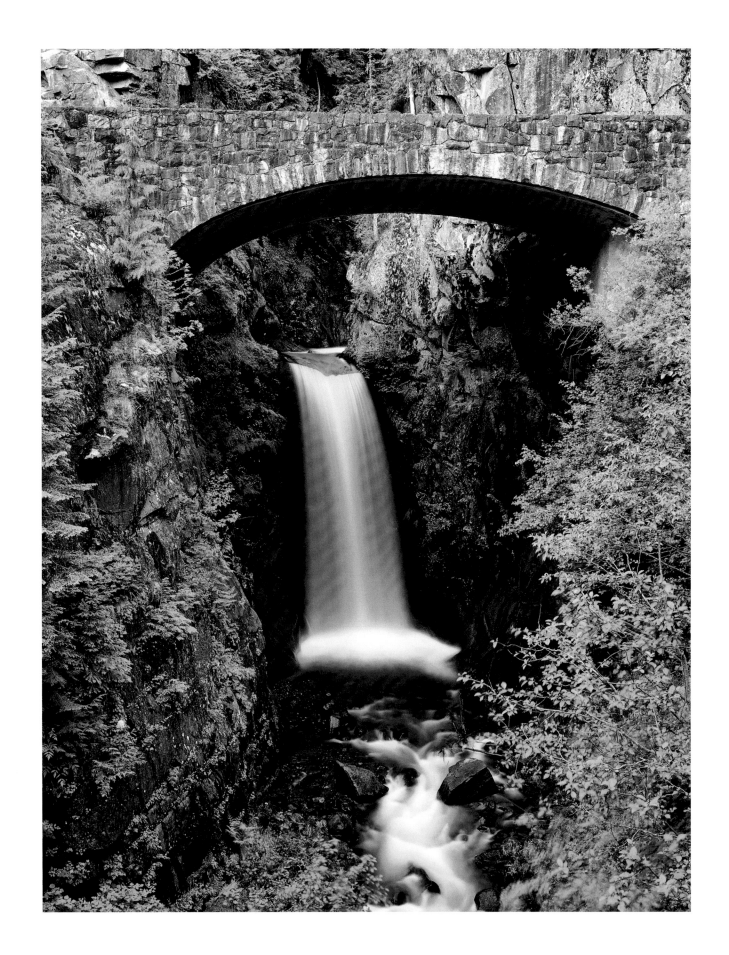

is cooling simply to look up and see the 14,411-foot protrusion holding thirty-four square miles of snow and ice, some of the glaciers more than a hundred feet thick, just sixty miles from the city as the crow flies. The mountain, John Muir concluded after a visit, "was so fine and so beautiful it might well fire the dullest observer to desperate enthusiasm."

Close to Rainier, I know my place. Its sulfur-scented summit is the smell of triumph, yes. And the view from the top—rust-colored coulees in the distant east, the islands of Puget Sound far below to the west, and volcanoes to the north and south—is heart-stopping. But the big peak is no idle cone, posing for pictures like a faded star. Rainier is alive. It may soon bury much of the urban lowlands, geologists have been warning for years. A mudflow 5,600 years ago removed nearly 2,000 feet from the summit and spread a swath of debris for forty-five miles down the valley. And of course, the hollowed top from the 1980 eruption of the youngest of the Cascade volcanoes, Mount St. Helens just to the south, is a reminder of the restless earth-shaping still going on in this part of the world.

"Civilization exists by geological consent," as Will Durant said, "subject to change without notice."

Among the big volcanoes, Mount Baker, Glacier Peak, and Rainier are the ones that frame the city, the ones that can been seen from inside a car while stuck in traffic, or while swimming in Lake Washington. They beckon. But over the years, I have developed a fondness for the smaller, more anonymous peaks closer to the city. In Seattle's back-yard—again, thanks to people who were thinking ahead to a time when the metro area would be bulging at the seams—is the Alpine Lakes Wilderness, sandwiched between Stevens and Snoqualmie Passes along the Cascade Crest. You can be at the trailhead for, say, Granite Peak, in forty-five minutes' driving time from downtown Seattle. A few hours' worth of uphill marching will leave you at the edge of the wilderness, staring into emerald pools of pure snowmelt in salt-and-pepper granite. The forest at that level is high alpine, stunted, shaped by snowpack and wind and a brief growing season. Flower meadows, of lupine and paintbrush, of heather and beargrass, show the range of pure color in a Cascade summer garden. Of course, it can also snow anytime in the high Cascades, and the notorious Fourth of July frontal system is a reliable weather companion to the holiday.

But as pretty as the Alpine Lakes are—and Switzerland, in my view, is the only thing that comes close—this wilderness is not just background for aesthetics or playground for hikers. Like the volcanoes, the land is alive. A lot of water rushes down the west slope of the Cascades, and as it thunders downhill it provides the animating beat for most everything in the Puget Sound lowlands. Every city on the East Coast gets more rain than Seattle. But what matters here is the variety of rain, from daily mist to coastal deluge, and how it shapes the region's wild character. Precipitation varies widely because of the mountains. Ninety miles due west of Seattle, on the storm-lacerated front of the

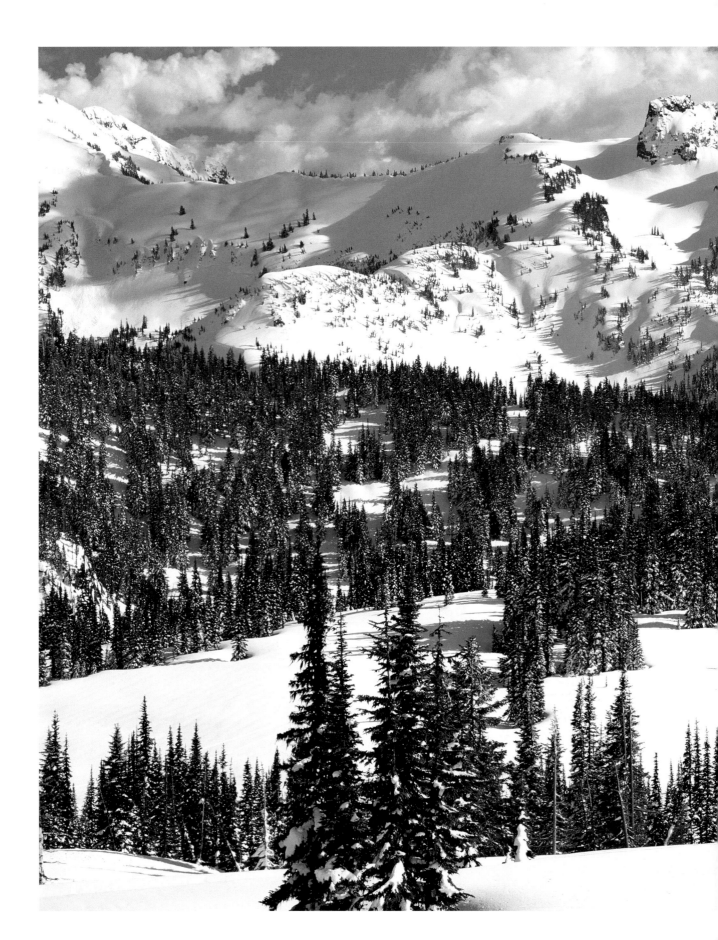

right: Winter-afternoon view of the Tatoosh Range, Mount Rainier National Park

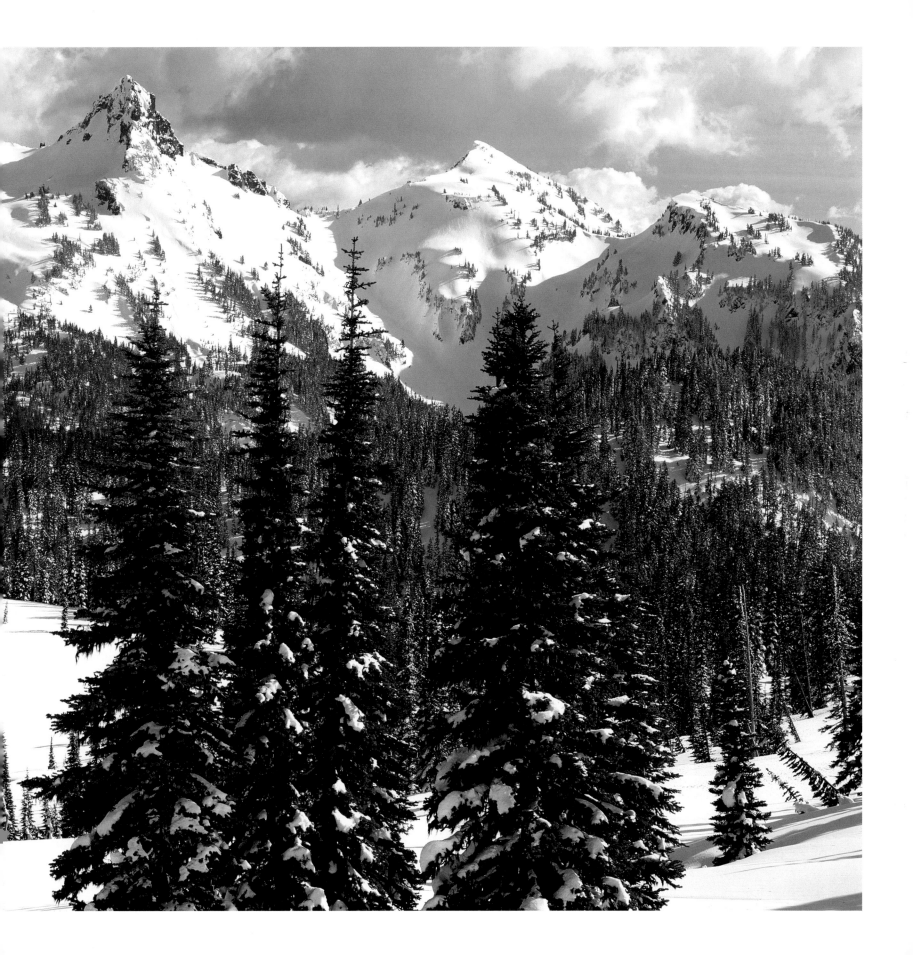

Olympics, the rain is prodigious, nearly 200 inches a year in some valleys, more than any other place in the contiguous United States. The bulky interior of the Olympics protects Seattle, which gets just under 40 inches annually. Then, ascending the Cascade Range, the predominant westerly storms gain strength again, and moisture increases. East of the Cascade Crest, down into the Yakima Basin, the land turns suddenly arid and brown-skinned, a haunt for sage grouse and rattlesnakes.

It seems unlikely now, but in 1890, when Seattle was a city of about 40,000 people, much of the Olympic Mountains was unknown to people settling in across the way. It was a mere forty-five miles from the city to the Olympic Peninsula and its warren of glaciers, fjords, deep forests, and abundant wildlife. But in 1890, so much of the region was uncharted that an exploratory expedition sent by a Seattle newspaper took six months to travel forty-nine miles, from one end of the Olympics to the other. What slowed them was the precipitation, "rain falling in sheets," as one member reported, and snow that was twenty-five feet deep in the lower mountains.

Today, the by-products of all that moisture are the lure for people looking to escape a Wal-Mart world. The only rain forest in the Lower 48 states is in the Olympics. A dozen rivers flow from the icy core of the mountains and make short sprints to the sea. Each has its own character. The Hoh is a hall of moss. The Hamma Hamma is a viewer's feast of Roosevelt elk. The Dosewallips carves a path through steep cliffs.

Old forests have a singular mystery, where young life embraces death and rot. On the ground, saplings reach for daylight from the hides of thick-matted nurse logs, long dead. Up above, numerous specialized creatures live in the forest canopy, among them birds like marbled murrelets and northern spotted owls. The murrelet and the owl are well known, having declined as the fabric of the forest has been ripped apart. Water runs through it, on it, oozes from it. This is the visual demonstration of Aldo Leopold's line about how tinkering with one thing alters the flow of everything, a misty web.

Once, I spent three days on a perch just above Marmot Pass in the Olympics. To get there, I hiked along a valley of old-growth trees, up an old burn at higher elevation, past the dwarfed firs and flower meadows at the mile-high level, and topped out on a *Sound of Music* summit. I never wanted to come down. Mountain goats, puffy-cloud-white and nimble-footed, browsed on forage. A black bear and her cubs appeared on a far slope. The huckleberries made for fine breakfast fruit. And the views, of the Strait of Juan de Fuca and Vancouver Island to the north, and the serrated tops of the Cascade Range to the east, changed with every new angle of the sun. At night, not-so-distant city lights glowed. Days later, in a downtown office building, I looked back at the Olympics, the other way, the very peaks I had visited. The urban-wild bond was sealed yet again.

In a gray funk, I sometimes drift east of the Cascade Crest, looking for dry-side wonders. I like the sound of

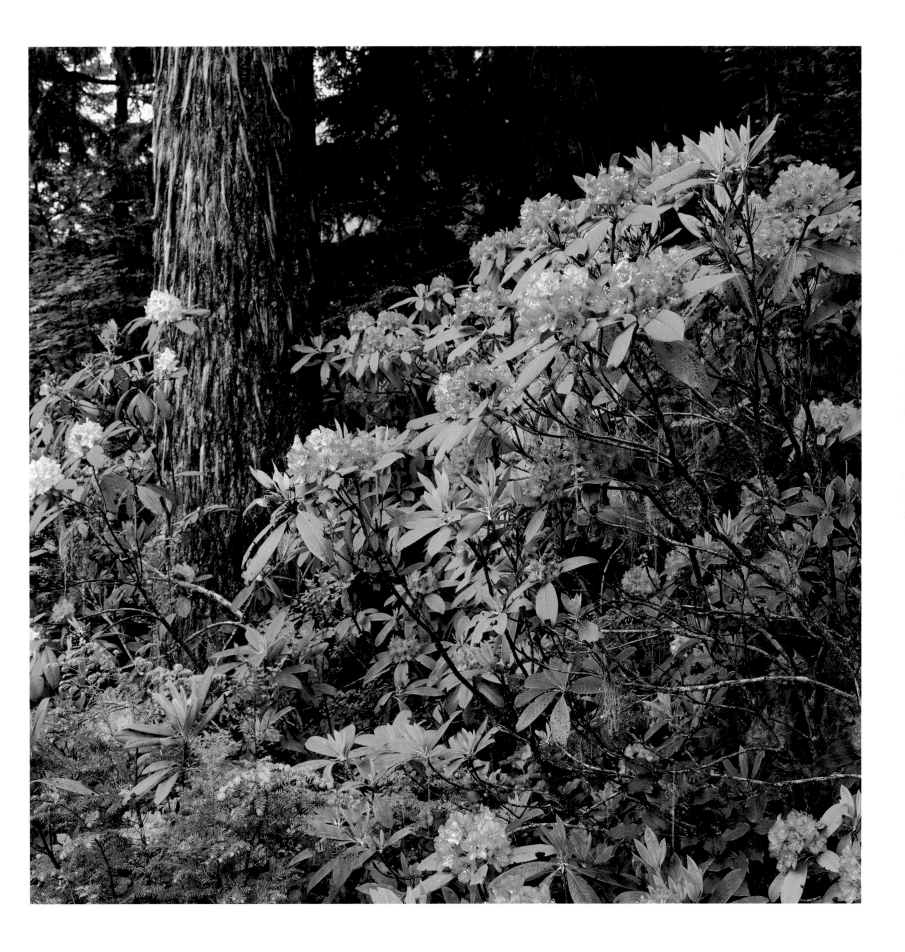

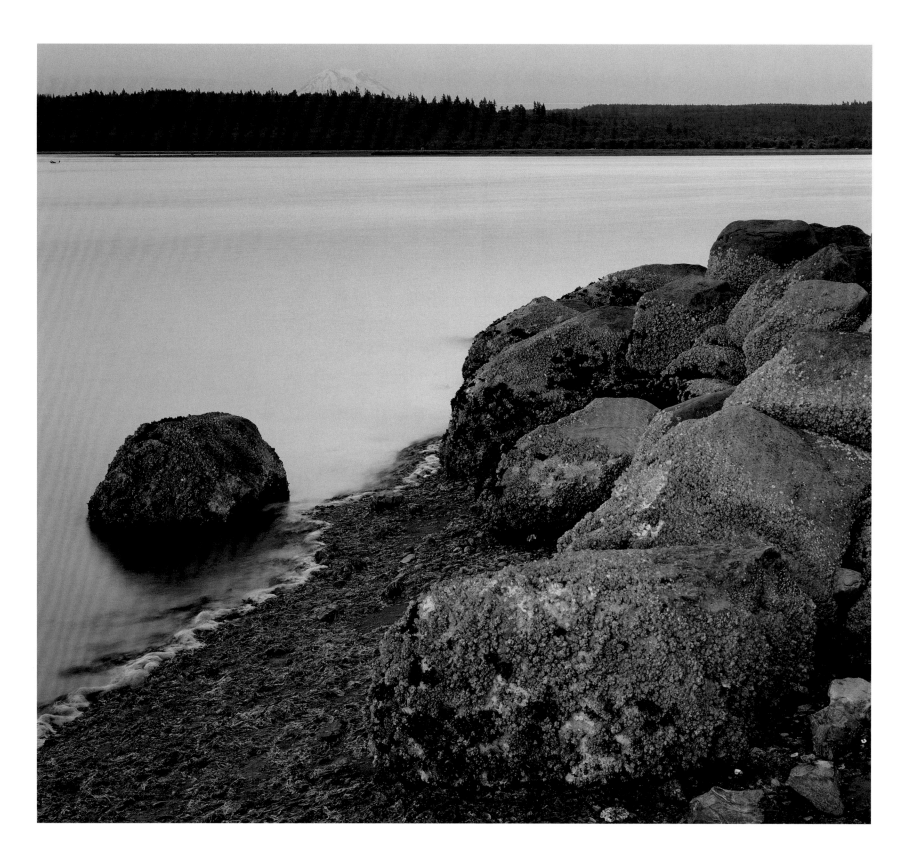

aspens in a breeze, the sight of high-alpine larch trees when their needles turn gold in the fall, and the smell of pine, especially the fat yellowbellies—ponderosas. Bighorn sheep, clambering over basalt, have become more of a presence, especially in canyons around the Yakima River. The east side of the Cascades is all about cold mornings, clear nights, and landscape that looks more like Colorado. William O. Douglas, the Yakima native who would become a Supreme Court justice and dominate much of twentieth-century American law, found his strength after a long illness and developed his love of the wild in these east-slope mountains. The protected wilderness that today bears his name is just beyond Mount Rainier National Park's eastern boundary.

As a young lawyer in New York, Douglas used to close his eyes on the subway and imagine the Cascades. In Seattle, no such visualization is needed to bring the wild close to hand. But it helps to make friends with the lowlands—the mud of tidelands, the marsh of river floodplains, the hypergrowth of cottonwoods. There are roughly 2,500 miles of shoreline along Puget Sound and its inlets. That's a beach that would stretch from Seattle to Pennsylvania. The sound is relatively new, created by the retreating glaciers from the last Ice Age, beginning about 15,000 years ago. An ice sheet covered an area from Vashon Island to the Canadian border and was nearly a mile thick in places. In its rumbling and epic retreat, the ice carved the land that became Seattle, Puget Sound, and all the urban appendages.

The sound is as deep as the Space Needle is high—about 600 feet in Elliott Bay—and rich in marine life, not just the charismatic mega-marine fauna, like whales and harbor seals, but the less glamorous workhorses—more than 2,000 kinds of invertebrates and an octopus that can stretch to twenty-four feet in length. Its tidal pull is ferocious in places. At Deception Pass, between Whidbey and Fidalgo Islands, the peak flow is nearly nine knots, with 2 million cubic feet of water passing through every second. This is eight times the average flow of the Columbia River, the biggest in the West. This tug of gravity and salt water is another way of reminding people that humility is better than hubris in approaching our native land. In the two places where sizable bridges have spanned Puget Sound's major inlets, over the Tacoma Narrows and the misnamed Hood Canal, storms and earthquakes have brought them down. They were rebuilt, with caveats that nature bats last.

But for all the strength of its tidal flush, for all the nearly 10,000 streams and creeks that drain into it, Puget Sound is only intermittently healthy. Three Puget Sound salmon runs are in danger of becoming extinct. The intertidal salt-marsh habitat—the bounteous set table that the Indians spoke of—has declined by 75 percent since people decided to build a city alongside Elliott Bay.

Sometimes it is best simply to behold the small world—a tidepool, for example. Barnacles, limpets, periwinkles, and sea urchins have their place, but a pink anemone, sensitive to the touch, and a starfish, its sandpapery hide the color of

sunset, can bring a marine biologist to fits of passion in short order. Salmon get all the attention, but Puget Sound flounder, with both eyes on the top side, looking like they missed a step up the evolutionary ladder, kept Natives fed between salmon runs. The variety of fish that live in these cold waters is extraordinary—sturgeon, sablefish, herring, sculpin, mackerel, rockfish, tuna, skate, smelt, eel, lantern fish, just to name a few.

The marine life draws the birds, as well. Great blue herons and American bald eagles have made huge comebacks. They love salt-marsh estuaries and city parks. People sometimes forget that the regal-headed predators are terrific hunters. I have seen a bald eagle harass a flock of shorebirds off Seward Park, just blocks from where I live, before snatching one from the water and hauling it off to a nest. Some people who witnessed this acrobatic hunt were appalled.

I thought it was wonderful. These birds don't live on dietary supplements from Purina.

Most city-dwellers connect to the marine world simply by hopping on a ferry. Washington has the nation's biggest fleet. As a boat slips out of downtown Seattle, the city falls away quickly. In short order, the world is all water and mountains in this great bowl of Puget Sound. This region is sometimes called Ecotopia, which I think is a reach. Seattle has an active environmental conscience, as do Portland, Vancouver, and San Francisco, but it is not because the people are any more virtuous in regard to the environment. It is because the natural world is so close, so ingrained in daily life. The outdoors—mountain, sea, and forest—are shared living rooms, not abstractions. Even in a thick fog, crossing Puget Sound by ferry, you feel it: the call of the wild so close to the urban center. At times, I hold my breath.

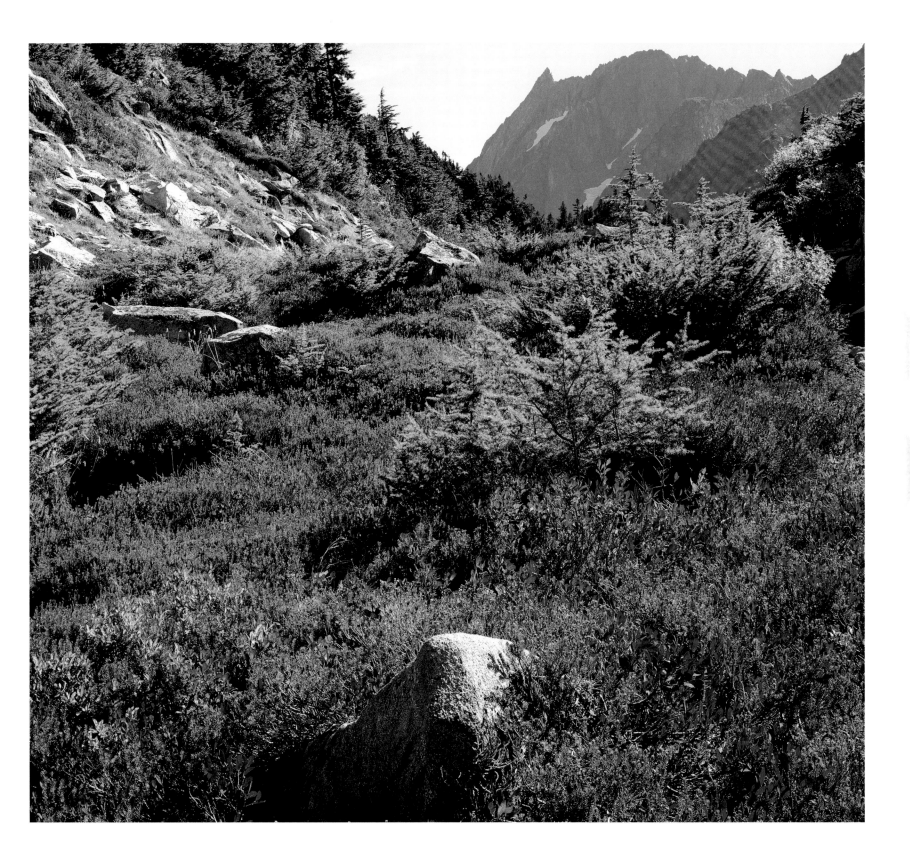

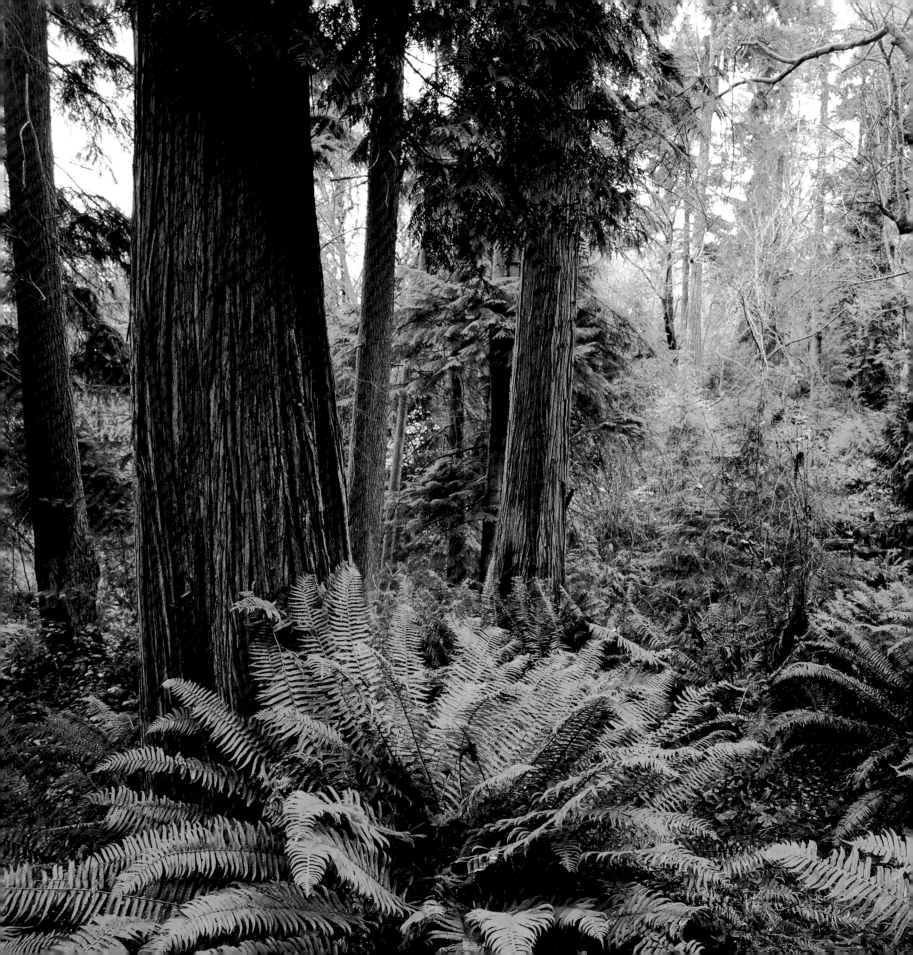

opposite: *Western red cedar, Douglas fir, and sword ferns in Schmitz Park* right: *Pacific tree frog, a small but vocal inhabitant near ponds*

Wild in the City

WHERE I GREW UP, BETWEEN GARY, INDIANA, AND CHICAGO, THERE WAS NO NATURAL WORLD. MY FATHER WORKED ALL HIS LIFE IN THE STEEL MILLS IN GARY. SO WHEN I CAME OUT HERE IN THE 1950S, IT WAS A GREAT SHOCK; I THOUGHT I WAS IN EDEN.

-DAVID WAGONER, in *Northwest Passages*

Wild
SEATTLE

It all looks so tentative. The shiny shell of Frank Gehry's Experience Music Project, carefully crumbled at the base of the Space Needle. The two floating bridges bouncing on the chop of Lake Washington. The roads holding one hill of Seattle to another. Close your eyes and look again and you can see a land in its birthday suit. Seattle is cosmopolitan, very much a West Coast city, a place of cool neon in the mist. But all the human amendments are secondary to the setting.

It's a vertical city, first and foremost, founded on seven hills, as a barnacle-encrusted native will tell you. This presented a challenge to the first city builders. There was no way a flat grid like Cleveland's was going to fit on top of Seattle's roller-coaster terrain. But they tried. And they failed, thank God.

So we have a city of hills, rising from water, and houses planted on the slopes. Sometimes they slip. But that is life in Seattle, an urban pact with a land that is young, alive, quaking, slipping. The hills have inspired a look—part Asian, part homage to Native cedar worship, and part Scandinavian—that gives a style to the city like no other, with houses that seem as if they sprouted from the moist ground, lots of exposed wood and stone.

Some Seattle neighborhoods face the sunrise over the Cascades. This is the Lake Washington side, the neighborhoods of View Ridge, Laurelhurst, Montlake, Leschi, Madison Park, part of Capitol Hill, Madrona, Seward Park, and Mount Baker. They get morning sunlight, glimpses of distant glaciers in the North Cascades. They usually don't see the storms until they are beneath them.

The city's other side looks west to alpenglow on the Olympics and ferries scooting across Puget Sound like water bugs. These neighborhoods are the first to see the storms coming in from the Pacific, bunching up at the Olympics, then gathering steam for another roll inland. These are West Seattle, Downtown, Magnolia, parts of Queen Anne Hill and Beacon Hill, Phinney Ridge, and Ballard.

In between are the watery bowls: Lake Union, Lake Washington, along the ship canal, or in the Green Lake neighborhood. And in one of those bowls is a houseboat community tied to the whims of Lake Union, living with turtles, ducks, cormorants, and other water-loving creatures going about their business.

The abundant rain and temperate air give the city a primeval feel, especially in late spring. A garage or small house, if left unattended for several years, will be covered in blackberry bramble. An alder or maple takes up residence next to an apartment and in no time is a towering neighbor. The air usually smells new, carrying clean currents in from the Pacific.

It's a city, yes, where people talk about their baseball team, their loves and heartbreaks, get angry at traffic, and wish some of the better secret places would remain just that. It has its pockets of the original Northwest, the old-growth forests in Seward Park, the cliffs of Discovery Park—both homes to breeding pairs of bald eagles—or the wind-polished madronas leaning away from the sea in West Seattle. And it has fish in its blood, several species of Pacific salmon working their way through the Hiram M. Chittenden Locks to find a spawning ground somewhere beyond the metro area. But all the neighborhoods, and the gilded new buildings, are connected by what's out there. One of the first things that people from other cities notice about Seattle houses is the windows. The urbanite here is always reaching for light, for view, for some peek out to a world that answers only to the seasons. So the workday chatter may be like that of any city. But by the end of a day, the common currency of conversation will have something to do with a flank of mountain glimpsed, a hint of wild felt in a place ever so tentatively settled in.

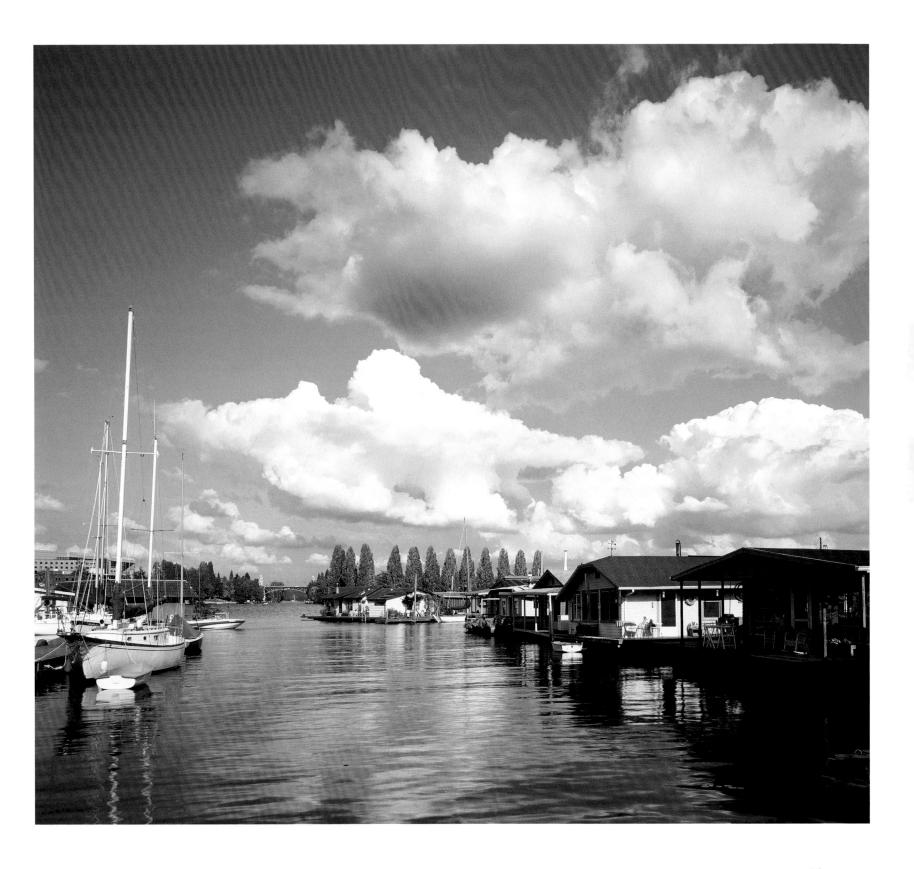

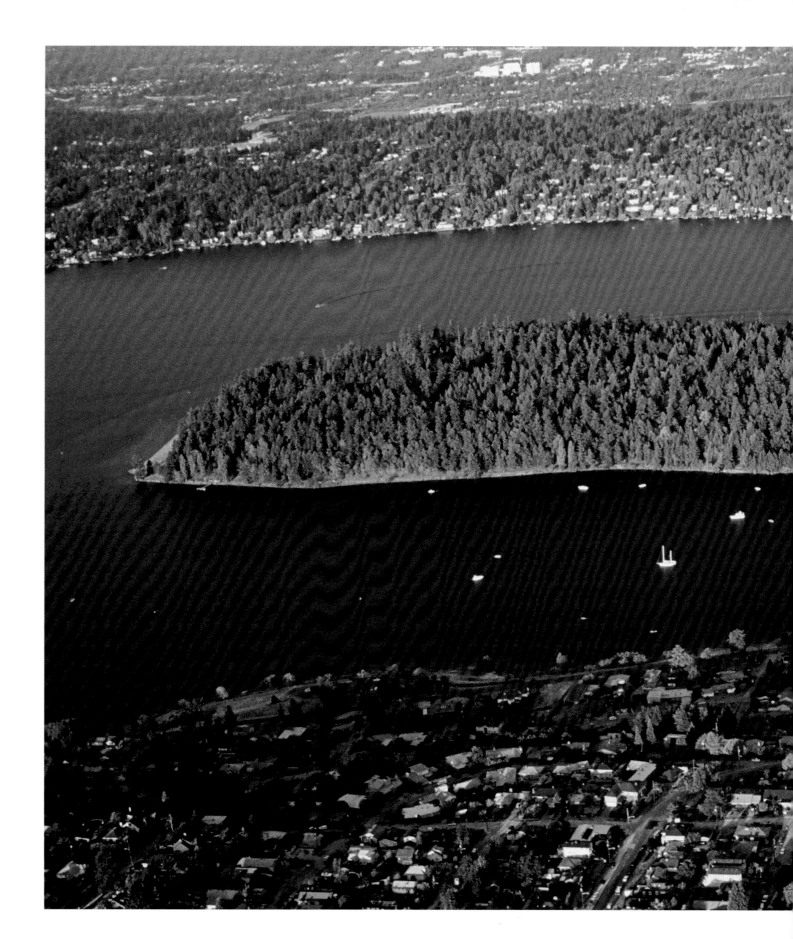

right: *Aerial view of Seward Park, Bailey Peninsula, on Lake Washington*

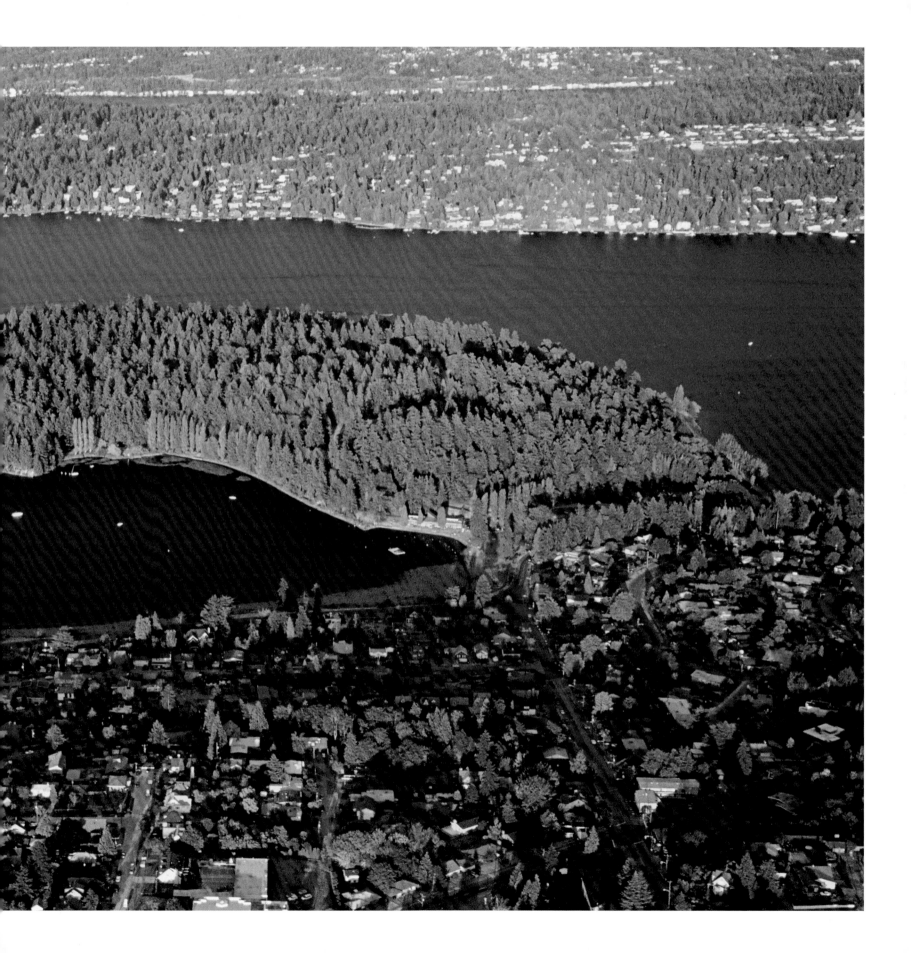

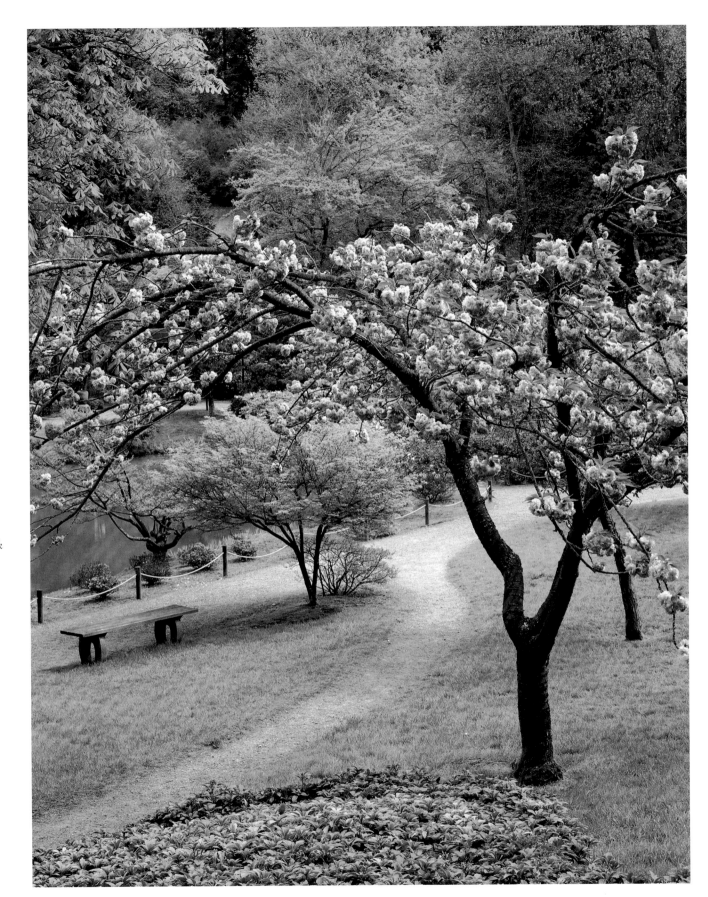

right: Japanese flowering cherry tree, Japanese Garden, Washington Park Arboretum

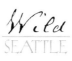

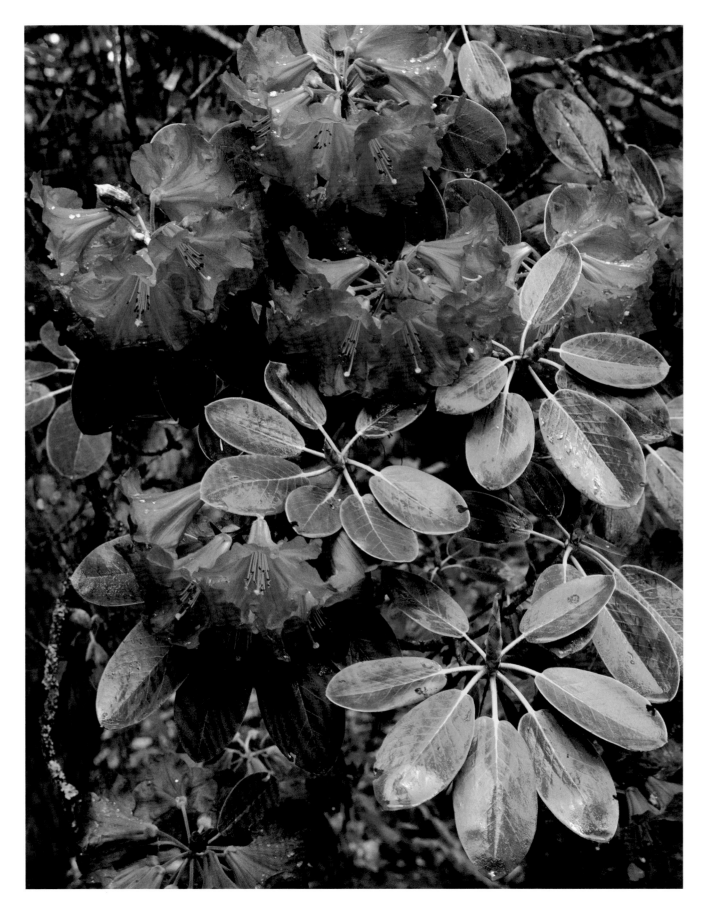

left: *Spring-blossoming rhododendron in 230-acre Washington Park Arboretum*

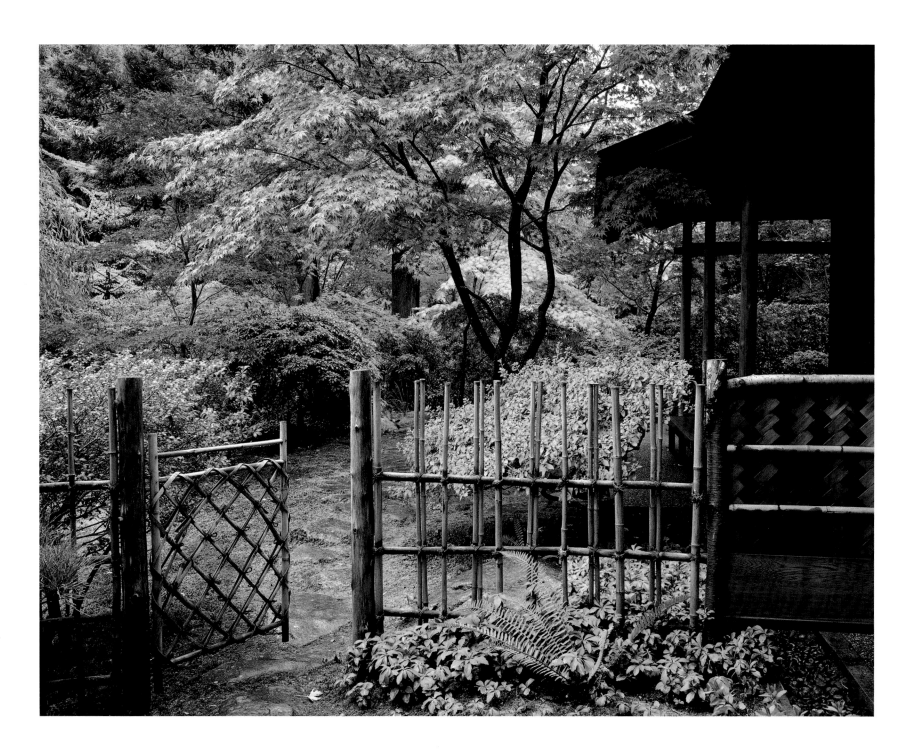

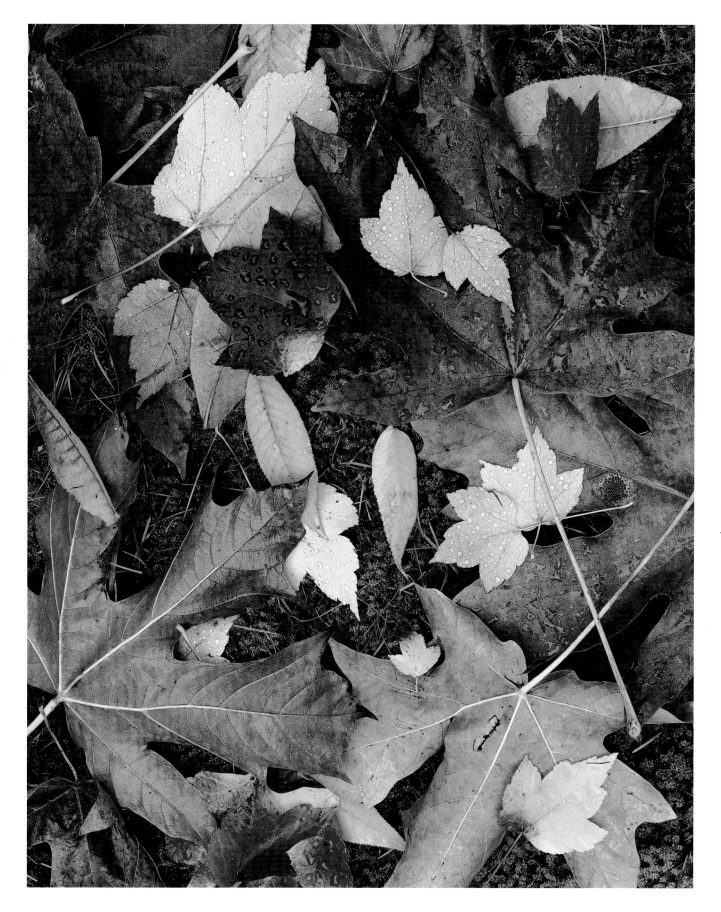

left: *Colorful fall foliage, Washington Park Arboretum*

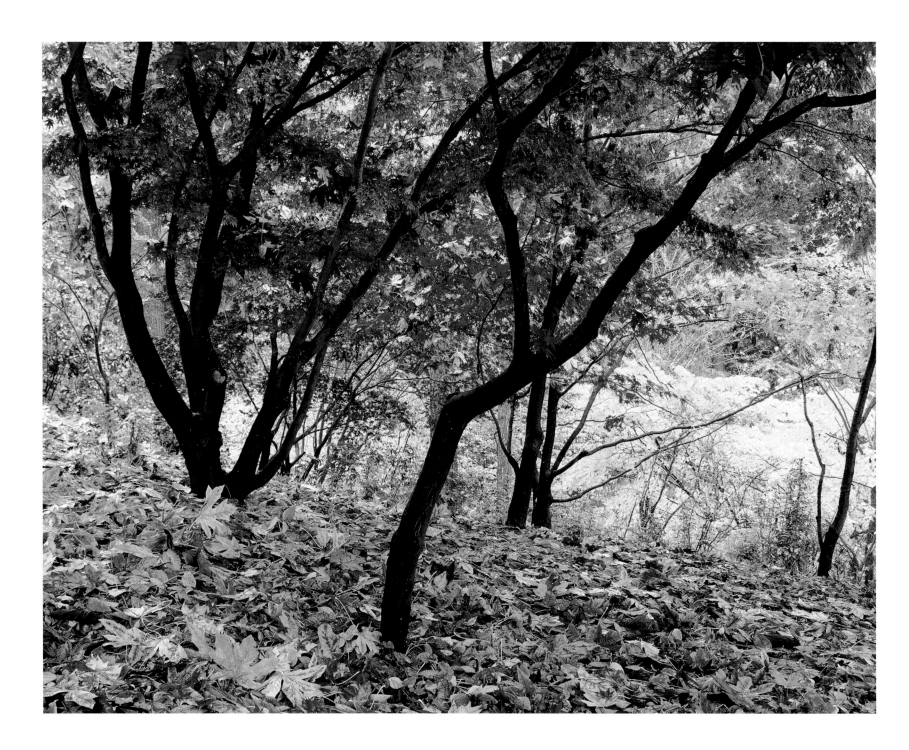

below: *Footbridge and pond in winter, Kubota Garden, South Seattle*

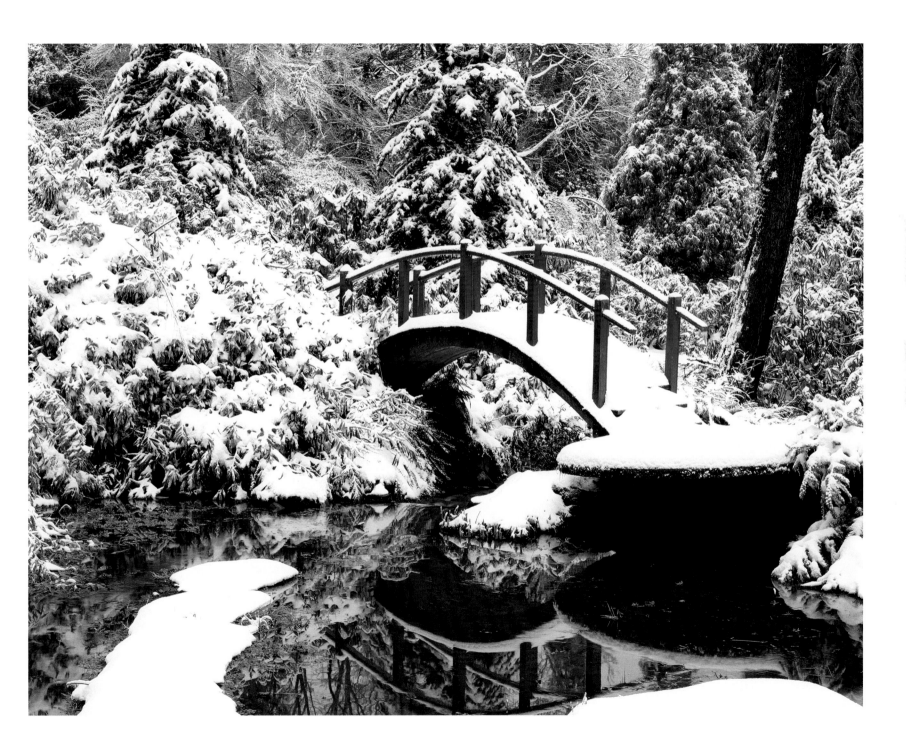

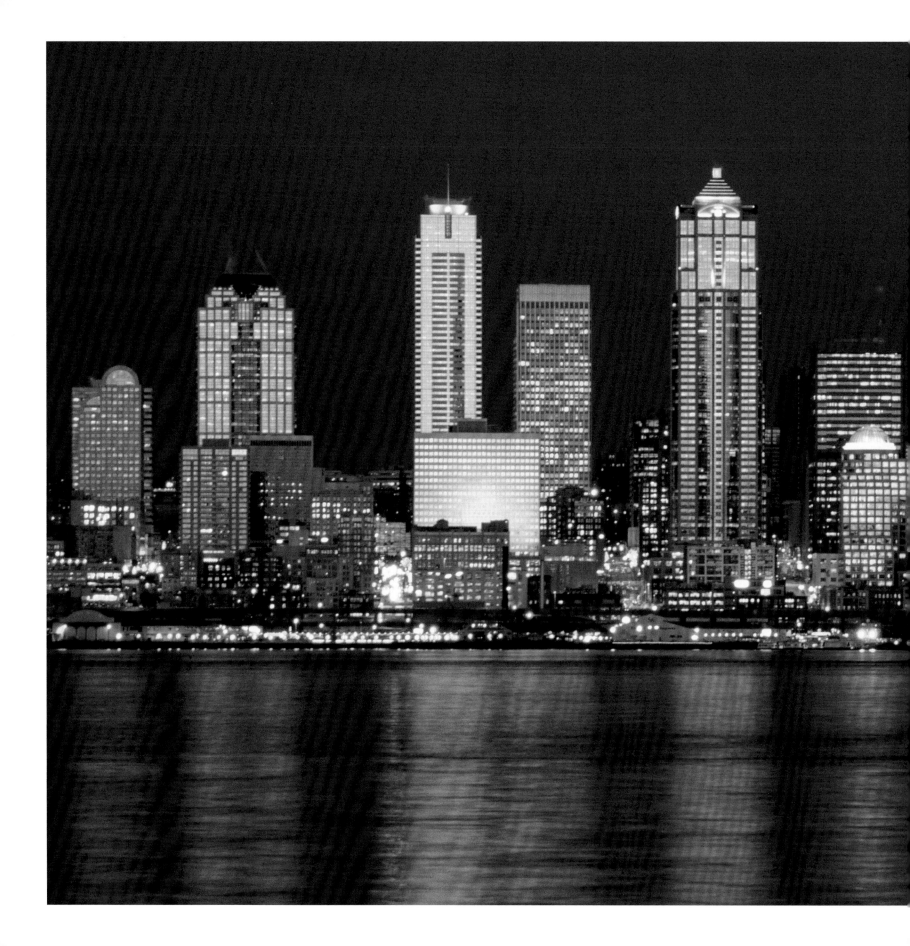

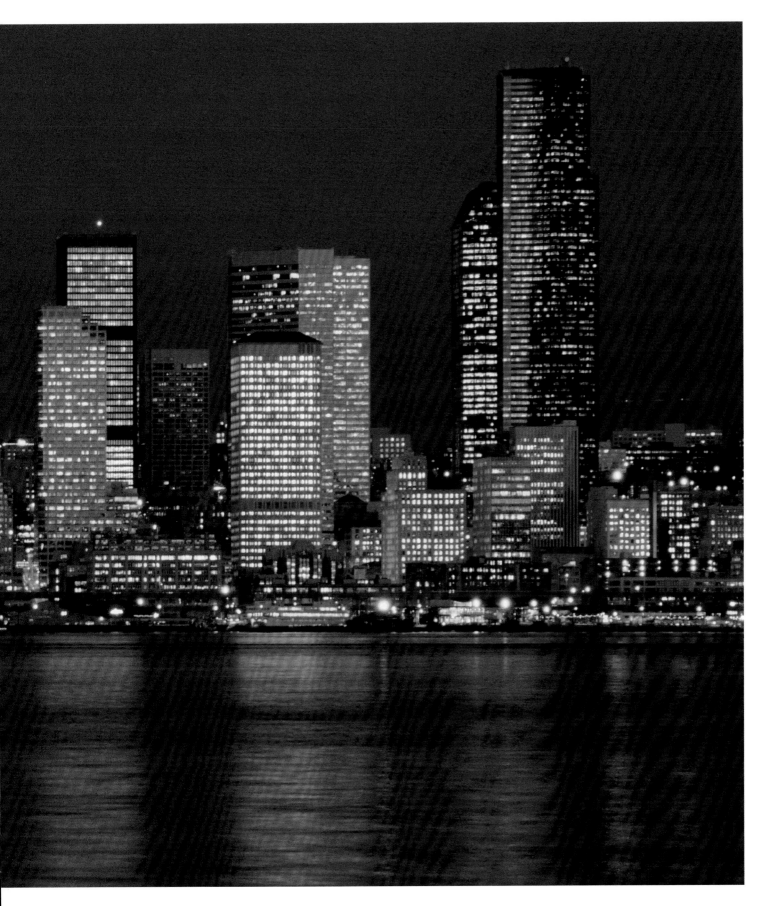

left: *City skyline at dusk, with reflections on Elliott Bay*

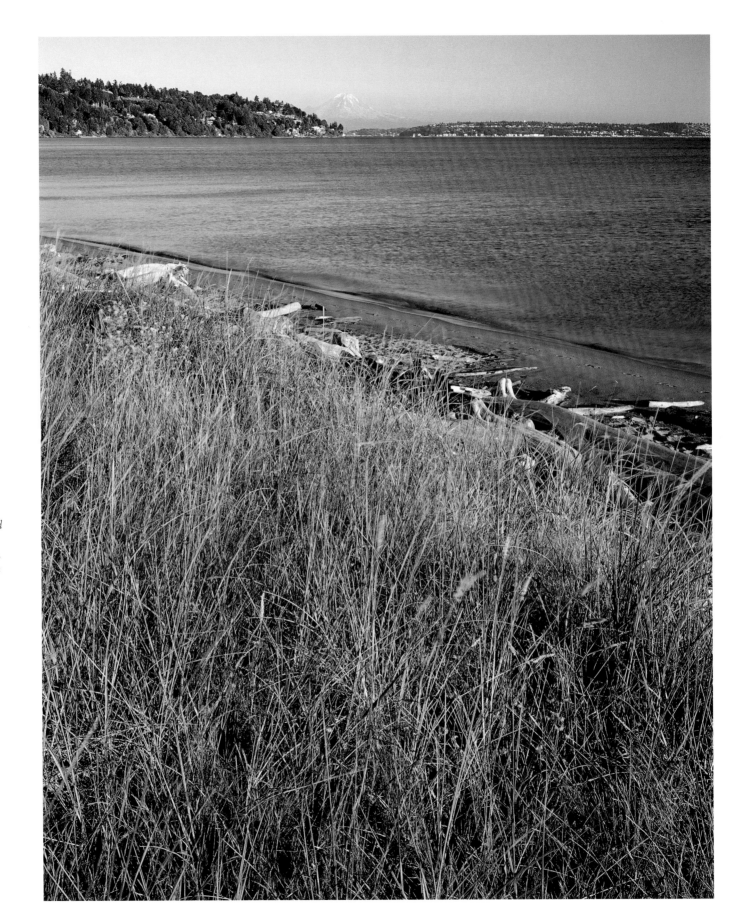

right: *Beach grasses and driftwood, West Point Beach, Discovery Park, with Mount Rainier in the distance*

46

below: *American kestrel, small falcon of the Washington skies*

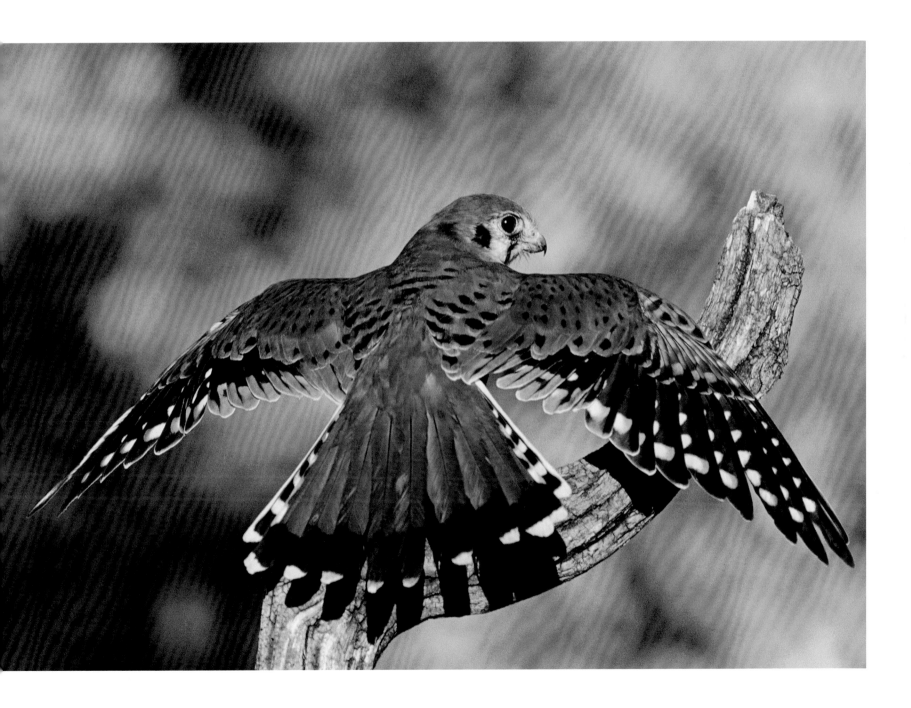

below: *Hiram M. Chittenden
Locks (also called Ballard Locks)
on Lake Washington Ship Canal
connecting Puget Sound with
freshwater Lakes Union and
Washington*

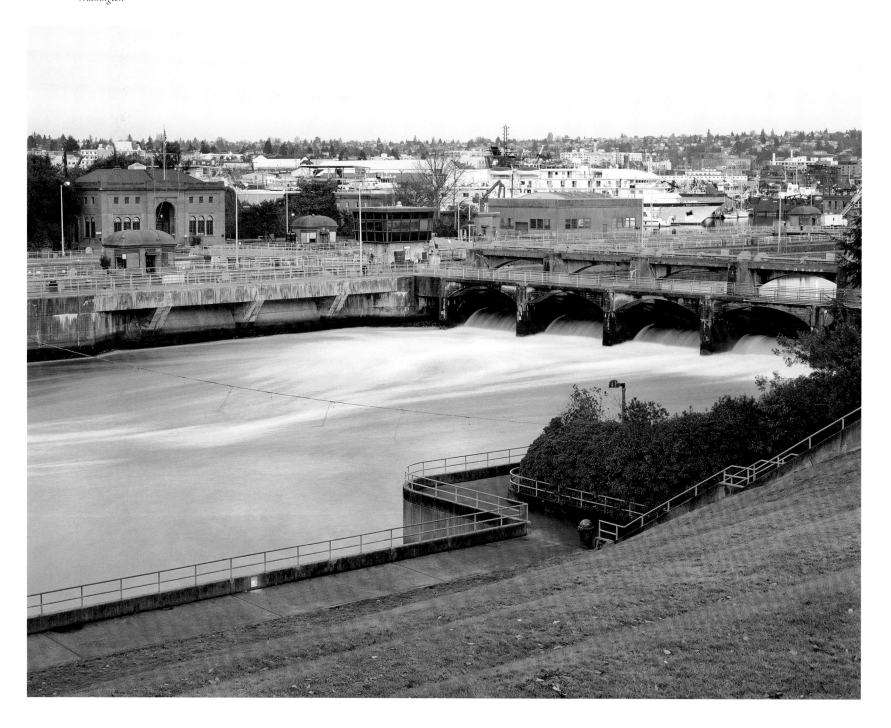

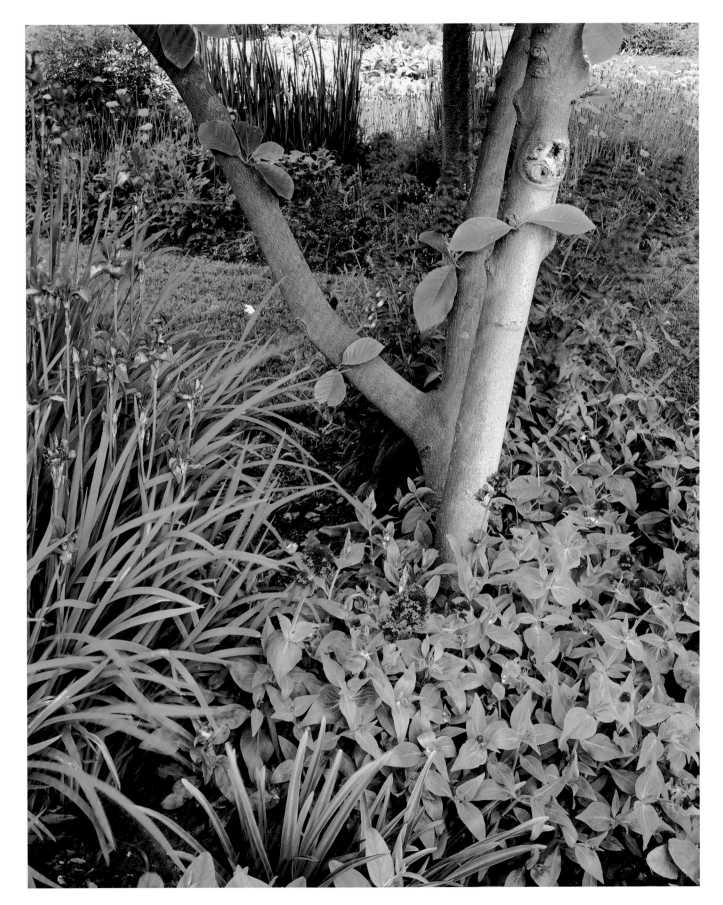

left: *Iris and valerian bloom in Carl S. English Jr. Botanical Gardens at Hiram M. Chittenden Locks*

49

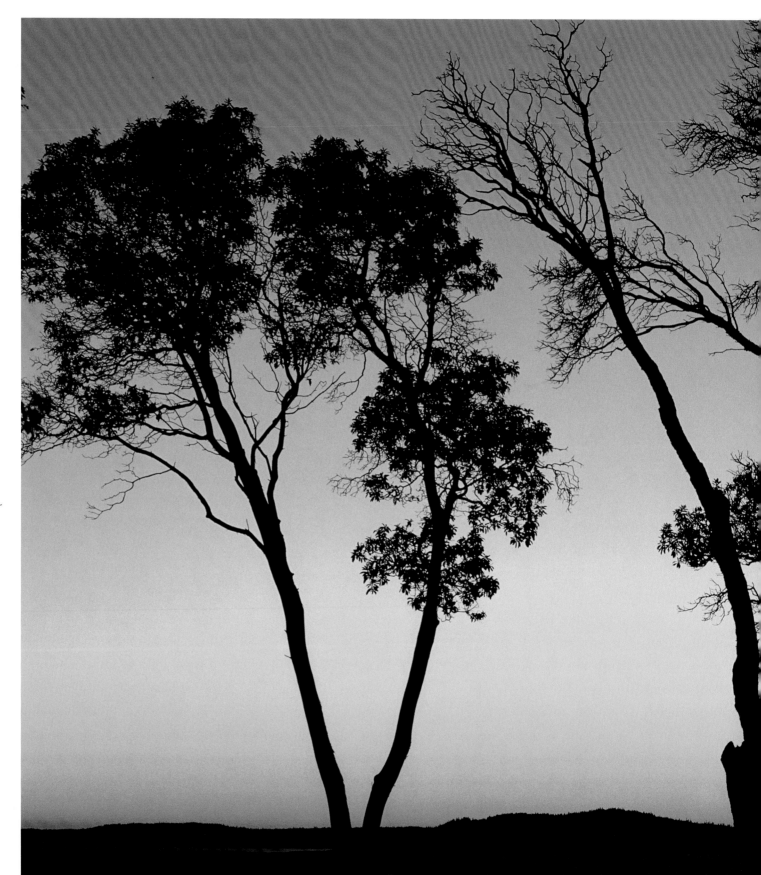

right: Winter trees at sunset, Magnolia Park, on Elliott Bay, with Kitsap Peninsula in the distance

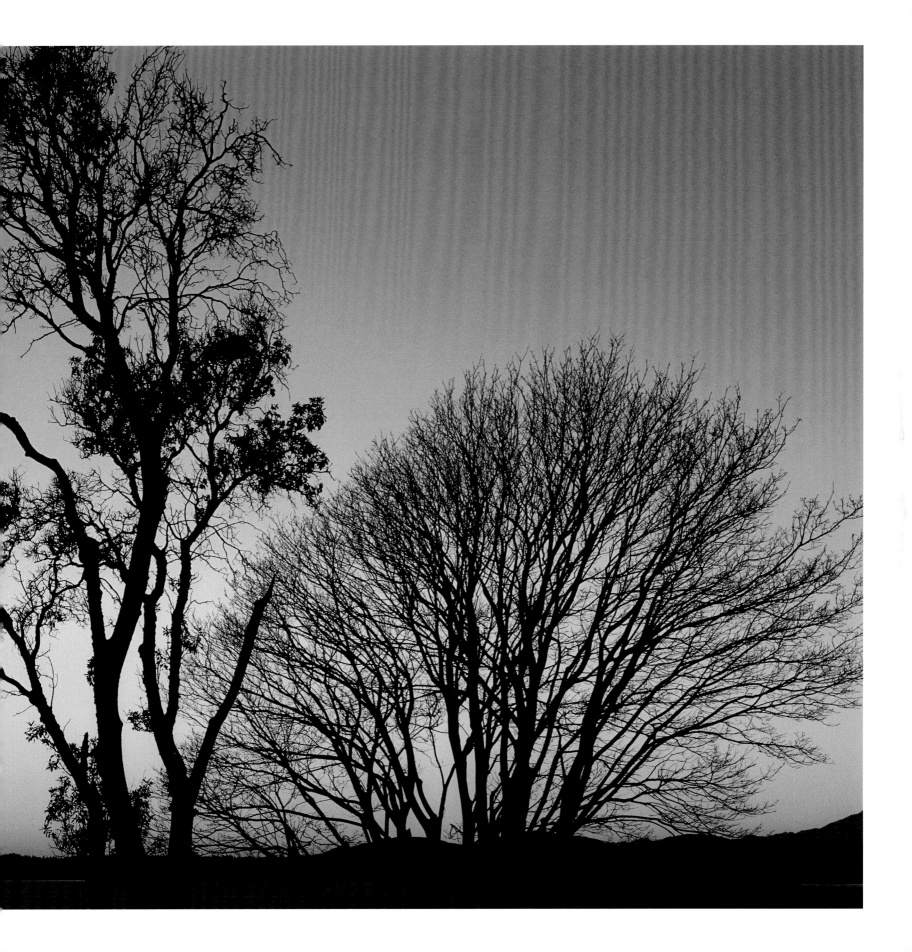

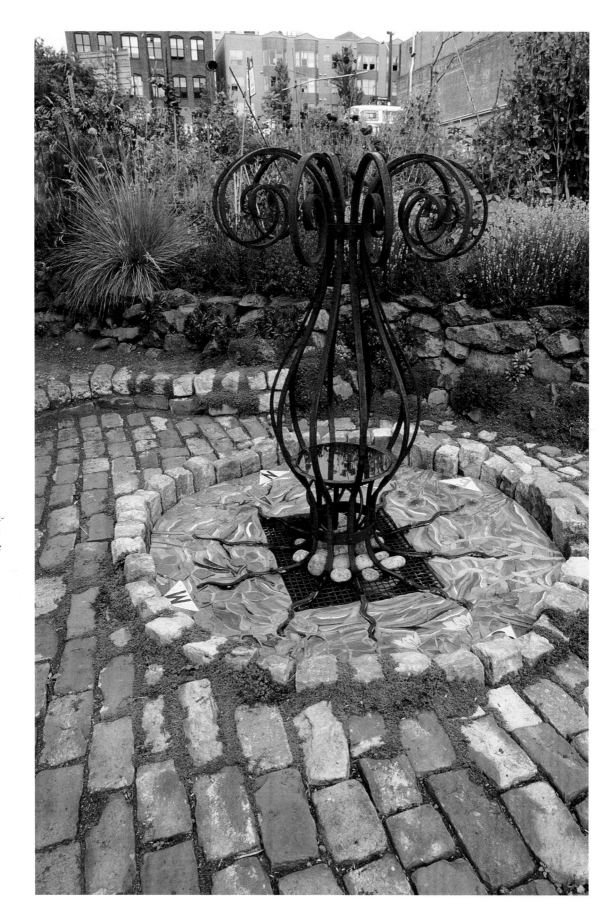

right: *Fountain and walk-way at Belltown P-Patch Community Garden, one of many in a citywide garden program*

left: *Belltown P-Patch Community Garden, the last preserved open space in downtown Seattle*

below: *Commuter ferry
silhouetted by the sunset on
Elliott Bay*

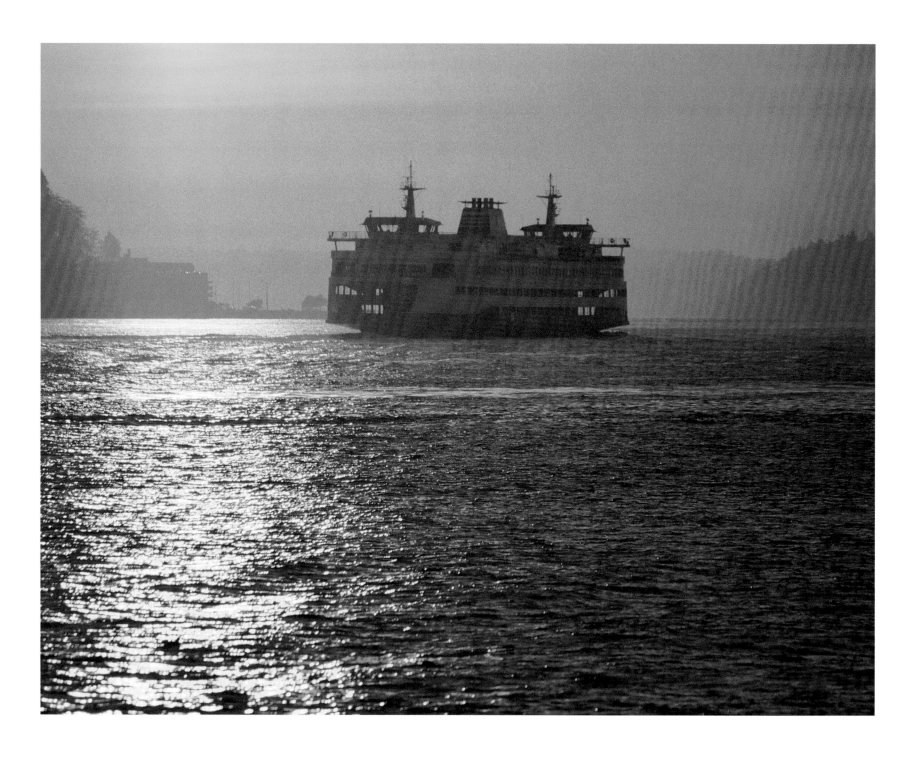

below: *Mount Rainier as seen
from Lake Union*

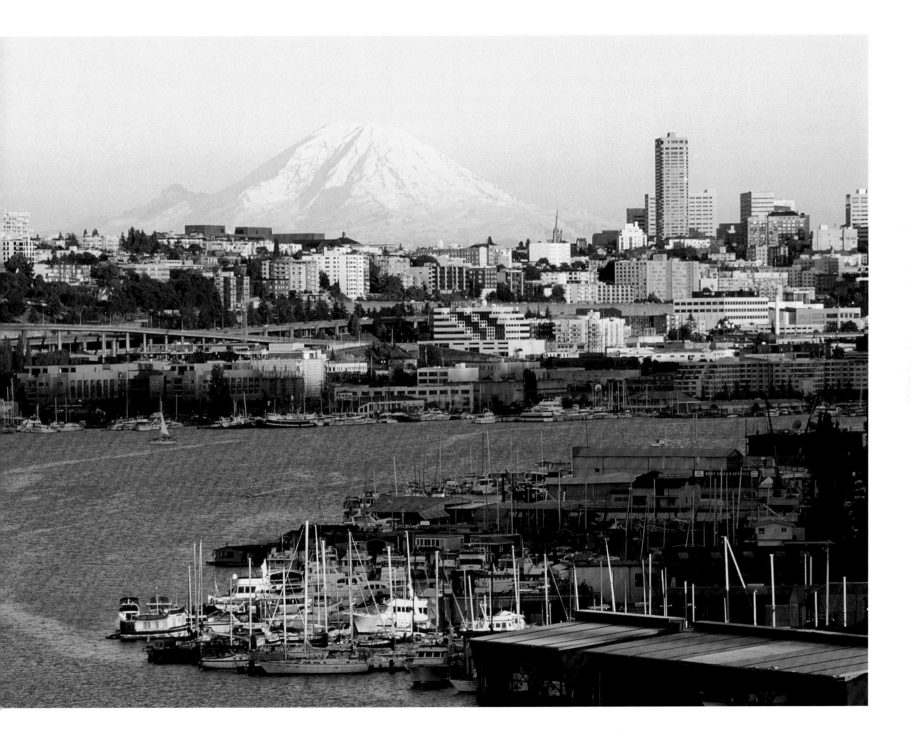

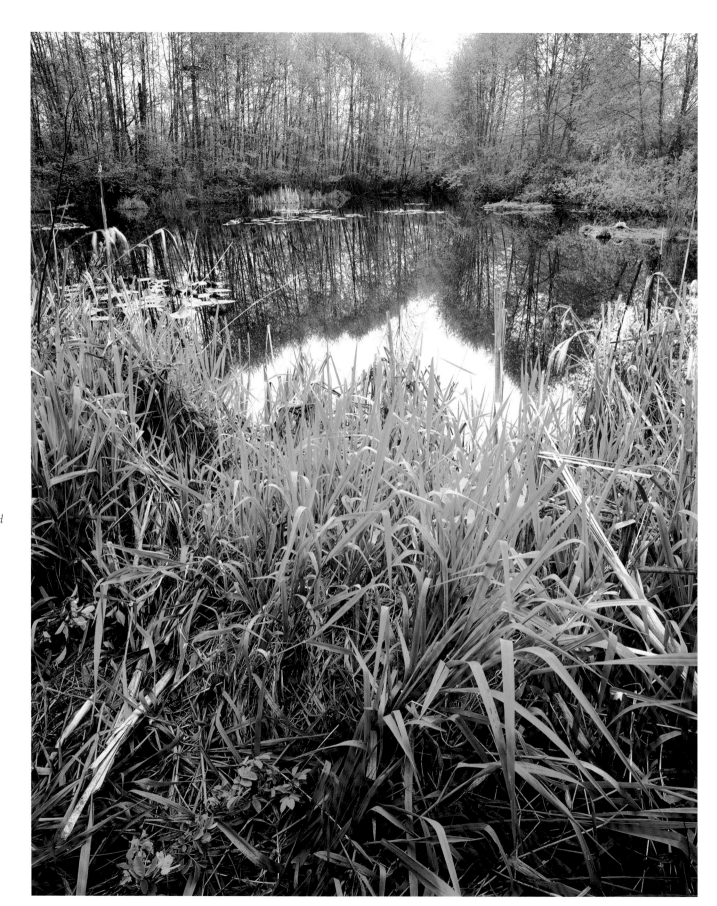

right: Grasses and wetland pond near Sweyolocken Landing, Mercer Slough Nature Park, Bellevue

below: *Raccoon, a common resident of Seattle's wooded neighborhoods*

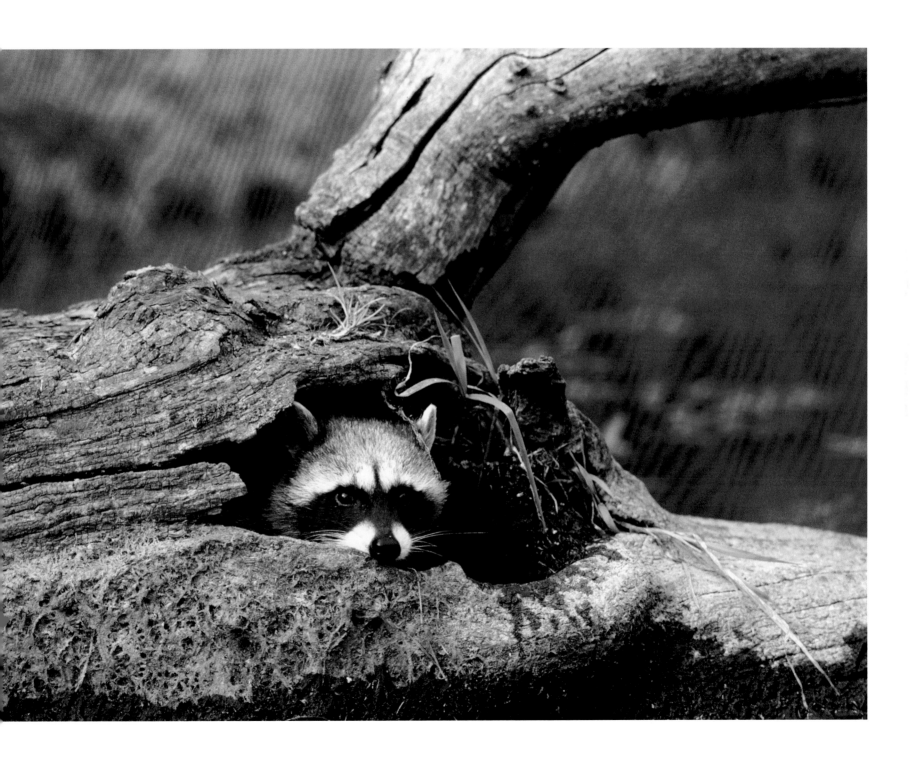

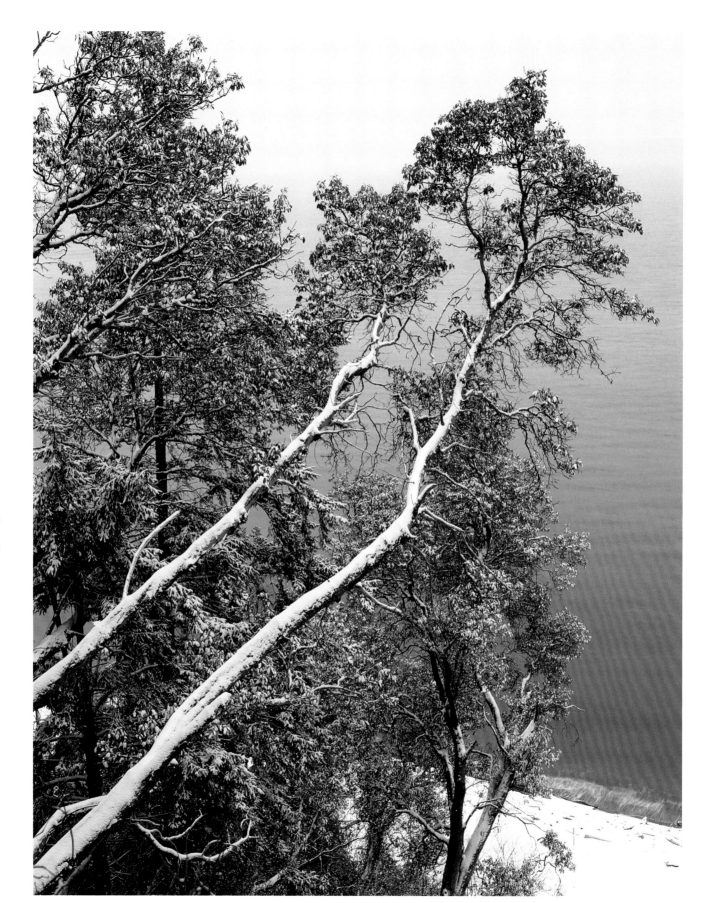

right: *Snow on madronas overlooking Puget Sound from Lincoln Park, West Seattle*

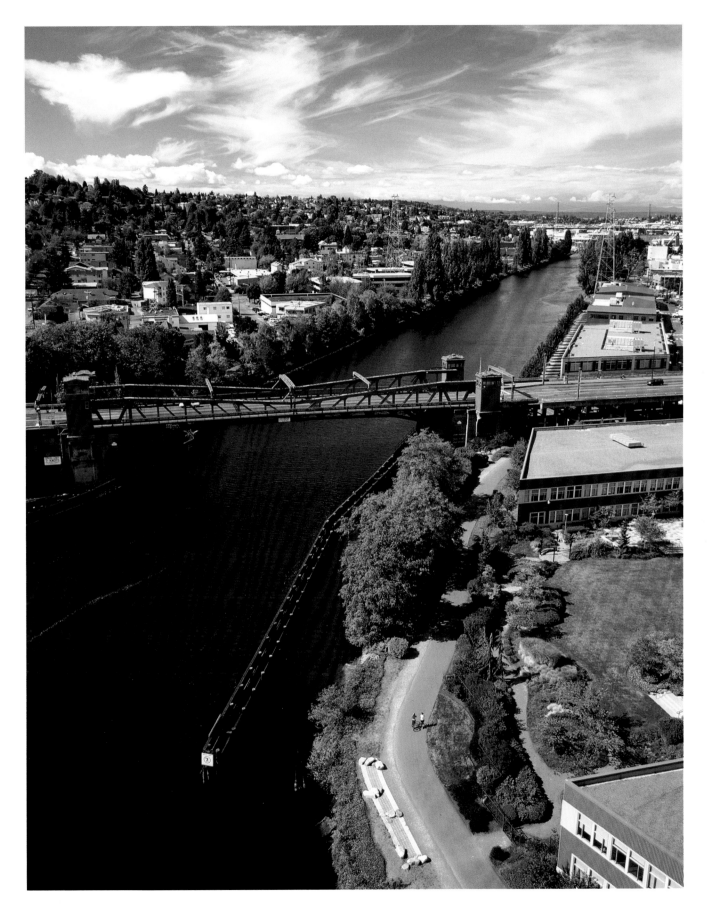

left: *Lake Washington Ship Canal and Burke-Gilman Trail spanned by the Fremont Bridge*

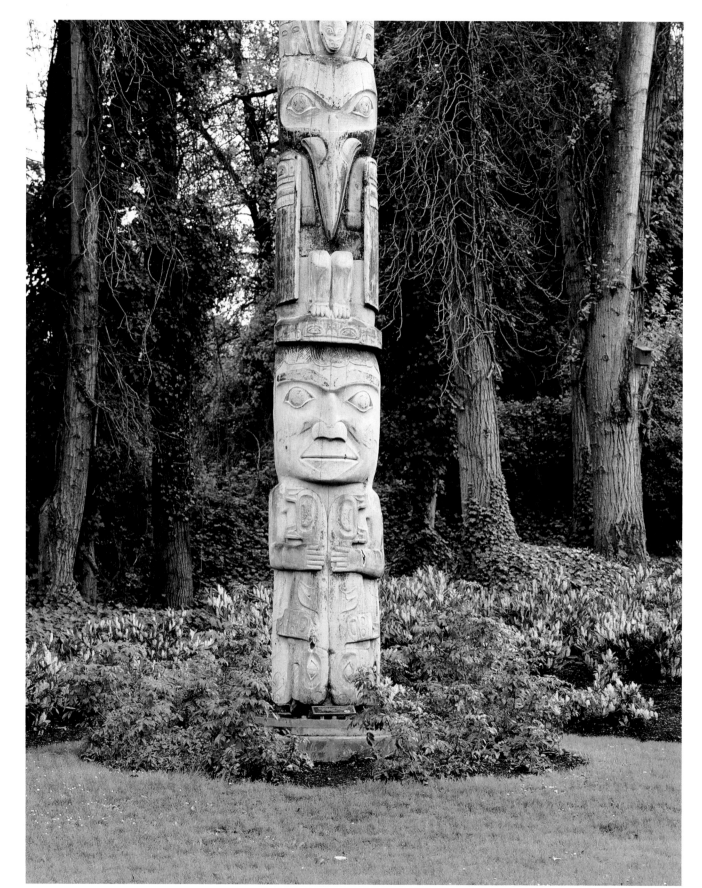

right: Haida totem pole and garden in McCurdy Park, Montlake Cut, Lake Washington

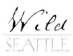

below: *Sunrise reflected on*
Green Lake

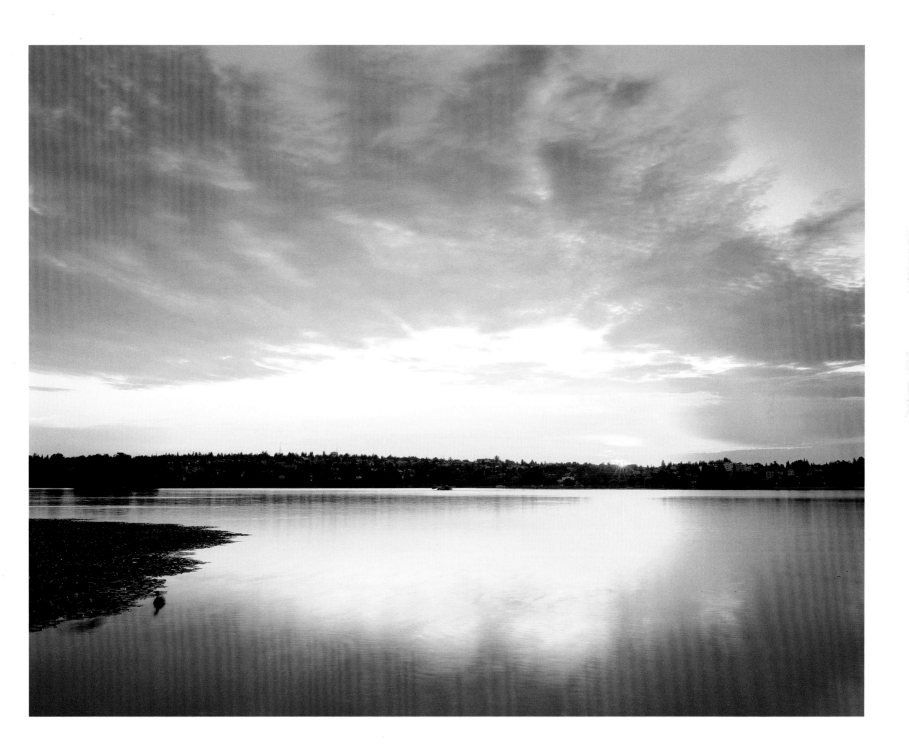

left: *Native Pacific rhodo-*
dendron in old-growth
forest, Rhododendron
Garden, Point Defiance
Park, Tacoma

63

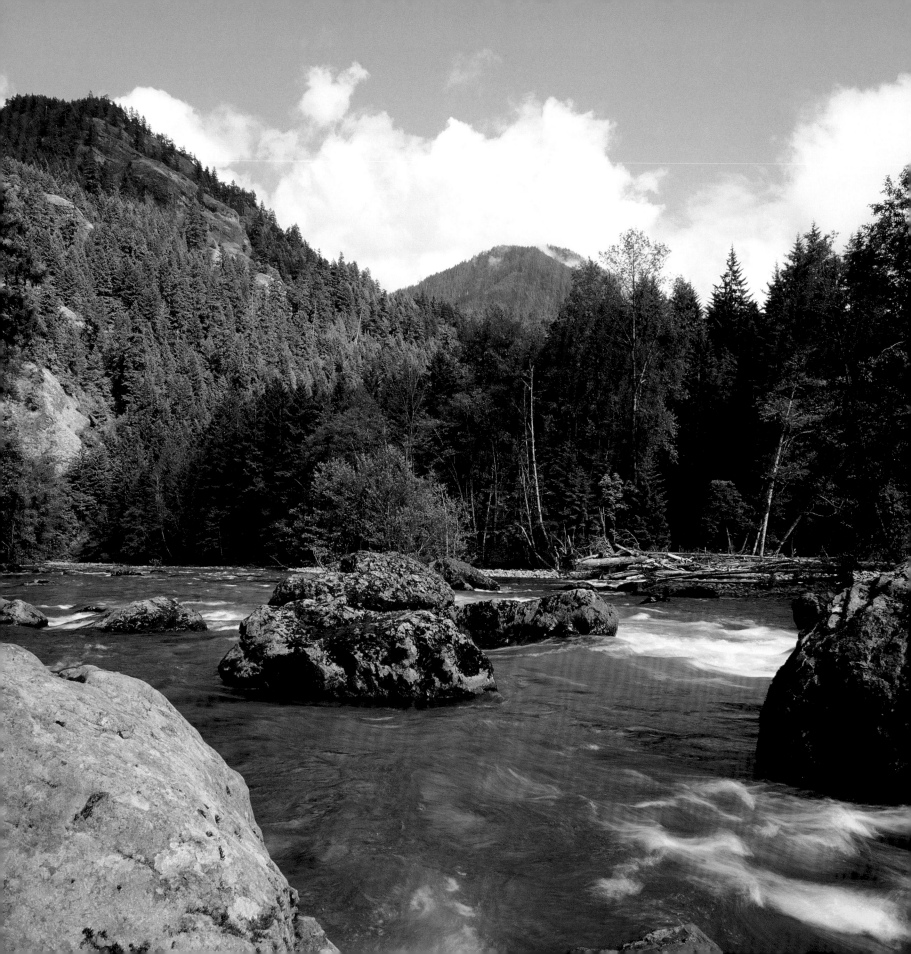

Olympic Peninsula

THERE ARE THOSE TO WHOM PLACE IS UNIMPORTANT, /
BUT THIS PLACE, WHERE SEA AND FRESH WATER MEET, /
IS IMPORTANT.

—THEODORE ROETHKE, *The Rose*

Surrounded by water on three sides, the Olympic Peninsula is bigger than the state of Massachusetts. And in some ways it calls to mind the New England coast, with its rocky shores, its abundant shellfish, and little harbor towns with more boats at anchor than people in the village. But there, the similarities end.

The peninsula encompasses at least a half-dozen wild worlds flourishing in a place where the continental United States runs out of land. Green is the dominant—some would say overwhelming—color, and the moisture is predatory. Snow and ice cover much of the peninsula,

Wild
SEATTLE

the higher reaches. But tide pools in hidden bays and the Dungeness Spit, its long, sandy arm sticking out into the Strait of Juan de Fuca, remind you that this is very much a marine environment as well. The spit and the crab share a name, and the same water.

On the west side, storms from the Pacific have whittled away at land's end, creating sea stacks and a huddle of ancient trees that slouch inland. It is the longest stretch of wilderness coast on the Pacific shore outside Alaska.

The temperate rain forest, with its carpet of continuous compost and fat cedars, is a web of natural intrigue and wet life. Away from the valleys, the land quickly buckles and rises. In the interior is Mount Olympus, the peninsula's highest peak, just under 8,000 feet. It was named by an English sailor for a place where gods dwell. Olympus hides from Seattle, obstructed by other peaks, but its massive mantle of glaciers can be easily seen from the top of Hurricane Ridge, at the end of a park service road to the clouds. With more than 100 feet of annual snowfall, Olympus has the lowest-elevation glacier system in the Lower 48 states.

The north side of the peninsula is a curious blend of dry-land flora and views across the Strait of Juan de Fuca to Vancouver Island and beyond. On this side, the mountains block the predominant weather systems, leaving a rain shadow. Pilots call it the blue hole. There are western red cedars, pink-flowering Pacific rhododendrons, gigantic sword ferns, and other signature plants of the Northwest.

But because so little rain falls here, cacti grow as well, and grassy meadows turn brown in late-summer drought.

The east side of the peninsula looks more like parts of Norway. The Kitsap Peninsula still has traces of its wild self, in forest thickets and a few lonely beaches, despite its proximity to Seattle and the pressure of population growth. Here are fjords, brooding stands of fir and moss-draped bigleaf maples, and the long, natural saltwater inlet of Hood Canal. Water oozes from every rock and vertical flank—or so it seems—up in the foothills. The front line of big Olympic peaks on the east side—The Brothers, Warrior, Mounts Townsend and Constance—give sunsets viewed from Seattle a painted look. These are rugged mountains, rising steeply to the sky, in a very young range, and they hold their snow for most of the year.

The Olympic Peninsula, so rich in terrain, is also full of wildlife. It was an island wilderness during the Ice Age, and as a result, some species are found there in abundance and nowhere else. Roosevelt elk flourish on the peninsula, munching on alder shoots in the valleys in winter, fleeing for cooler air in the alpine reaches in the summer. The oldest land dwellers, amphibians, are plentiful in the lowlands; the peninsula has fourteen species of salamanders and frogs. Mountain goats, with that impossible dexterity, climb the highest reaches. These athletic ungulates share the high peaks with bipeds, many from Seattle, taking in a part of the wild world that lies just a ferry ride from their city home.

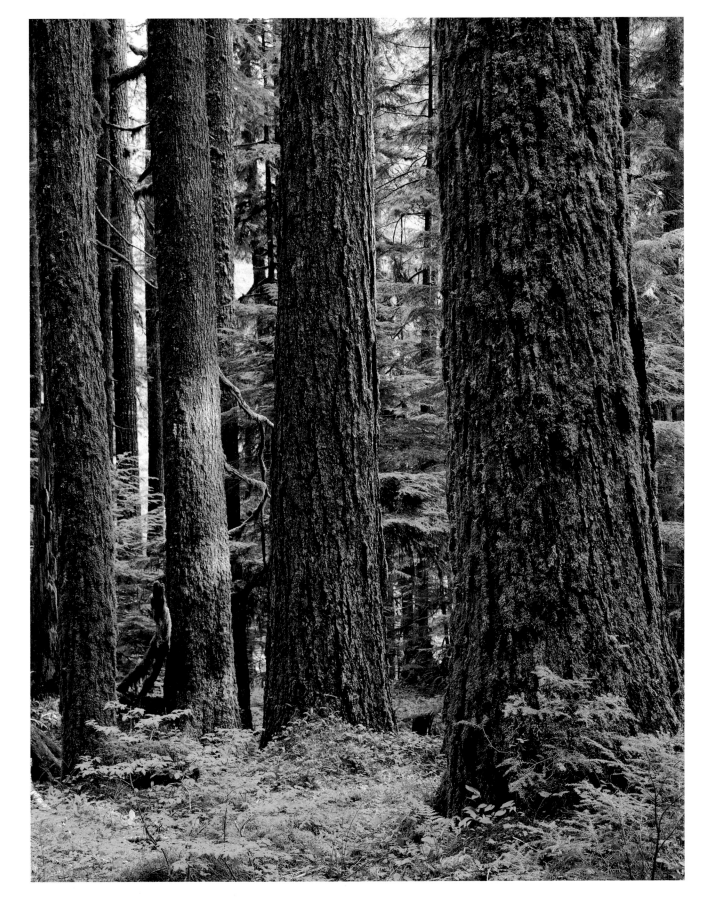

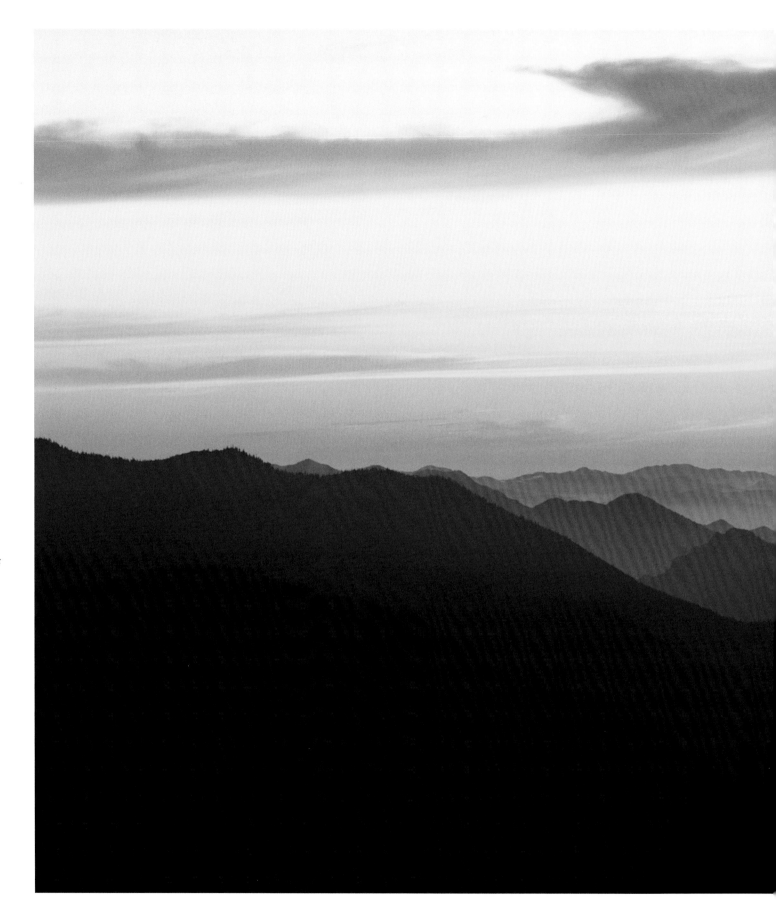

right: Twilight colors on ridges and valleys of the Olympic Range from Hurricane Hill, Olympic National Park

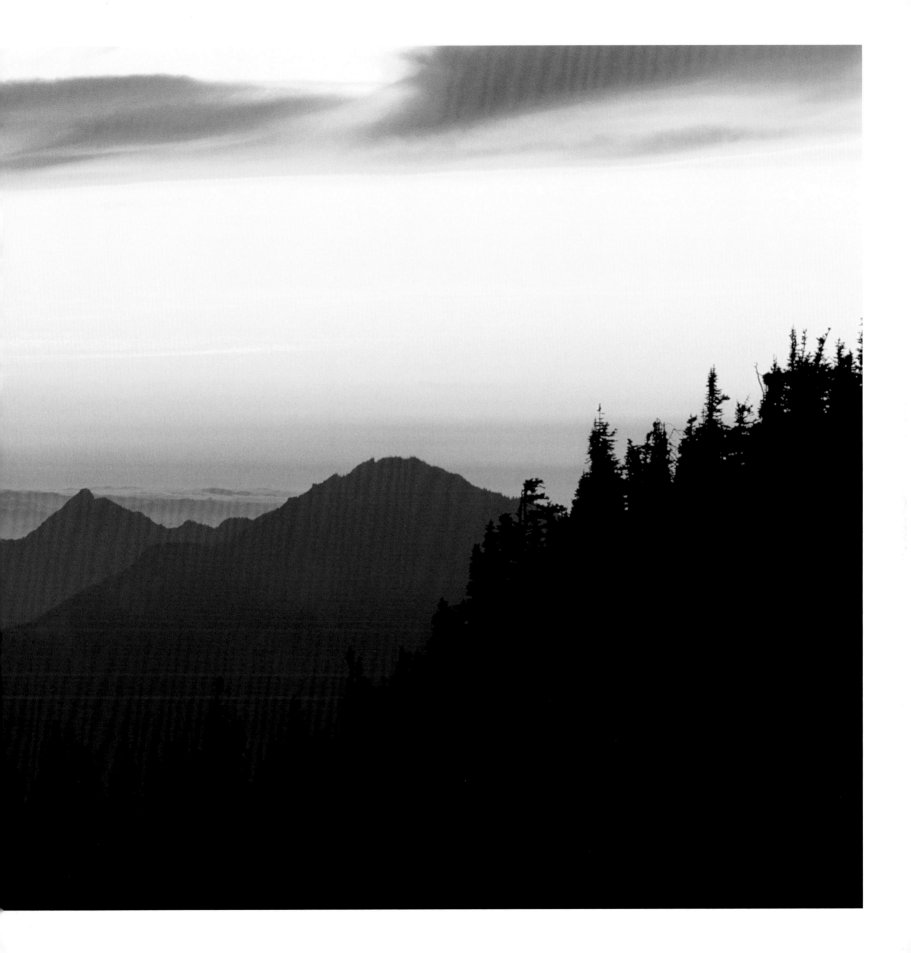

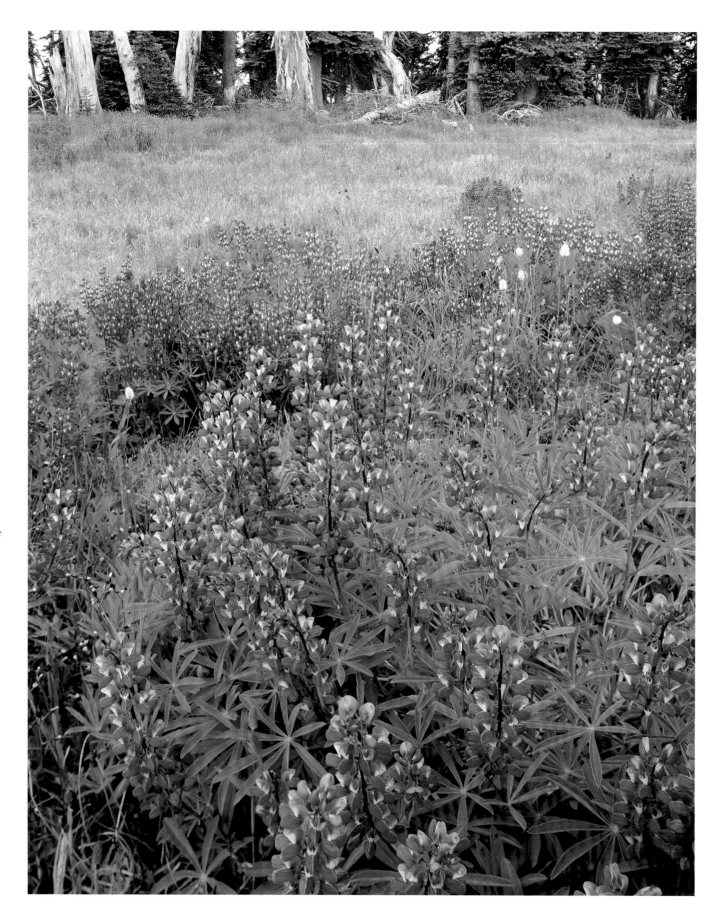

right: *Summer lupine in alpine meadow, Hurricane Ridge*

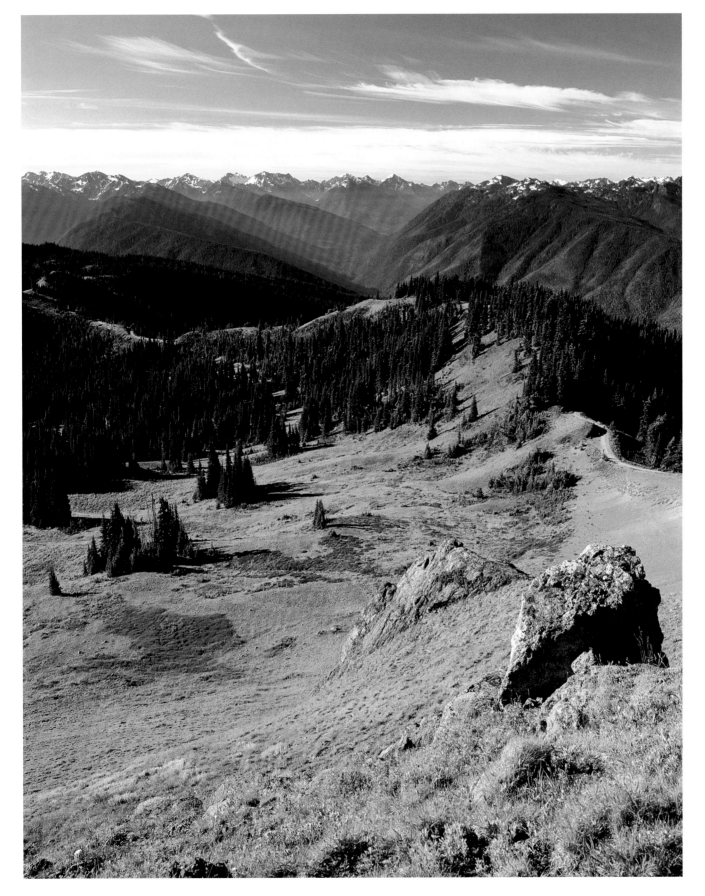

left: *Olympic Range and trail to Hurricane Hill, Olympic National Park*

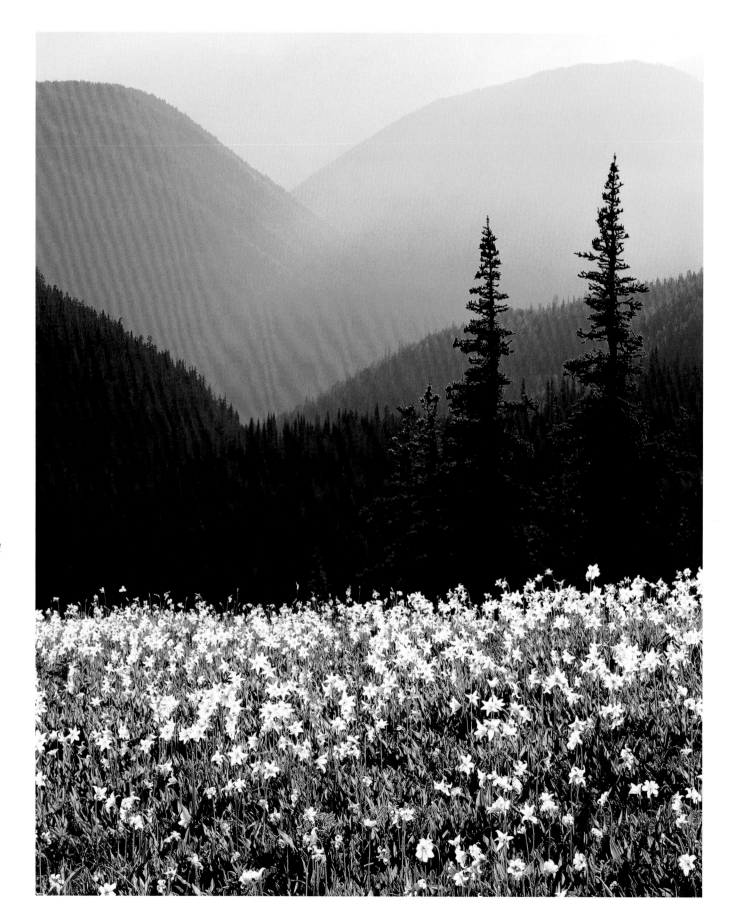

right: *Avalanche lilies at 6,100-foot Obstruction Point, Olympic National Park*

below: *Olympic marmots,
endemic to high slopes of the
Olympics*

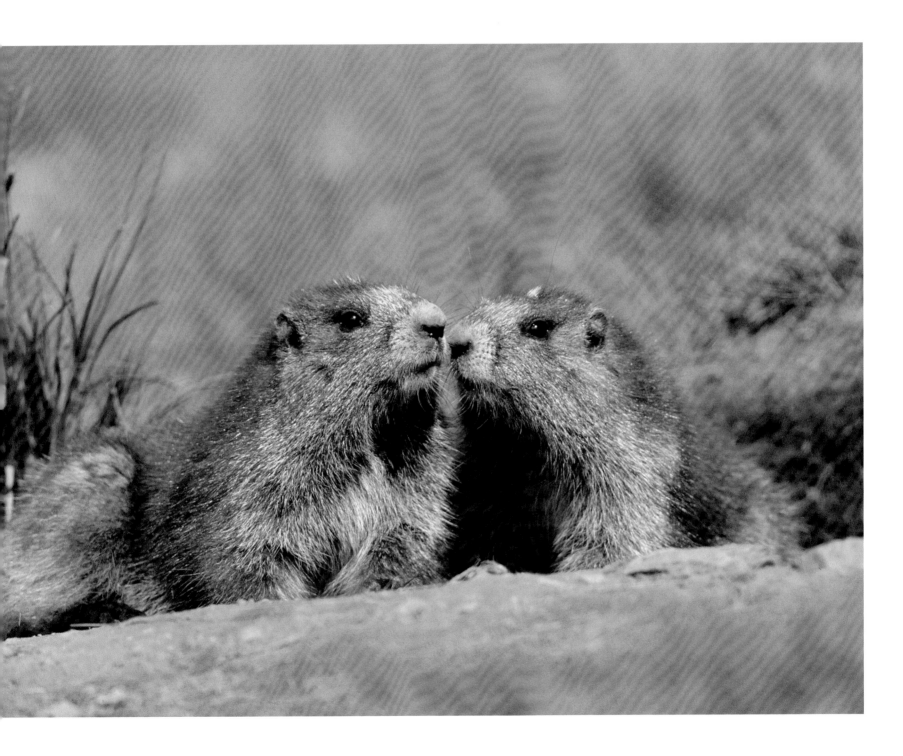

right: Red alder grove, foothills of Olympic National Park

below: *Low-growing, flowering bunchberry dogwood, Olympic National Forest*

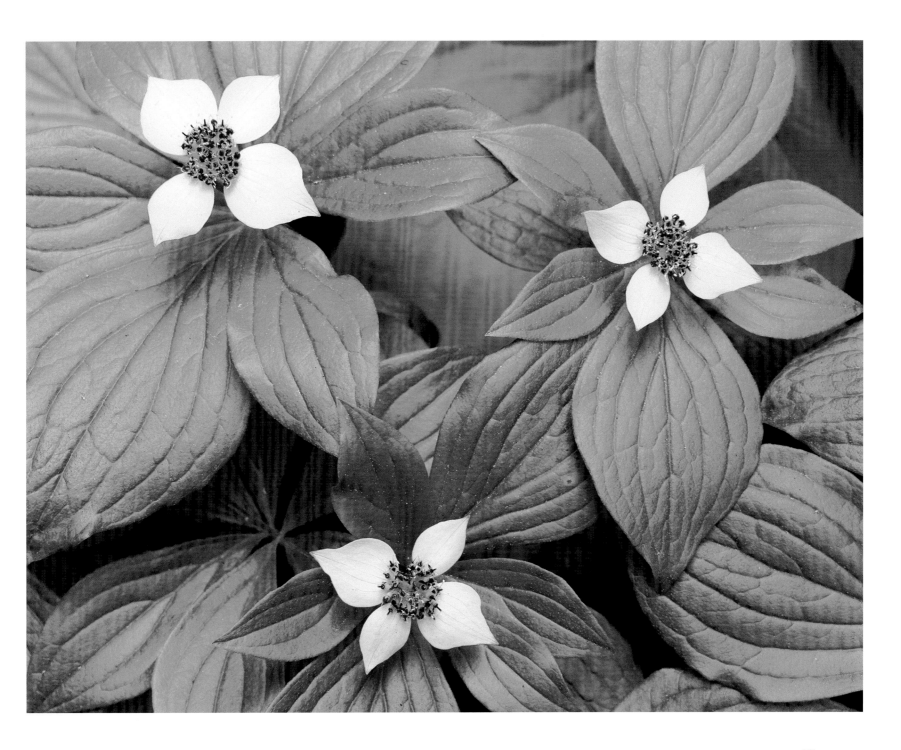

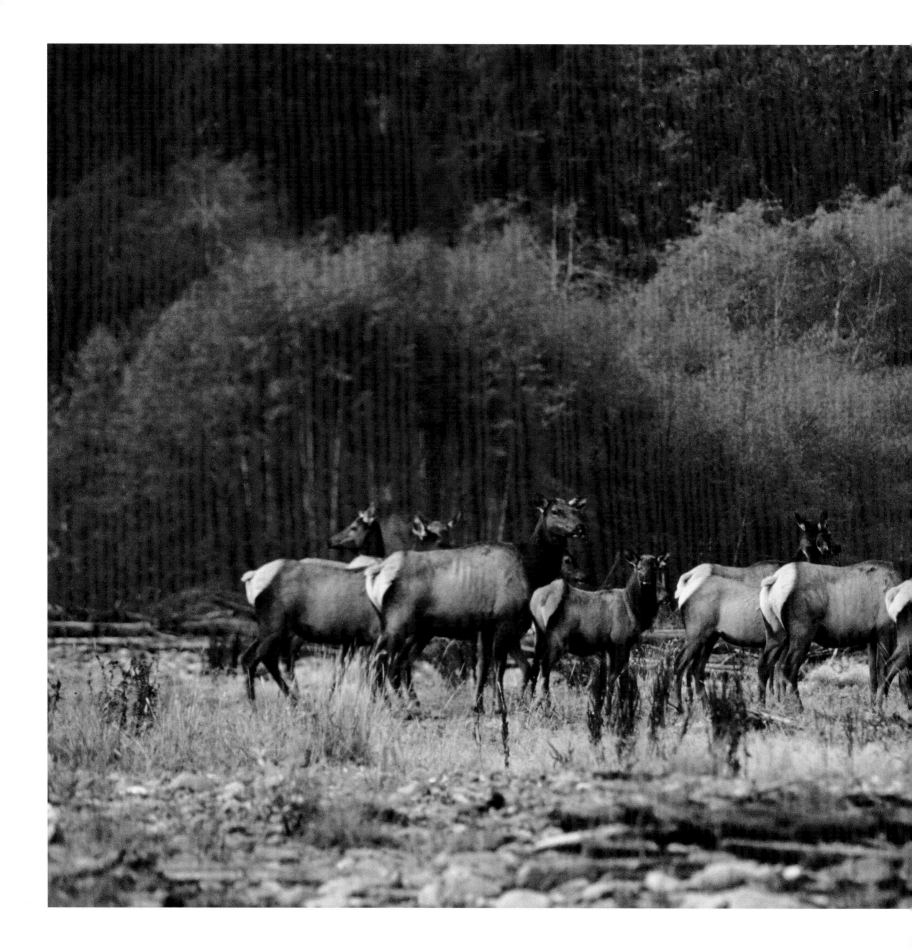

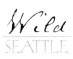
left: *Olympic National Park's Roosevelt elk, named for President Teddy Roosevelt*

right: Brackish marsh and lagoon at Foulweather Bluff Preserve, a wildlife haven on the Kitsap Peninsula

below: *Dune grasses and Puget Sound gumweed at Point No Point Lighthouse, northern tip of the Kitsap Peninsula*

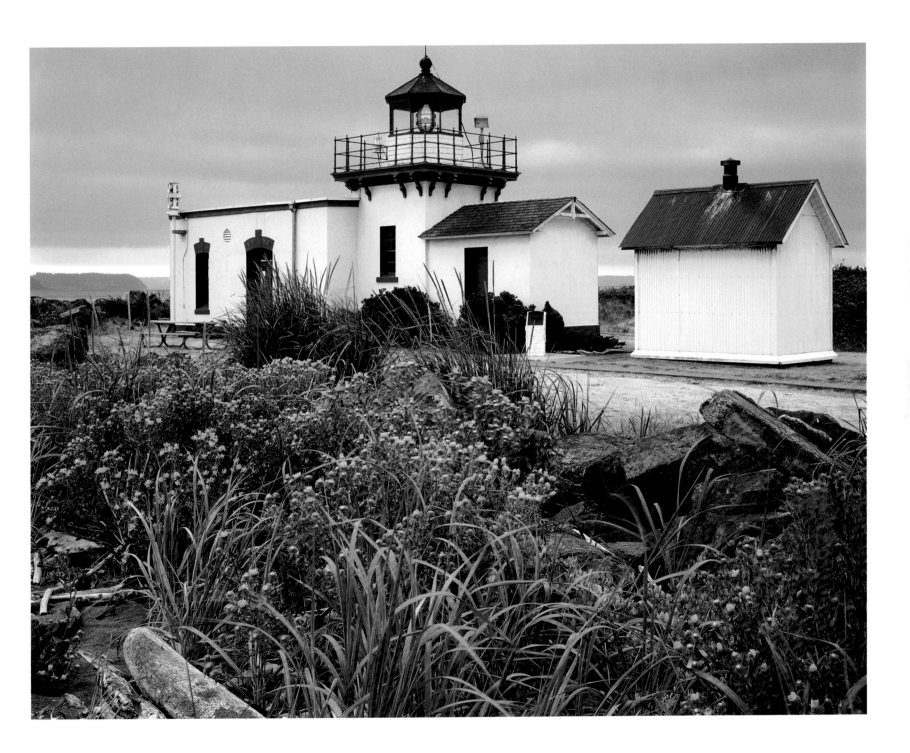

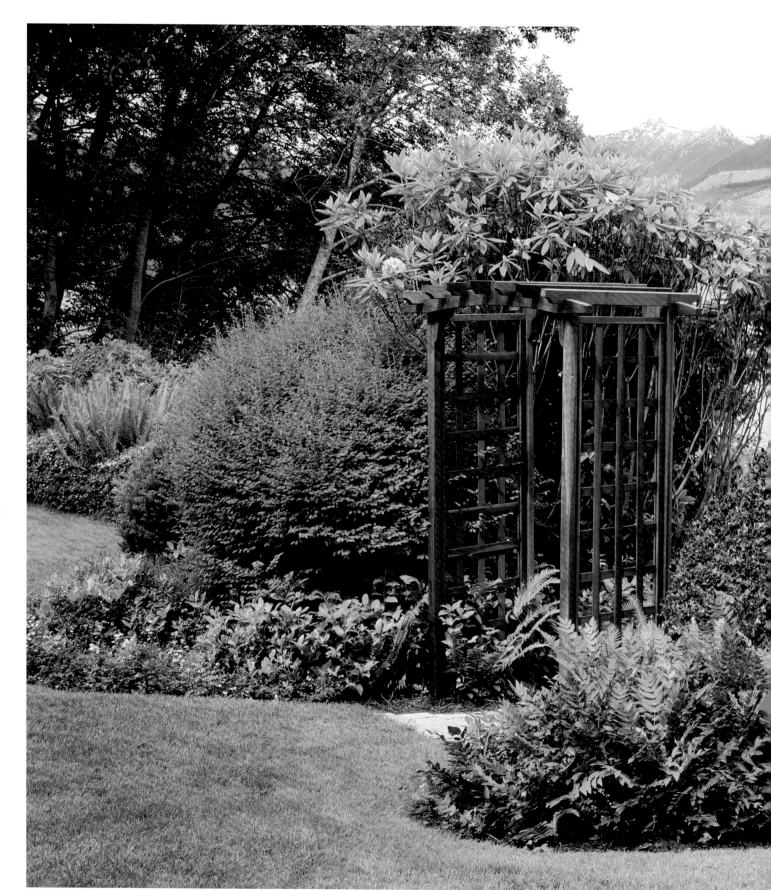

right: *Rhododendron garden at Emel House, Scenic Beach State Park on Hood Canal, Kitsap Peninsula, with Olympics beyond*

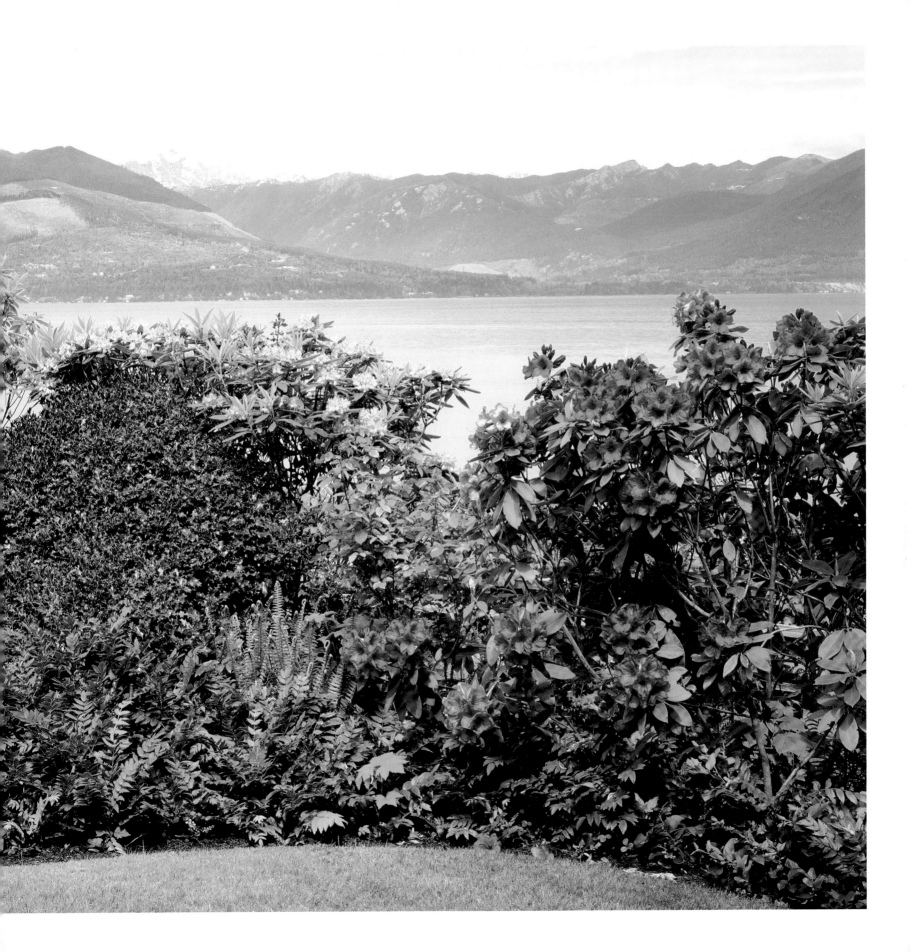

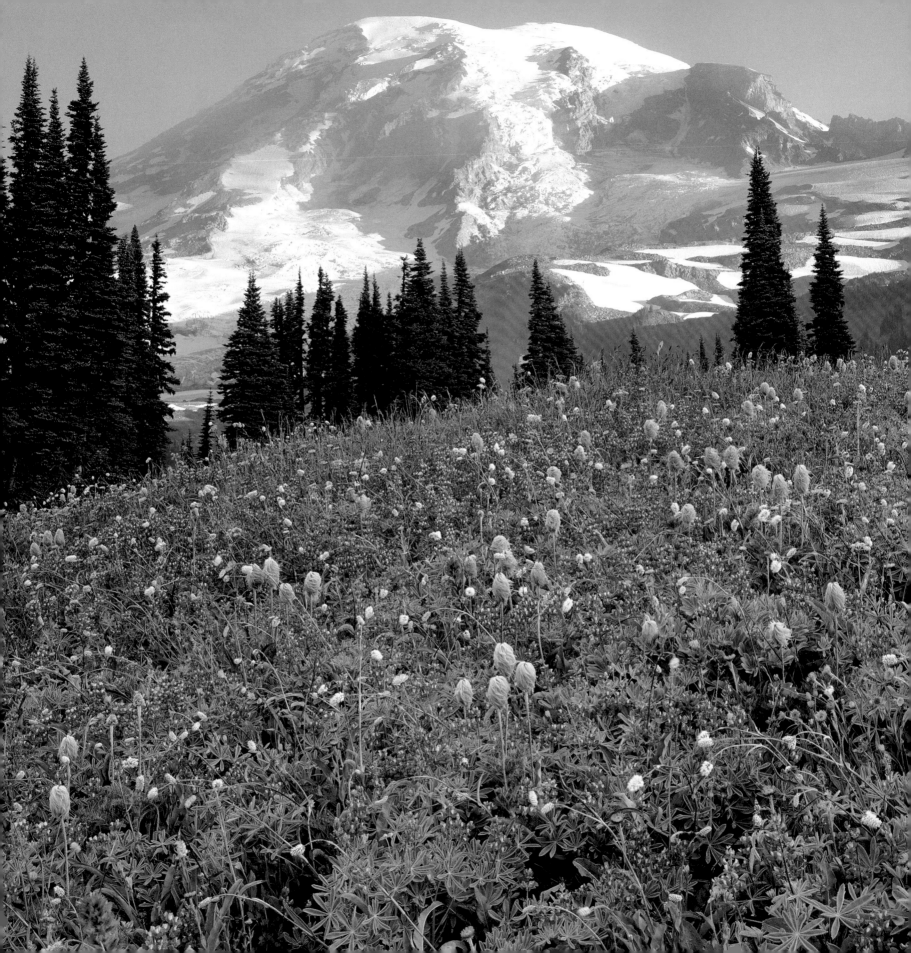

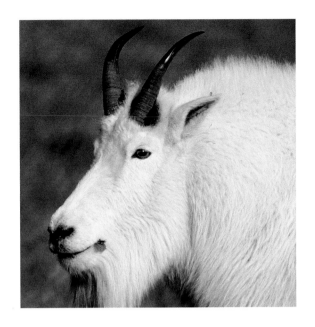

Mount Rainier to the Nisqually

DOUBLY HAPPY, HOWEVER, IS THE MAN TO WHOM LOFTY MOUNTAIN-TOPS ARE WITHIN REACH, FOR THE LIGHTS THAT SHINE THERE ILLUMINE ALL THAT LIES BELOW.

-JOHN MUIR, *An Ascent of Rainier*

The Natives called it Takhoma, the Big Mountain. Another name meant Place Where the Waters Begin. Both conveyed the same image: the highest point in the Pacific Northwest is no idle snow giant. It's a volcano with a pulse, even if the name George Vancouver gave it in 1792—after a British admiral who fought against Americans in the Revolutionary War—does not hint at its power. The mountain last erupted sometime in the 1840s, geologists believe. There are bigger mountains in North

Wild SEATTLE

83

America, but no other peak presents such a dramatic vertical uplift from sea level to summit as does Rainier.

Rainier creates its own microclimate, grabbing at warm clouds that ride winds in from the Pacific, forcing them upward, to condense and break and stick around, ultimately, as snow or ice. There are glaciers on Rainier formed of precipitation that fell before there was a street in Seattle. Warm gases vent from slits at the summit—a breath from deep in the earth. The permanent ice is a memory field of blue and white, draped around a cone with fire deep inside. The glaciers yawn and crack in summer, opening crevasses that provide peeks into a layered tomb. They change color with the light and the seasons. Whether Rainier's glaciers are truly permanent will depend on what the planet does— warming gradually, or stabilizing.

The mountain's midsection is a shaggy green belt of cedar, fir, and hemlock forests and broken basalt—the rock left over from prior eruptions. Mountain lions, elk, black bears, feisty little pine martens, and whole neighborhoods of whistling marmots depend on life just below the ice for their sustenance. The Wonderland Trail, which circles Rainier and rises from deep forests to timberline, is aptly named. A person can spend a half-dozen summers exploring the sideways of this trail, never going to the top or even to the higher glaciers, and be satisfied. There are meadows that burst with the color of flowering heather and avalanche lilies, and alpine tarns where the water settles, holding in their reflection the volcano at a deceptive moment. Better

yet is Rainier in winter, when sounds are muffled by nearly a thousand inches of snow in places.

In the congested urban corridor that runs from Olympia to well past Seattle, Rainier and its neighboring saltwater ecosystem, the Nisqually Delta, stand out like springs in a desert. One is dominant. The other is subtle. From the rich stew of delta grass, where migratory waterfowl on the Pacific Flyway have long feasted, Rainier looks like a different piece of the planet—high, cold, white, aged. But the delta and the mountain are more alike than they appear, one connected to the other by water.

The Indians were afraid to climb Rainier. That would be hubris, moving the gods that dwell in the Big Mountain to anger. "Don't go there," said Sluiskin, the Native guide who accompanied Anglos halfway in 1870. "You will die." They nearly did. The first two men to make Rainier's summit, P. B. Van Trump and Hazard Stevens, were forced by high winds and encroaching darkness to spend the night on top, huddled next to a crater vent.

Many have perished trying to stand atop Rainier's smoldering summit. About half the people who attempt the climb every year do not make it to the top. Others are content just to know that Rainier exists, framing Seattle's southeastern view, giving pilots something to talk about, and capturing all that water that feeds the delta, where Puget Sound picks up the runoff from one of the mountain's biggest glaciers and sends it back, eventually, to the sky and the mountain.

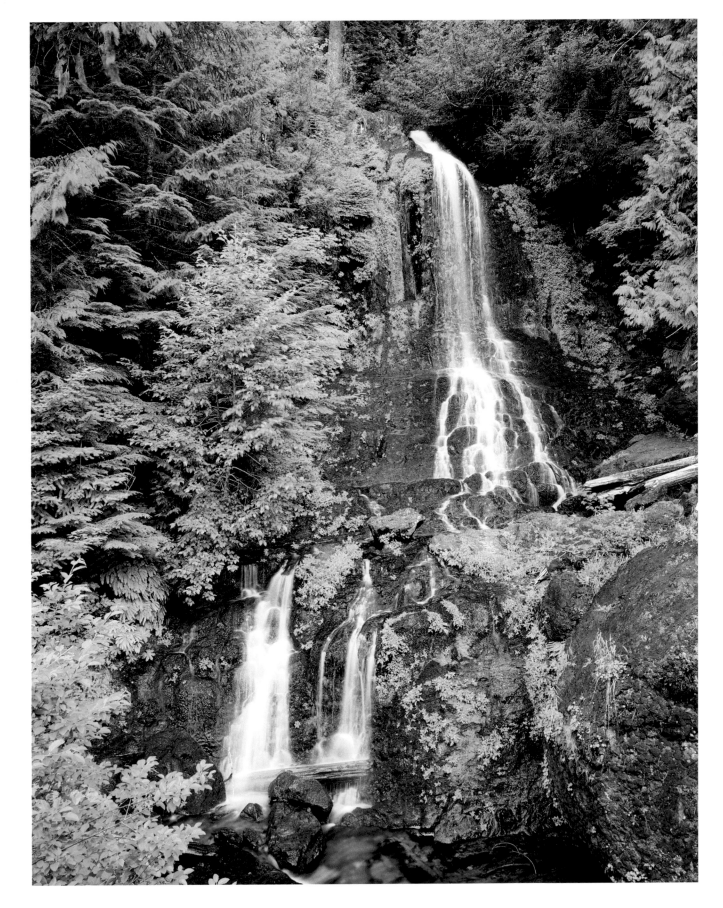

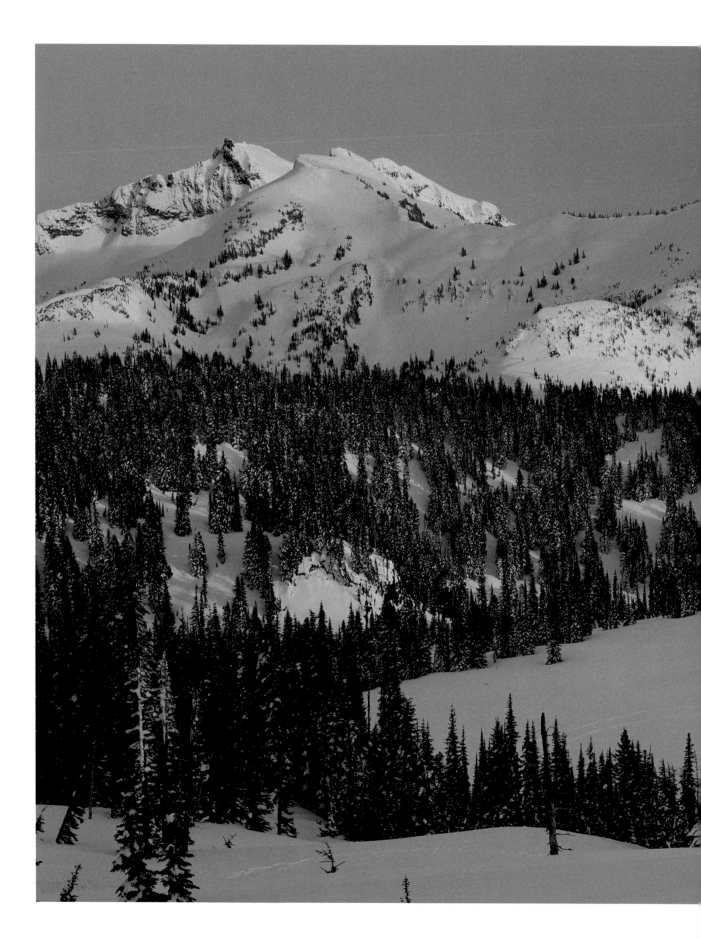

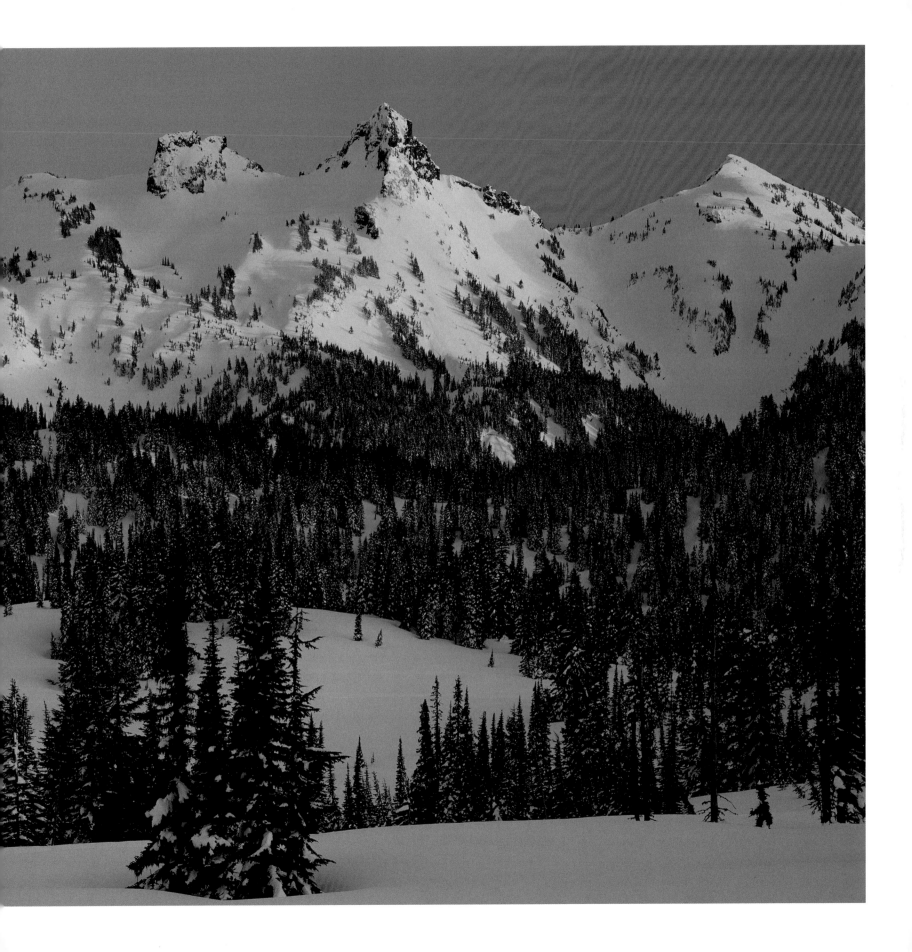

right: *Mountain arnica and lupine in summer, Mount Rainier National Park*

left: *Submerged fallen tree in glacial waters of Lake Christine, Glacier View Wilderness, Mount Baker–Snoqualmie National Forest*

below: *Fall vine maple at edge
of hemlock forest, Mount
Rainier National Park*

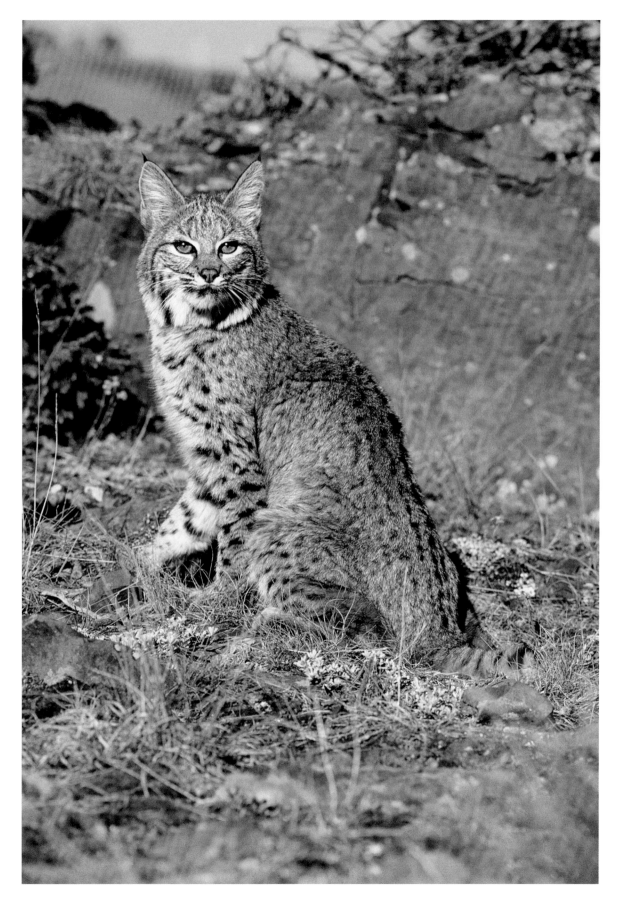

left: *Bobcat*

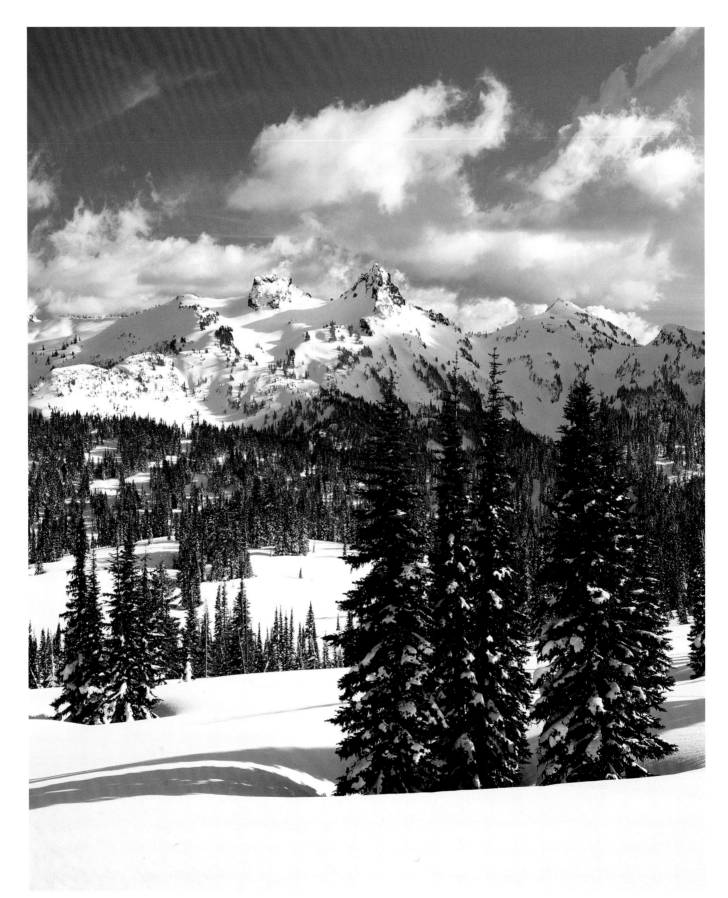

right: Winter afternoon view of the Tatoosh Range from snowfields at Paradise

below: *Clearing winter storm*
clouds reveal Rainier's summit
and Gibraltar Rock

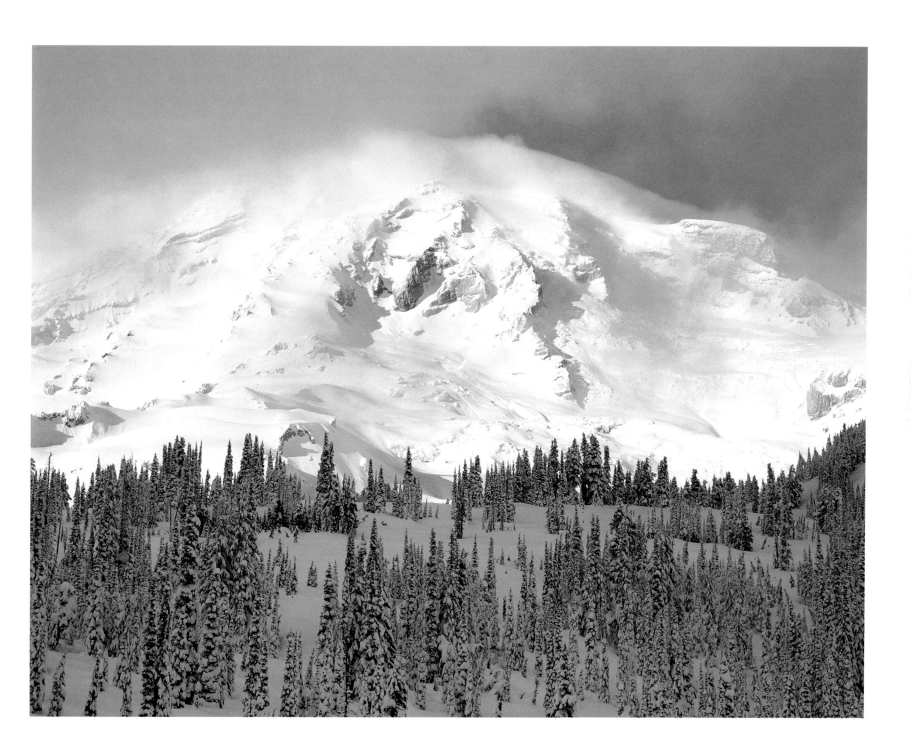

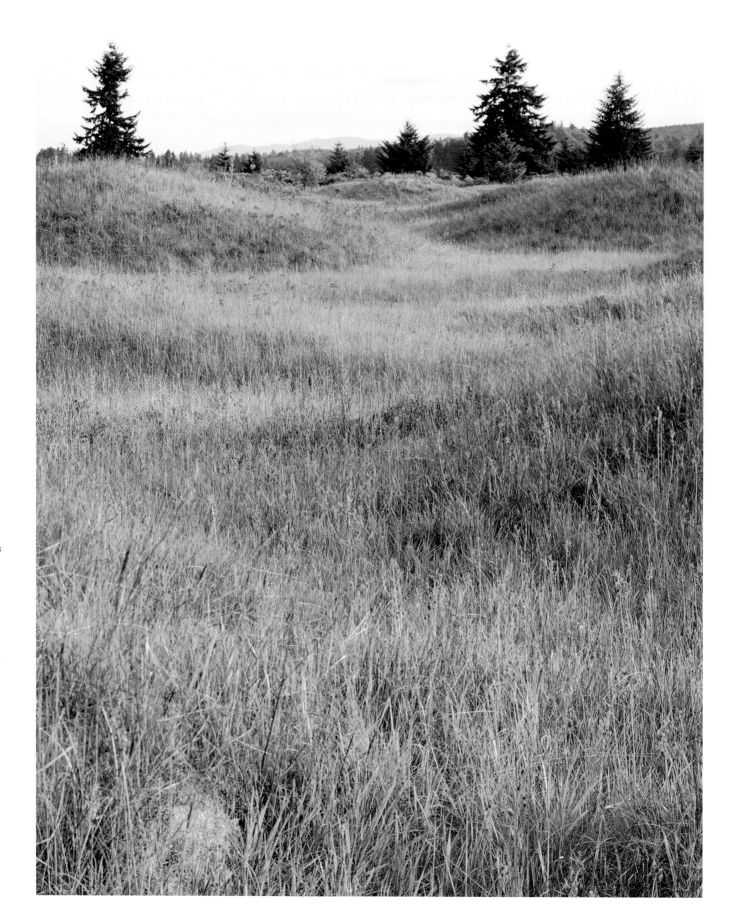

right: Mysterious grass-covered mounds at 400-acre Mima Mounds Natural Area Preserve

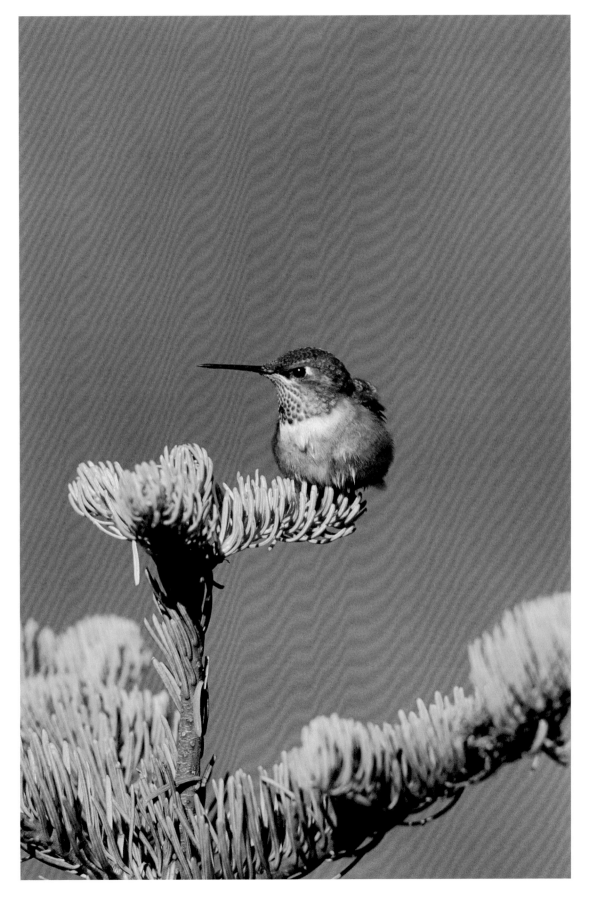

left: *Rufous humming-bird, frequently seen Northwest backyard visitor*

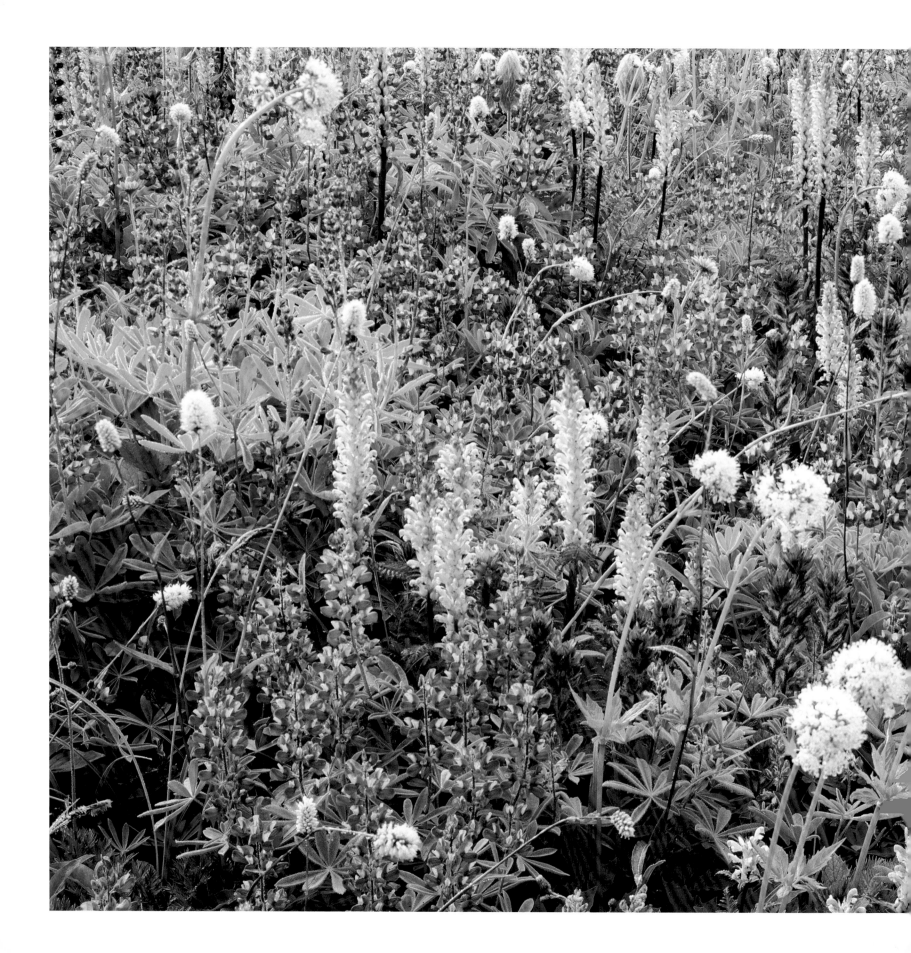

left: *Lupine, paintbrush, lousewort, valerian, and bistort on Mazama Ridge, Mount Rainier National Park*

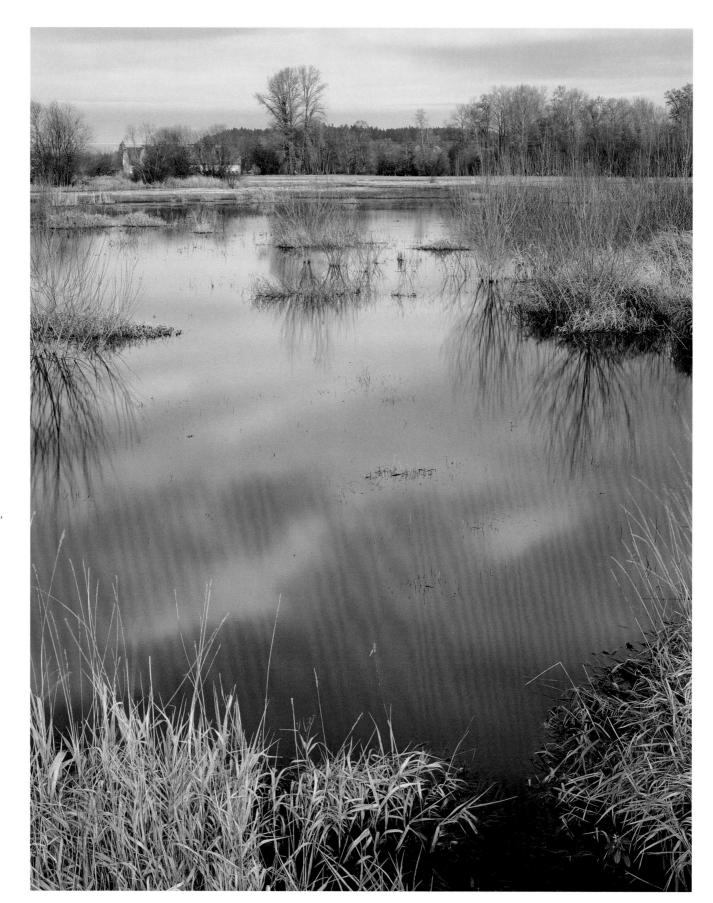

right: *Willows and grasses,*
Nisqually River Delta,
Nisqually National
Wildlife Refuge

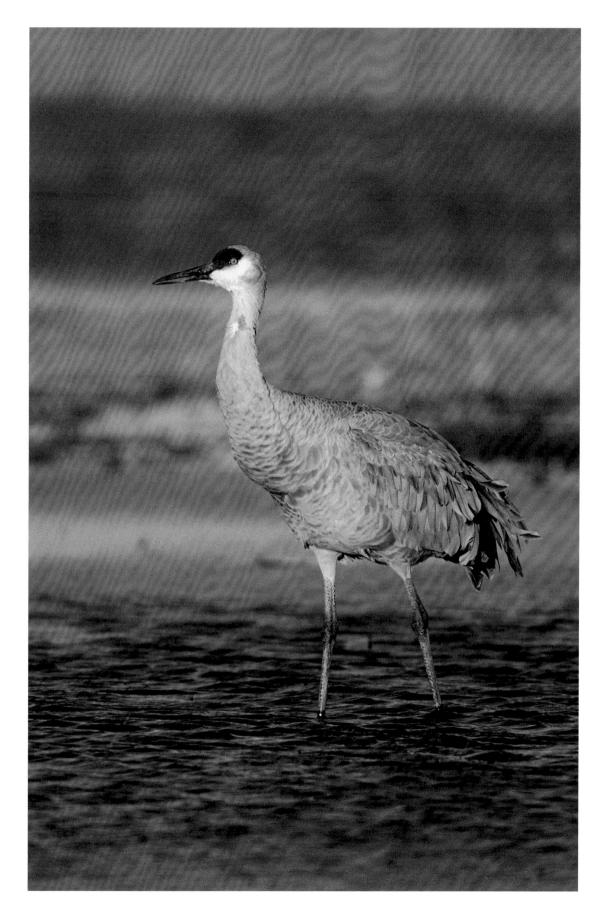

left: *Sandhill crane, rare visitor to the Nisqually River Delta*

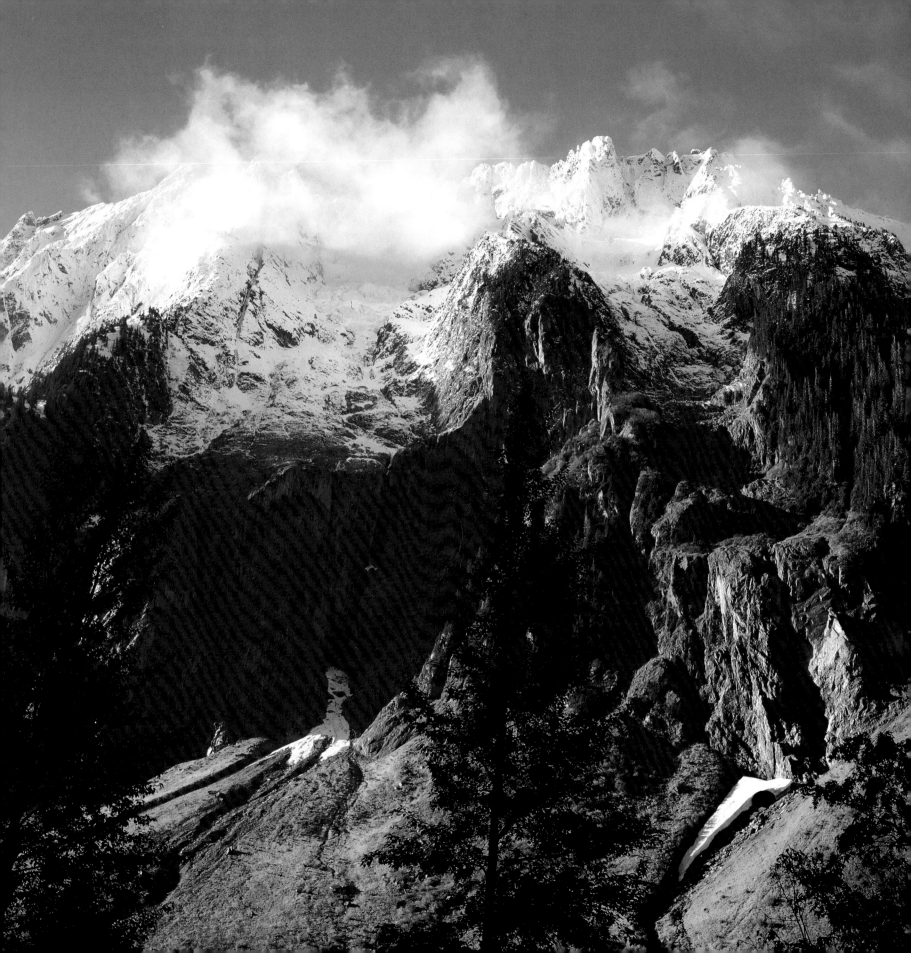

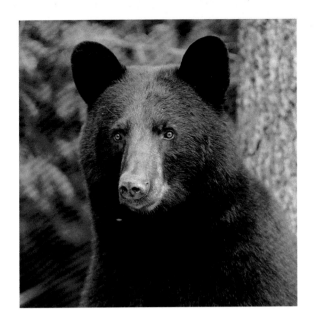

Cascades

NOW I WAS BEGINNING TO SEE THE CASCADES ON THE NORTHEAST HORIZON, UNBELIEVABLE JAGS AND TWISTED ROCK AND SNOW-COVERED IMMENSITIES, ENOUGH TO MAKE YOU GULP. THE ROAD RAN RIGHT THROUGH THE DREAMY FERTILE VALLEYS OF THE STILLAGUAMISH AND THE SKAGIT, RICH BUTTERFAT VALLEYS WITH FARMS AND COWS BROWSING UNDER THAT TREMENDOUS BACKGROUND OF SNOW-PURE HEAPS.

-JACK KEROUAC, *Dharma Bums*

The Cascade Mountains of Washington have many moods. They divide east from west, dry side from wet side, rural from urban. The northern section is the most rugged, wildest, most glaciated part of the range that runs from California to British Columbia. Still, these mountains are not

Wild SEATTLE

easy to categorize. Yes, they are part of the Ring of Fire, that strip of volcanoes that runs along the Pacific Rim. But they are named for what happens to water—a very active name. And that water helped to create a forest as thick as the hair on a sheepdog's back, and thousands of lakes. Fred Beckey, the ageless Northwest climber, author, and storyteller, who has mapped virtually every alpinist route in the Cascades north of the Columbia River, calls them the Range of Glaciers. Beckey can be scientific and droll, but when he gets going on these mountains, he is effusive.

To the north, the heart of the range forms North Cascades National Park, a protected piece of high ground that is somewhat unknown outside the Pacific Northwest. No complaint there. Mountains should never be crowded. Off the park's main road are visitor stops where a person can admire the turquoise color of Ross Lake, the mad-dash energy of Thunder Creek, or the pink-granite glow at sunset on Liberty Bell. Some parts remind people of the Dolomites, in Italy. But the names hereabout—Rainy Pass, Devils Dome, Desolation Peak, Mount Fury—imply that there have been some difficult experiences, nothing close to the pace of a visit to the Italian Alps. That is because, more than anything, the North Cascades are wilderness mountains. Imagine the Dolomites without cute huts, trams, or villages. Until the North Cascades Highway was cut through the park about thirty-five years ago, there was not a single road that traversed the North Cascades.

Gold prospectors, timber cutters, and assorted resource plunderers have all gnawed away at the Cascades, but the range remains pretty much intact as a mountain ecosystem. The shy and seldom seen lynx lives on the drier east side. Seeing footprints left in fresh snow by these versatile cats is

the next best thing to coming eye to eye with one. Some biologists still believe there may be a stray grizzly bear or two living in the far northern reaches of these mountains as well. The very thought of *Ursus horribilis* wandering within a few hundred miles of a big metro area is enough to speed up many a wilderness-lover's heart.

These mountains should be explored on foot. That's the best way to experience the multiple personalities of the Cascades. Enchantment Basin, a hiker's heaven of fine-edged stone flanks and soft-needled larch trees, has been loved nearly to death, as the favorite destination of the Alpine Lakes Wilderness. But for pure grandeur, there are the Picketts, a subrange, serrated and glaciated, needle-point summits barely big enough to stand on. No gentle uplifting there.

The glamour peaks of the range—the volcanoes Baker and Glacier Peak, and the pyramidal giant Mount Shuksan—can be seen out Seattle's northeast window. Pink at sunset, or bone white in a fresh coating of winter snow, these peaks are one of the reasons a clear day in the Northwest is worth waiting out two weeks of rain. Shuksan has posed for more calendar covers than perhaps any mountain in the West, and its picture once appeared on the wall of Grand Central Terminal in New York.

Mountains are inevitably described as behemoth, massive, sky-blocking—the superlatives of size. But to be intimate with the quiet, less showy part of the Cascades is to know a more complex world. At sea level, say from valley tulip fields, or slightly higher in the noisy drainage of the Snoqualmie River on a day when the clouds are in your hair, the Cascades can be at their most alluring. You can watch mountains change in the light. You can also listen to them.

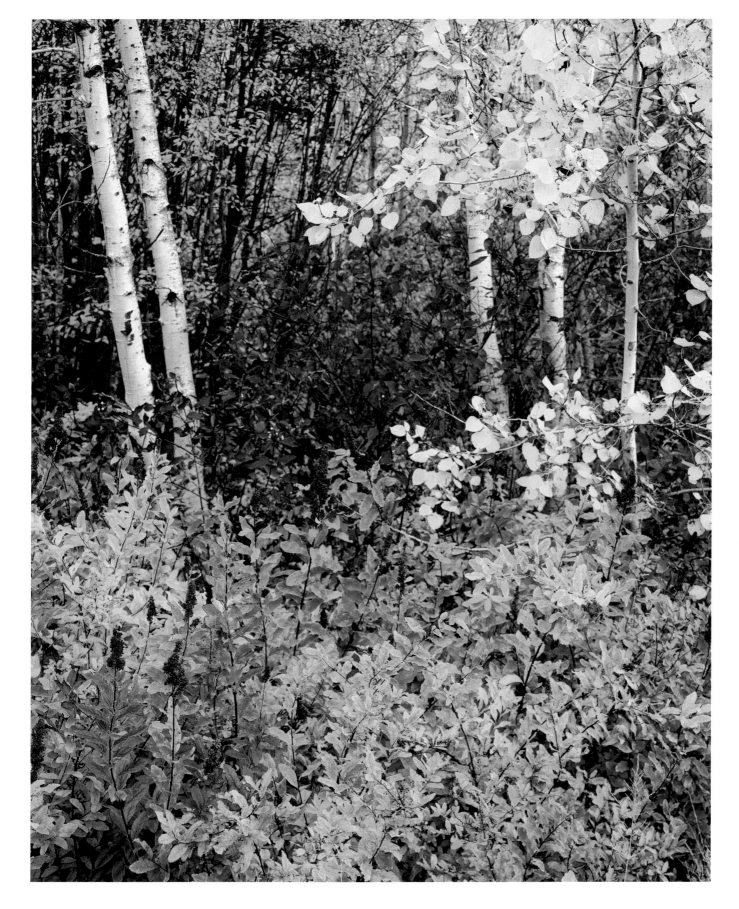

right: *Summer forest along Boulder River, Boulder River Wilderness Area, Mount Baker–Snoqualmie National Forest*

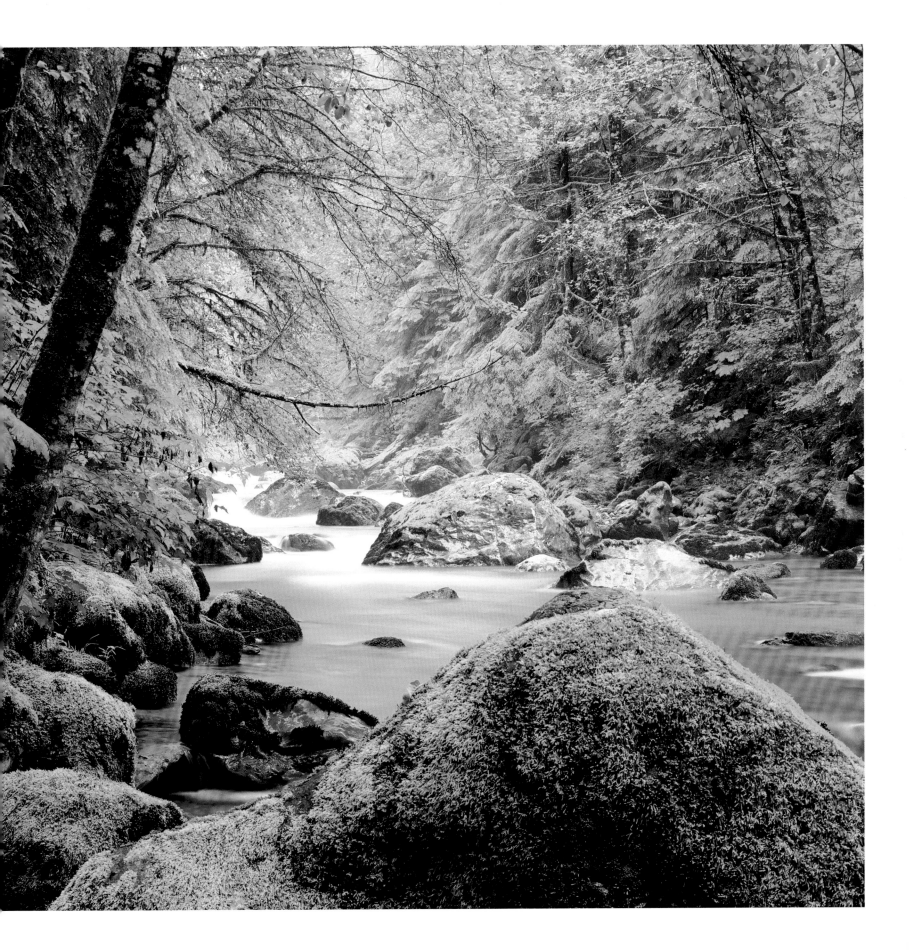

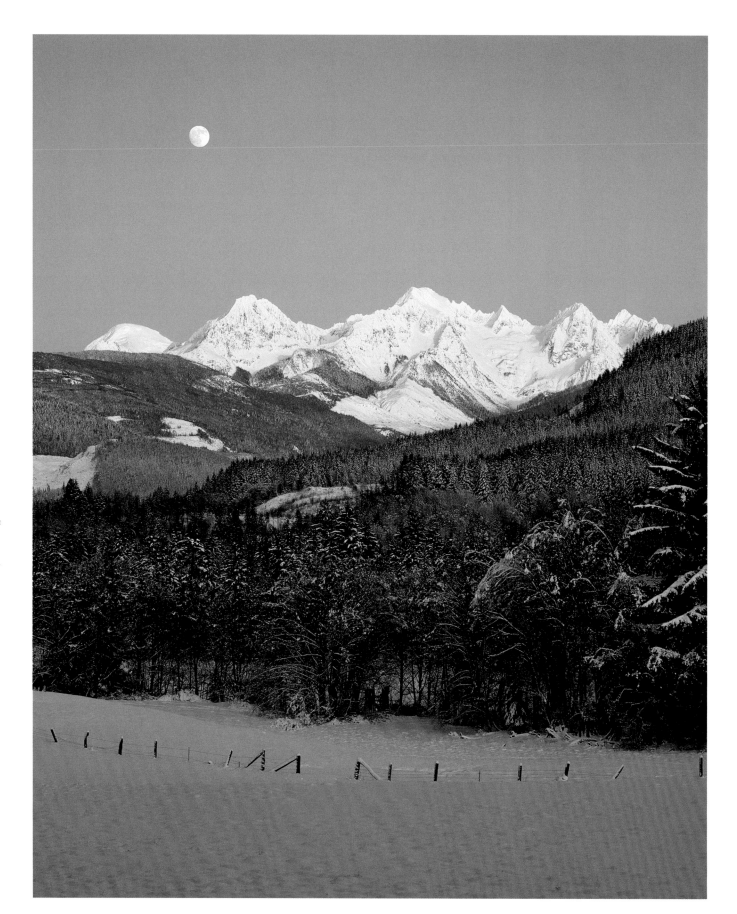

right: *Rising winter moon over the Twin Sisters Mountains and Mount Baker, Whatcom County*

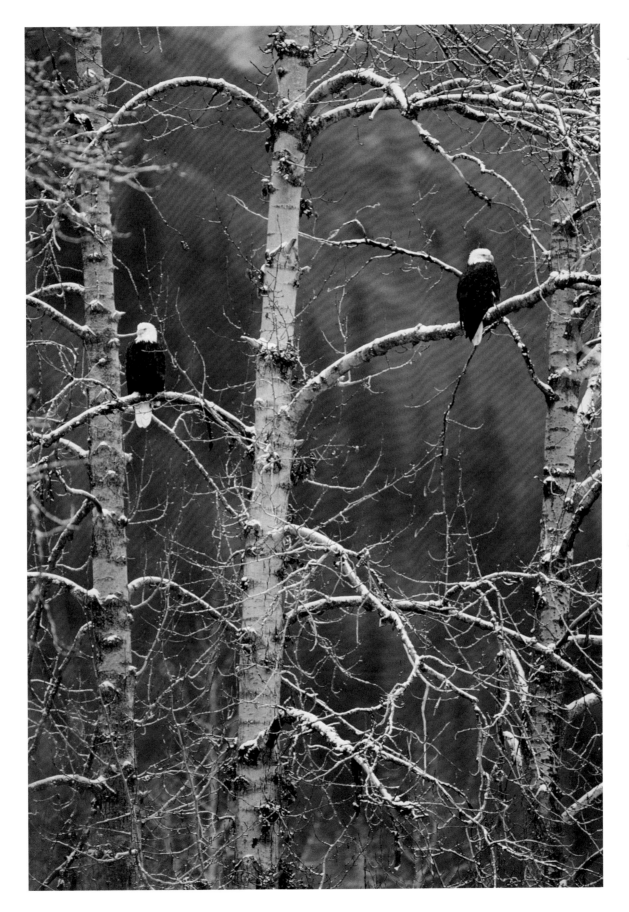

left: *Winter gathering of bald eagles along the Skagit River, largest in the Lower 48*

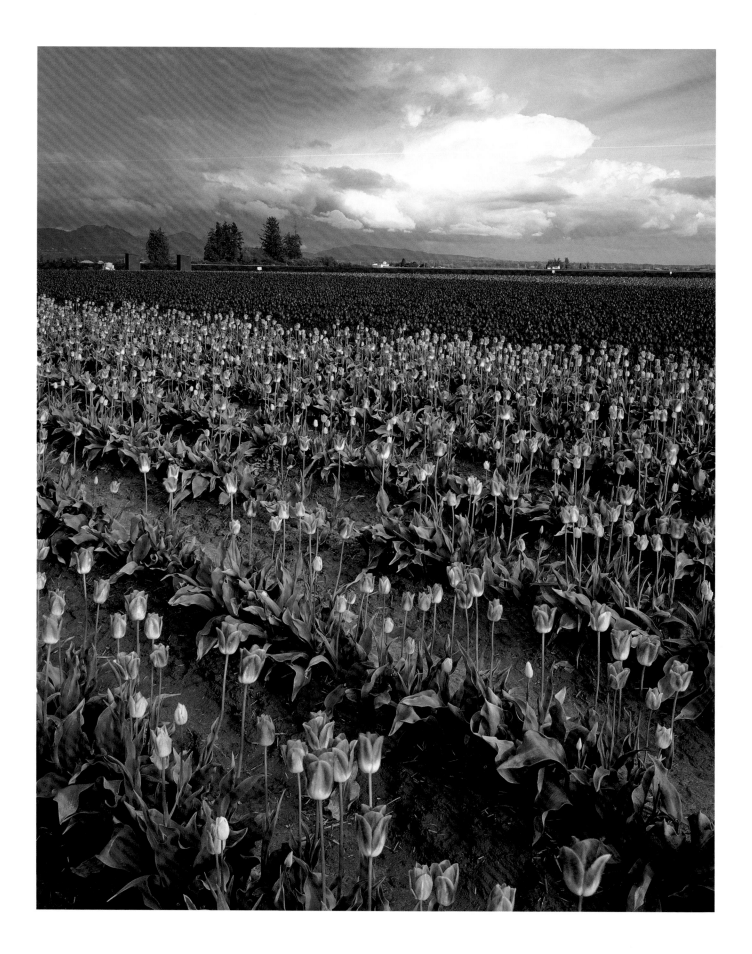

opposite and below: *Spring tulips at Roozengaarde, Skagit Valley, with distant storm clouds over the Cascade foothills*

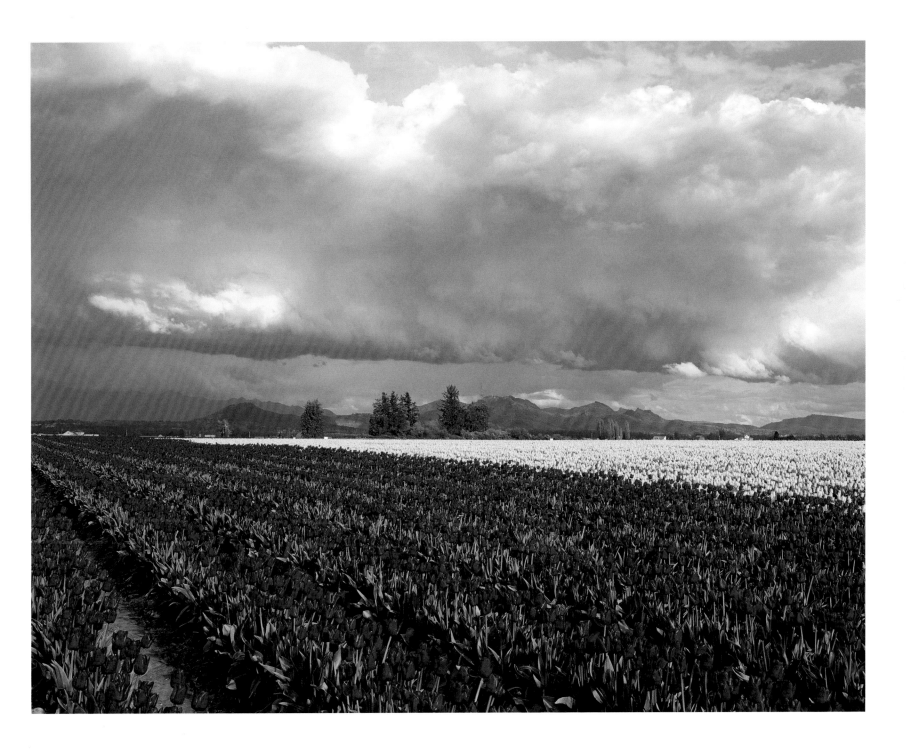

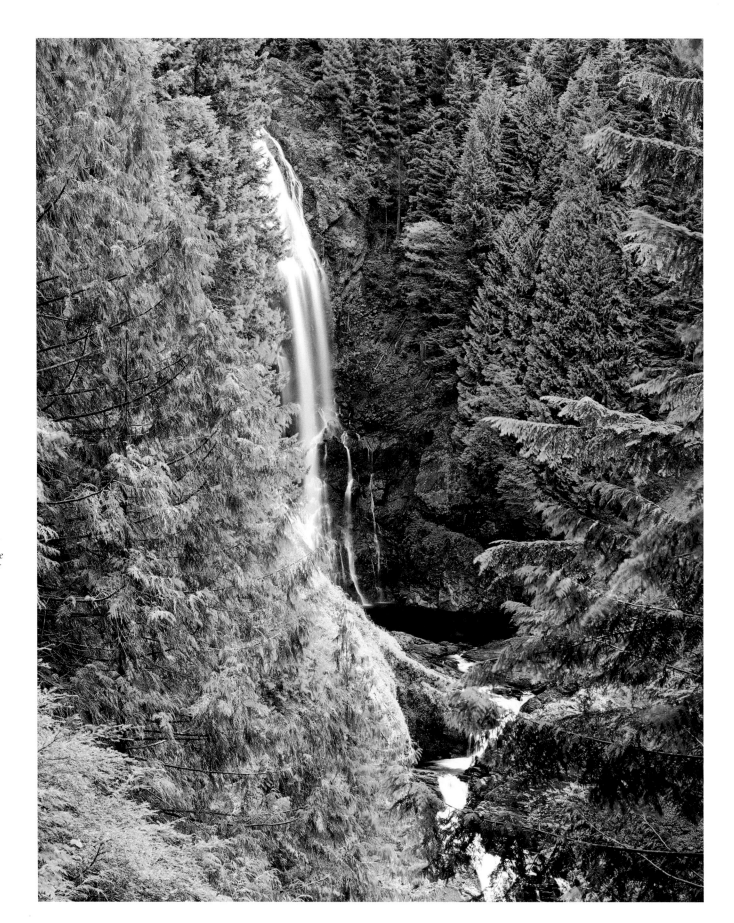

right: *Middle Wallace Falls flowing over basalt rock in summer, Wallace Falls State Park, west of Stevens Pass in the Cascades*

below: *Steelhead, or rainbow trout*

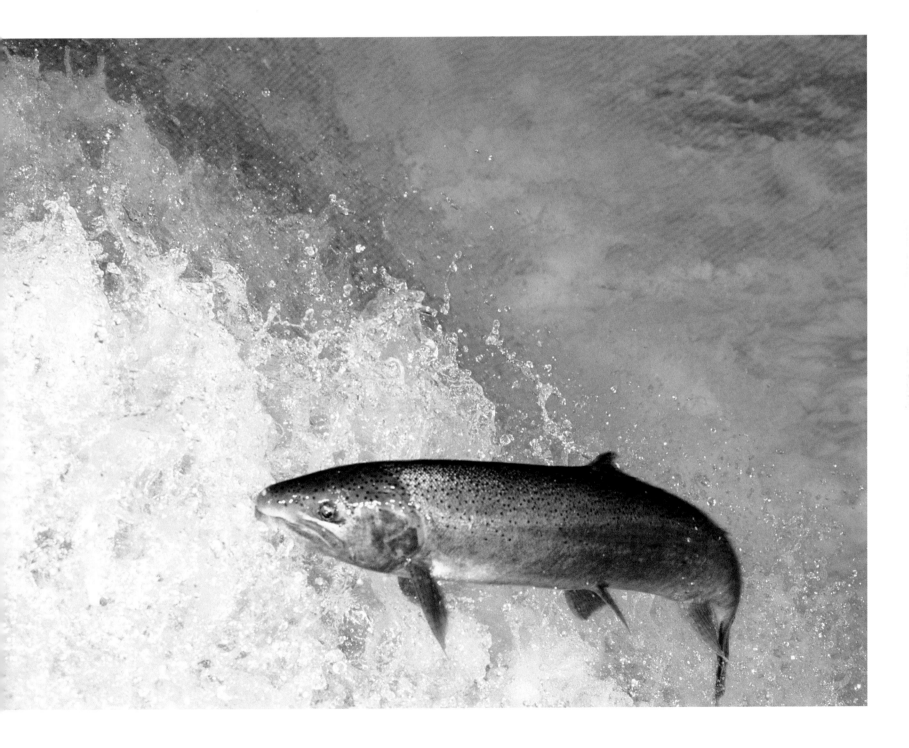

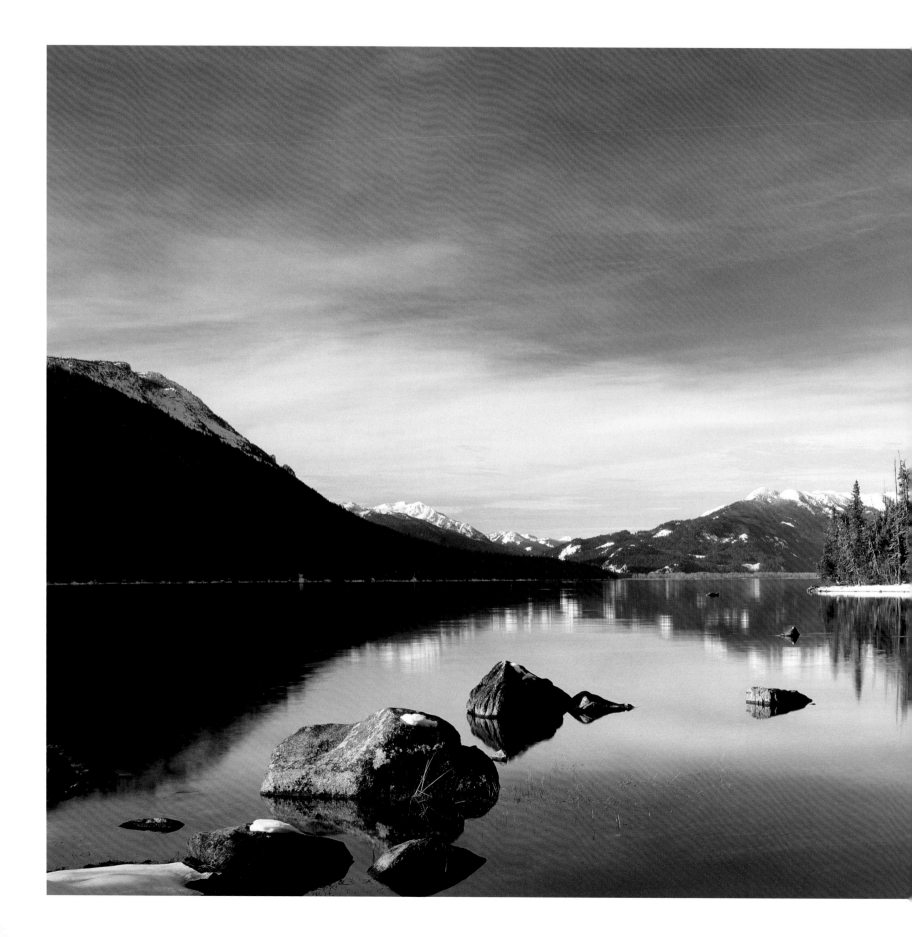

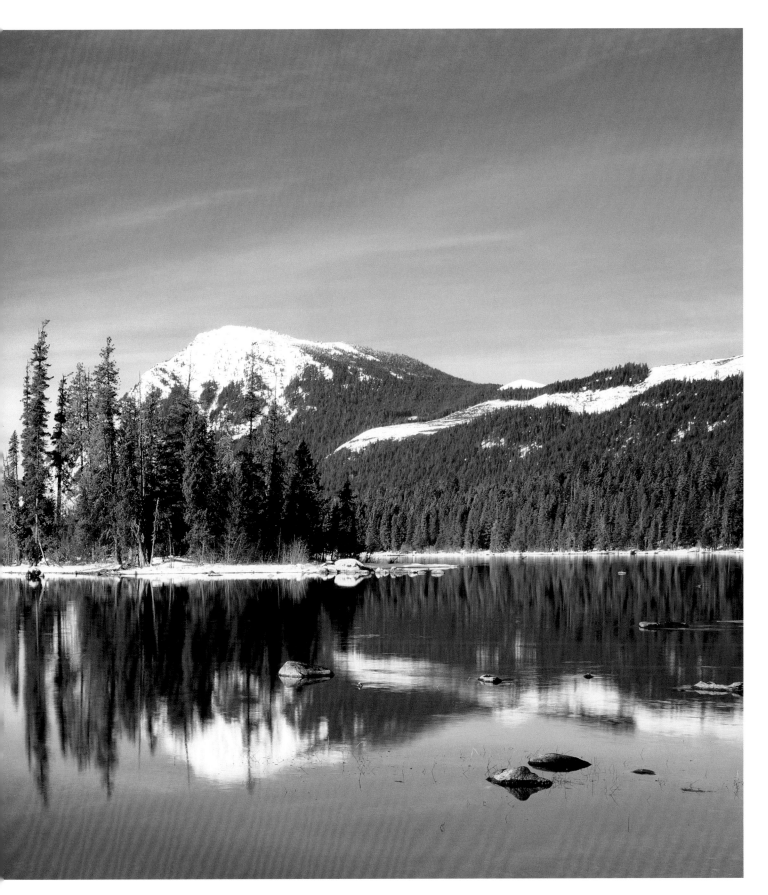

left: *Emerald Island and reflection of the Cascades on Lake Wenatchee, Lake Wenatchee State Park, Wenatchee National Forest*

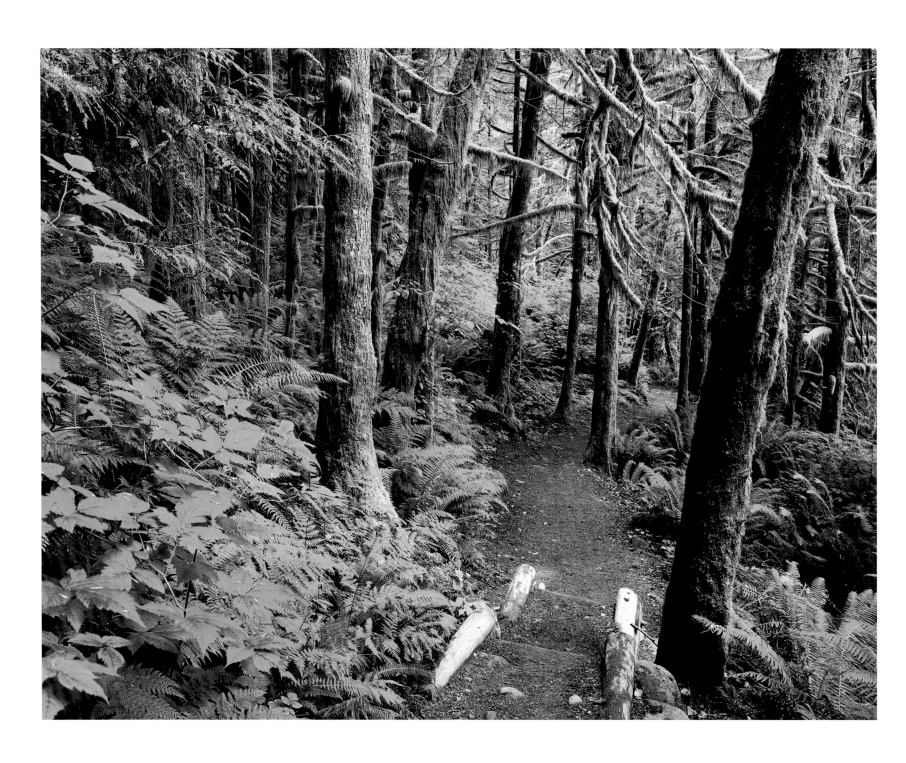

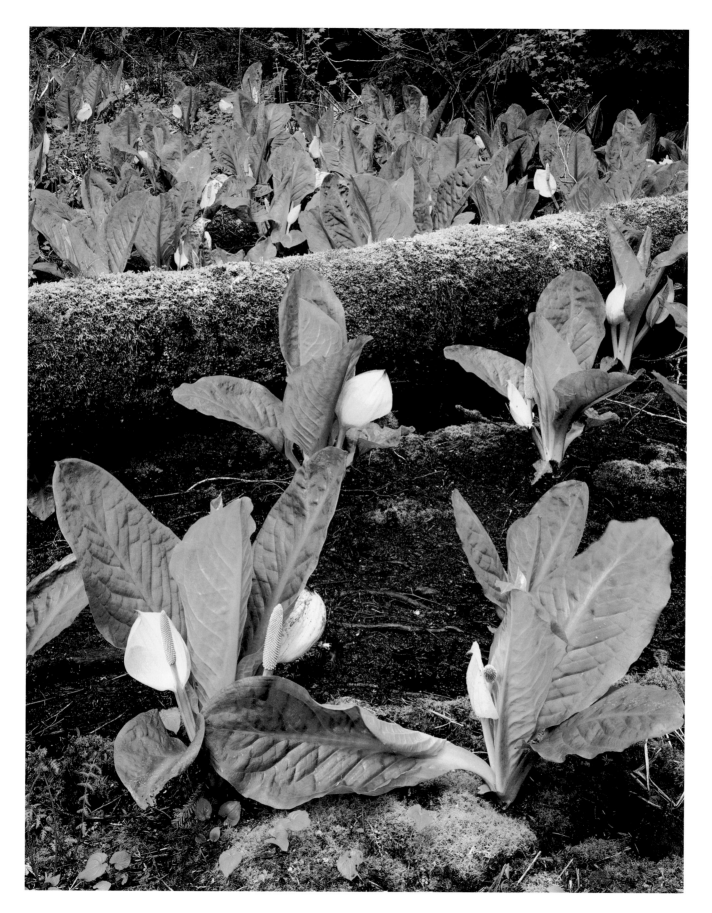

left: *Skunk cabbage, Sauk River Valley, Mountain Loop Highway, Mount Baker–Snoqualmie National Forest*

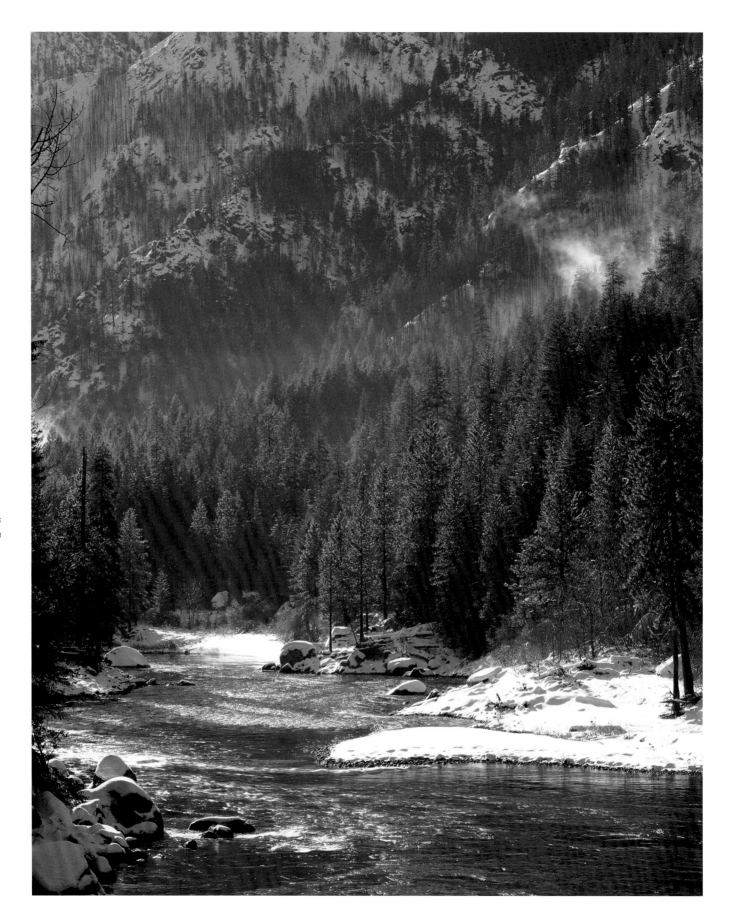

right: *Snow-covered banks of the Wenatchee River in Tumwater Canyon, Wenatchee National Forest*

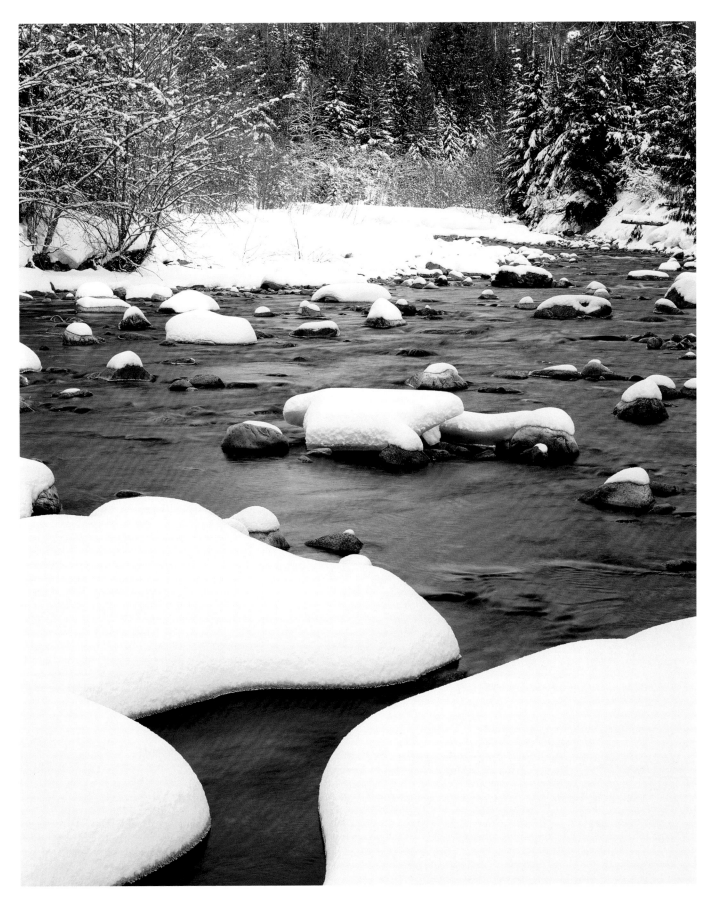

left: *Snoqualmie River,
Mount Baker–Snoqualmie
National Forest*

117

below: *The Triplets and Johannesburg Mountain from Cascade Pass, North Cascades National Park*

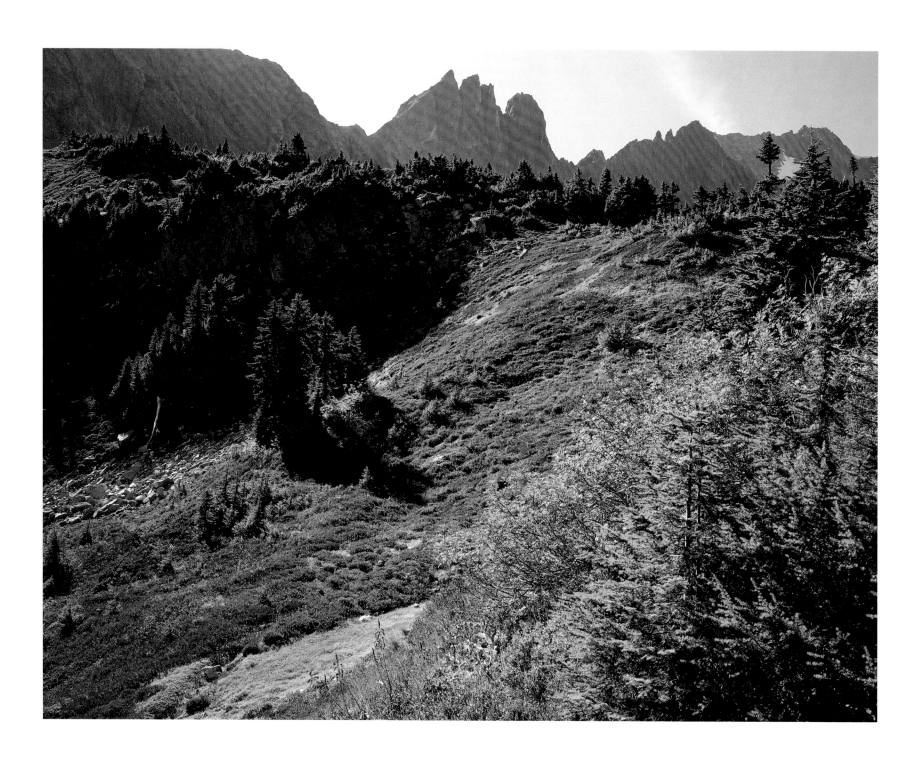

below: *Bobcat, elusive and on the move*

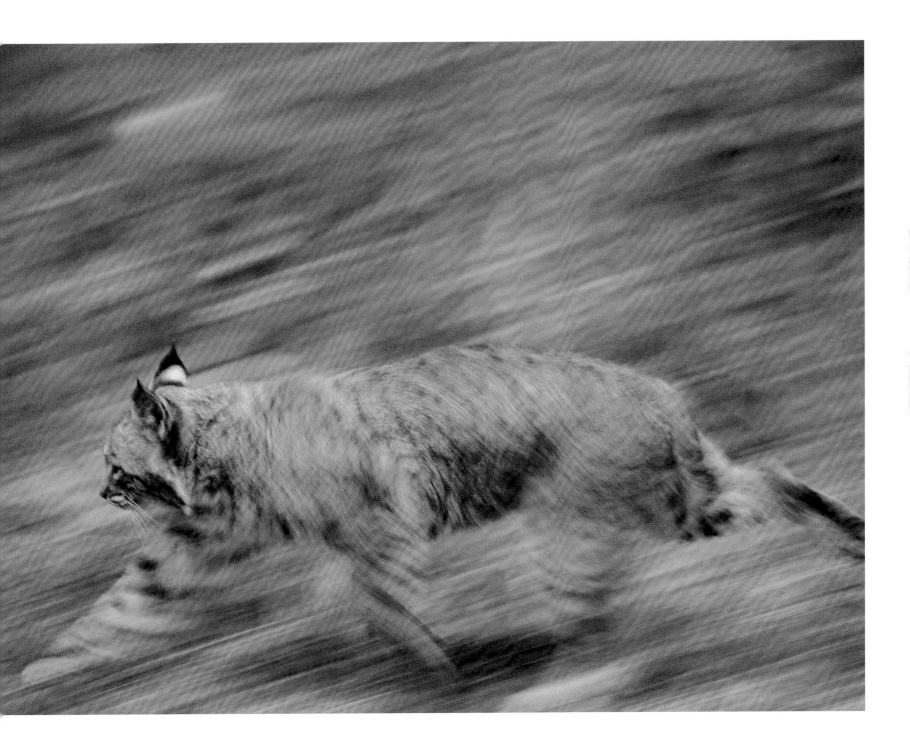

right: *Red alders along the Skagit River, Ross Lake National Recreation Area*

below: *Black-tailed doe and buck, a smaller deer species found statewide*

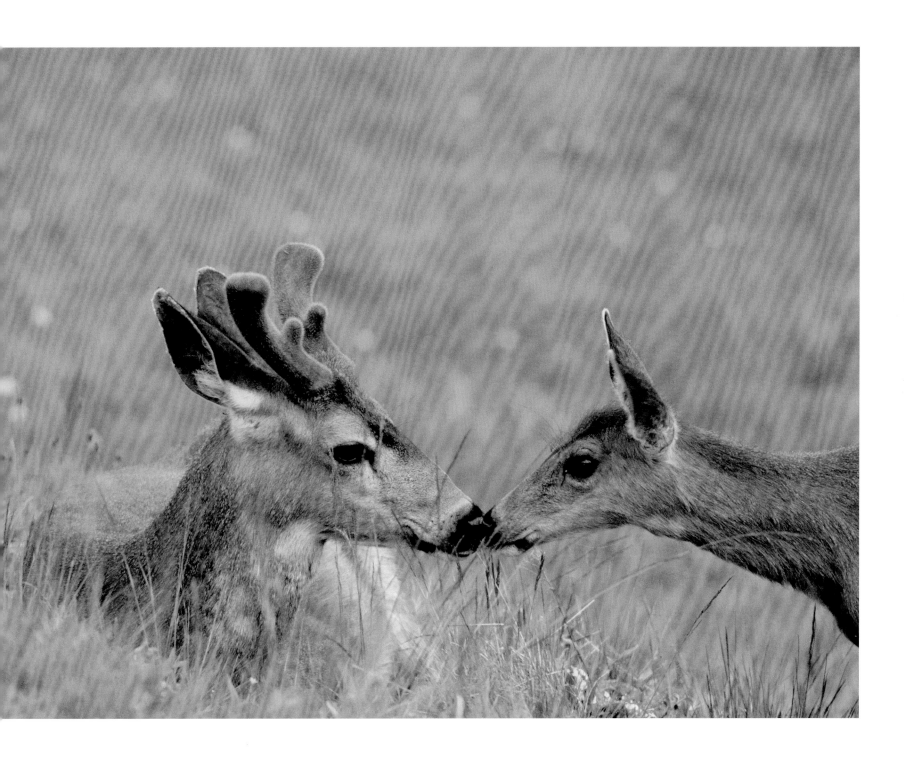

right: *Douglas fir and western red cedar forest near Denny Creek, Mount Baker–Snoqualmie National Forest*

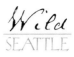

left: *Great gray owl in snag in a snowstorm*

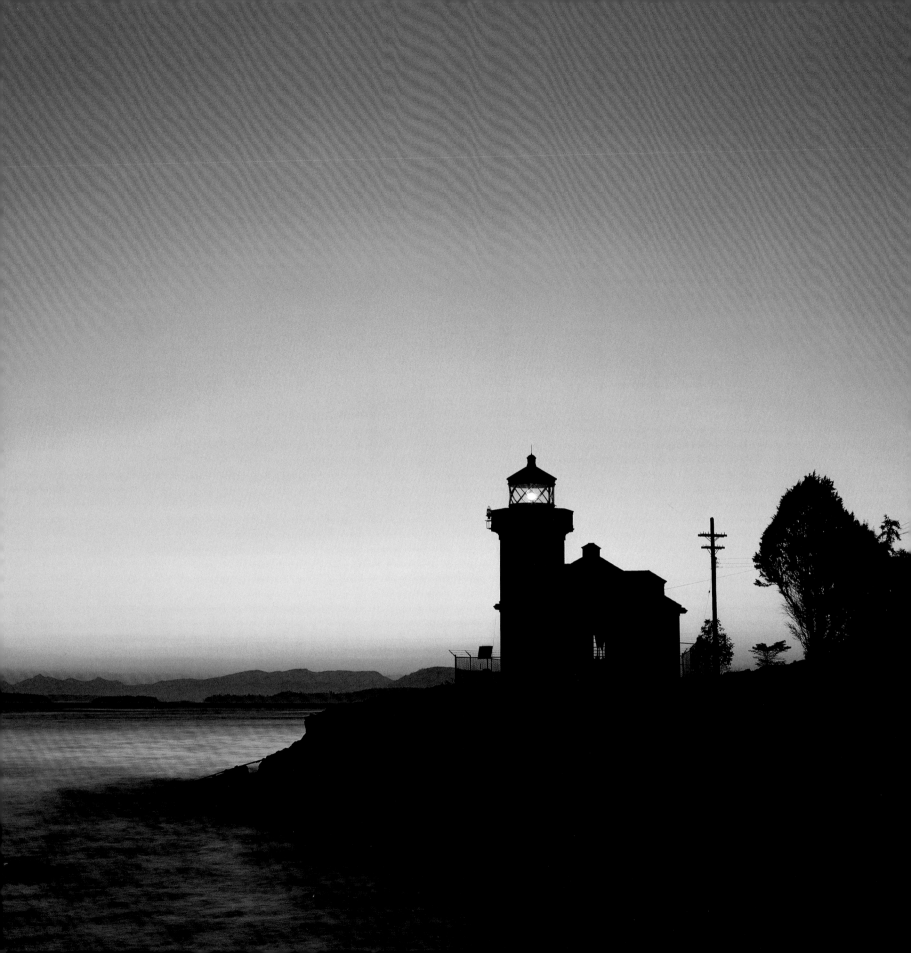

Islands and Waterways

To stand at the edge of the sea, to sense the ebb and flow of the tides, to feel the breath of a mist over a great salt marsh ... is to have knowledge of things as nearly eternal as any earthly life can be.

—RACHEL CARSON, *The Edge of the Sea*

A harbor seal in a kelp bed, a common loon on a watery runway, and a sea anemone in full flower at high tide would seem to have little in common. But a simple stroll around the lowlands of Puget Sound can bring an encounter with any of these living things, sometimes at the same time. It can be a surprise because, as the population has pushed out across the sound to the Kitsap Peninsula and filled in islands that used

to be lonely, the habitat for creatures that depend on salt water has gotten very crowded. Somehow, a fragile coexistence remains.

Foxes and coyotes wander the beaches, scouting for food. Huge pileated woodpeckers bang away at snags, while occasional black bears show up at river mouths at the peak of salmon runs. Brilliantly colored harlequins live between the coast and snowmelt-swollen rivers where they nest. The forces that produced a deep trough of salt water, numerous tiny inlets, and a land's edge thick with sedges, flowers, and forest have made these islands and waterways a perfect place for sea-dependent life. The astonishing thing is the pure variety.

The Puget Sound basin is easy geology, telling a story of how Ice Age glaciers once covered the land and, in their retreat, carved a trench that was filled with currents of the Pacific. What the glaciers missed, or left behind, formed the islands that dot the waterways. Most of them are simply underwater mountains. The tiniest ones in the San Juan archipelago are visible only at low tide.

On a misty day—which is to say, a typical day in the Northwest—anyone on a boat or even walking on shore can catch the poetry of this land. A small, older fir, bent and pressed by the winds, appears between rocks anchored to Puget Sound. It looks like the subject of a Japanese painting. On rare days, a crowd of dolphins may cruise by this scene, breaking the water's surface. And the occasional California gray whale may stray into these waters as well. Sea otters, once hunted to near extinction for a plush hide that allows them to stay warm in waters that would kill a

human in less than a hour, have reclaimed a fraction of their old waters.

The inland sea of the Northwest is, of course, first and foremost a marine environment, with cold-water wonders such as urchins and purple-colored sea stars. But connected to this water world is almost every other natural feature of the Pacific Northwest. Vine maples, skunk cabbage, and salal are native and well known. So are huckleberry bushes. The blackberries, as ubiquitous as they are, came from somewhere else.

In a windstorm the inland sea is a furious thing, especially a place like Admiralty Inlet near the San Juan Islands. It is not a wine-dark sea, like the Atlantic of old seafaring novels, but a great rage of gray. Low tide, with a full moon to light the way, shows why surfaces are so deceptive. Here are big bivalves that live to be nearly a hundred—geoducks (pronounced *gooeyducks*), oysters with a true taste of the region, and purple-sheened mussels. Oysters are sticklers for clean water.

Mudflats seldom make the guidebooks. But it is there, in the twice-daily flush of salt water over nutrient-rich ground, that certain birds are most productive. Belted kingfishers—their hairdos in a gravity-defying brush-cut—black oystercatchers, and sandpipers are among the creatures of the feather that feed on these tidelands.

"Hope is the thing with feathers," Emily Dickinson wrote. And in places like the Skagit River Delta, where a profusion of birds live as the Natives did, on a bounty that presents itself to anyone who gives it enough time, you can find enough wildlife on a good day to feel the poet's optimism.

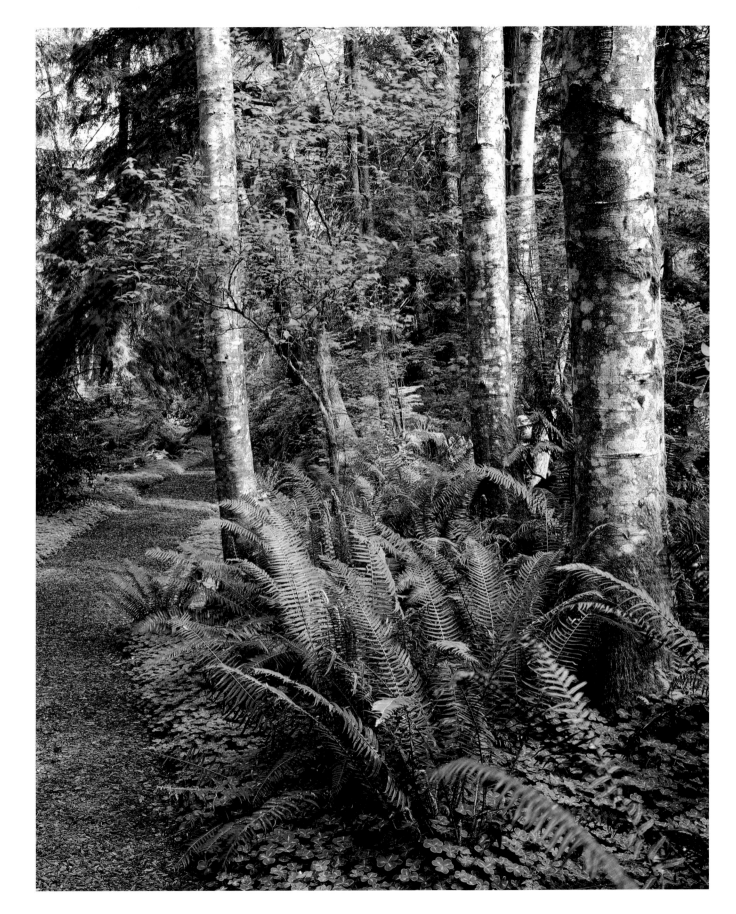

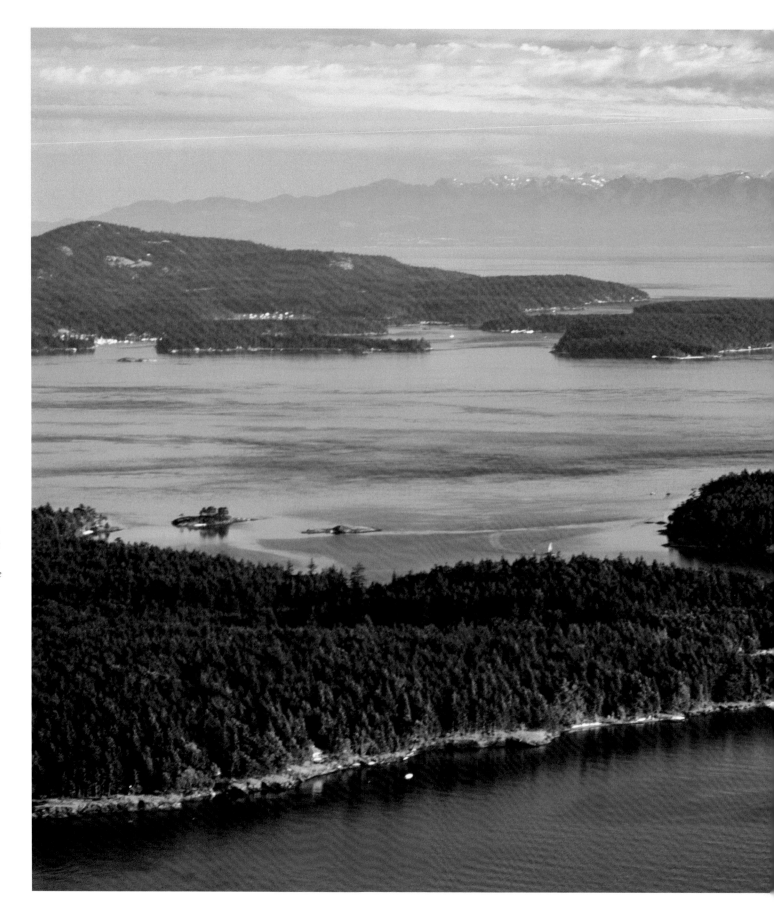

right: Spieden Channel and Henry and San Juan Islands from above Stuart Island, with Olympic Mountains in the distance

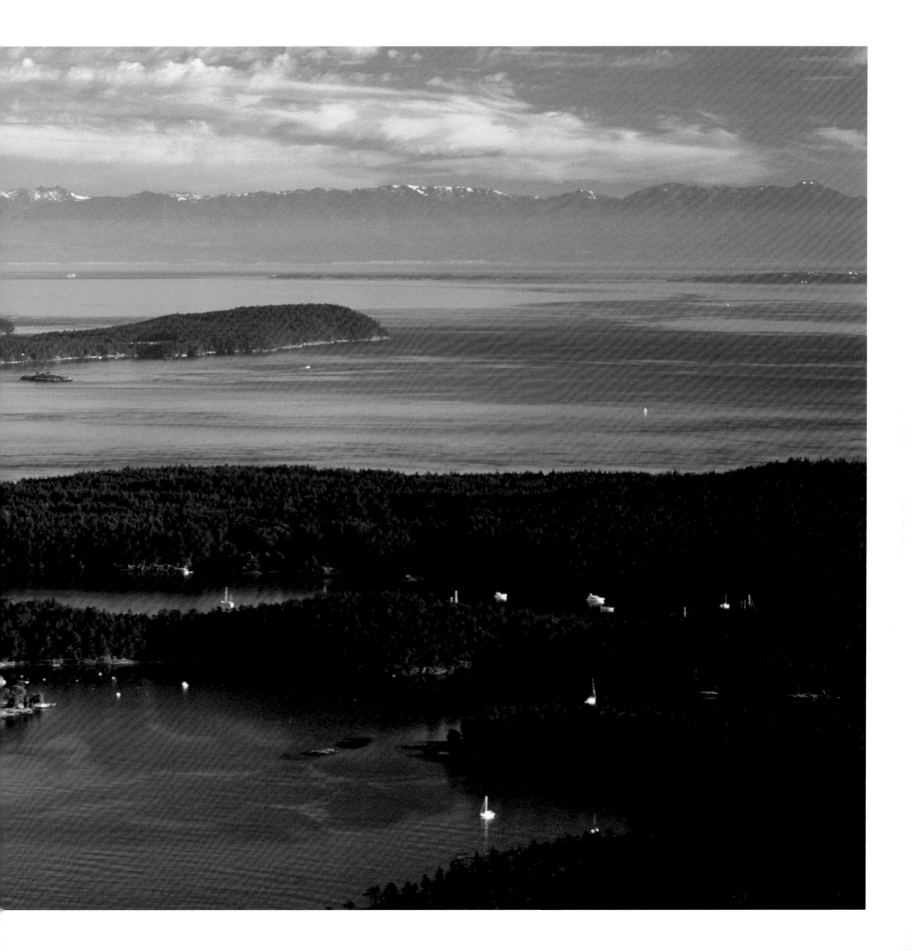

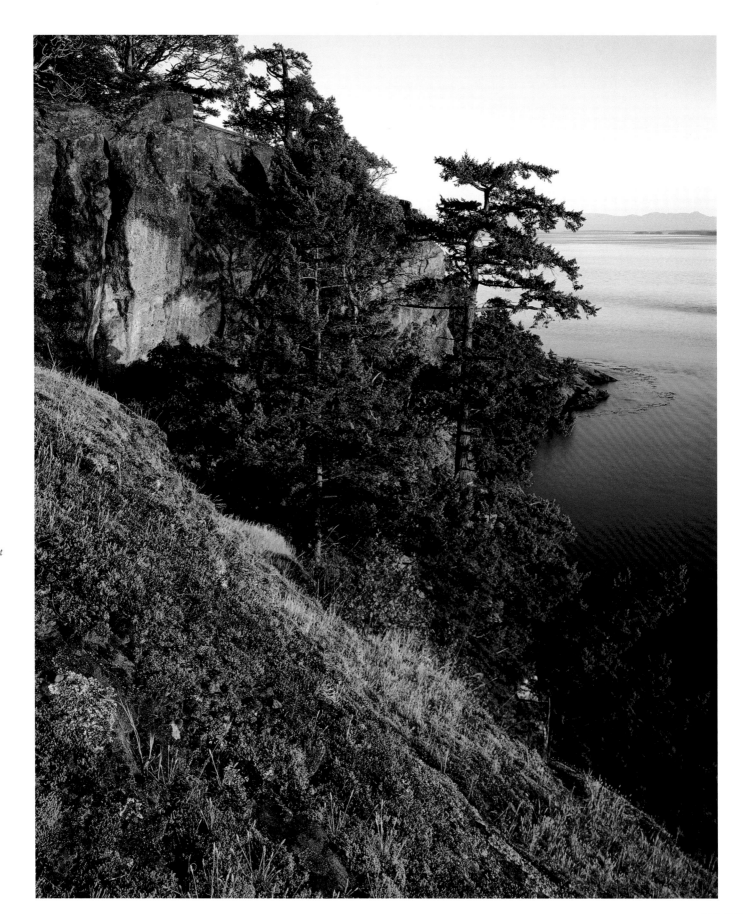

right: *Evening light on rocky cliffs of Turn Point above Haro Strait, Stuart Island, San Juan Islands*

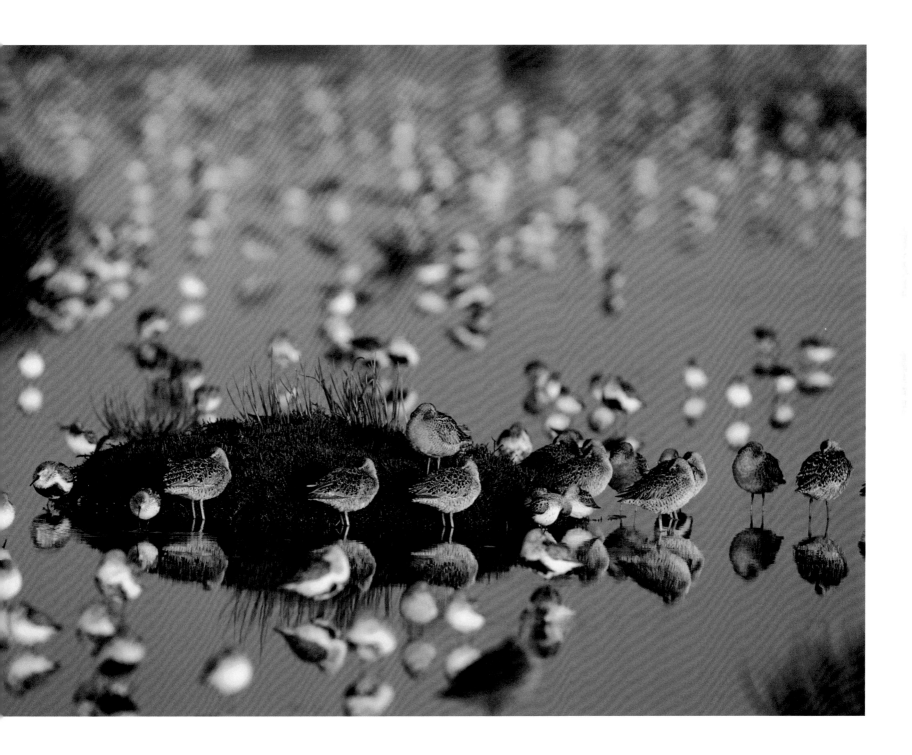

below: *Long-billed dowitchers,
common to Washington's salt-
marsh estuaries*

right: *Skunk cabbage and redwood sorrel in forest understory, Green Valley Creek, Vashon Island*

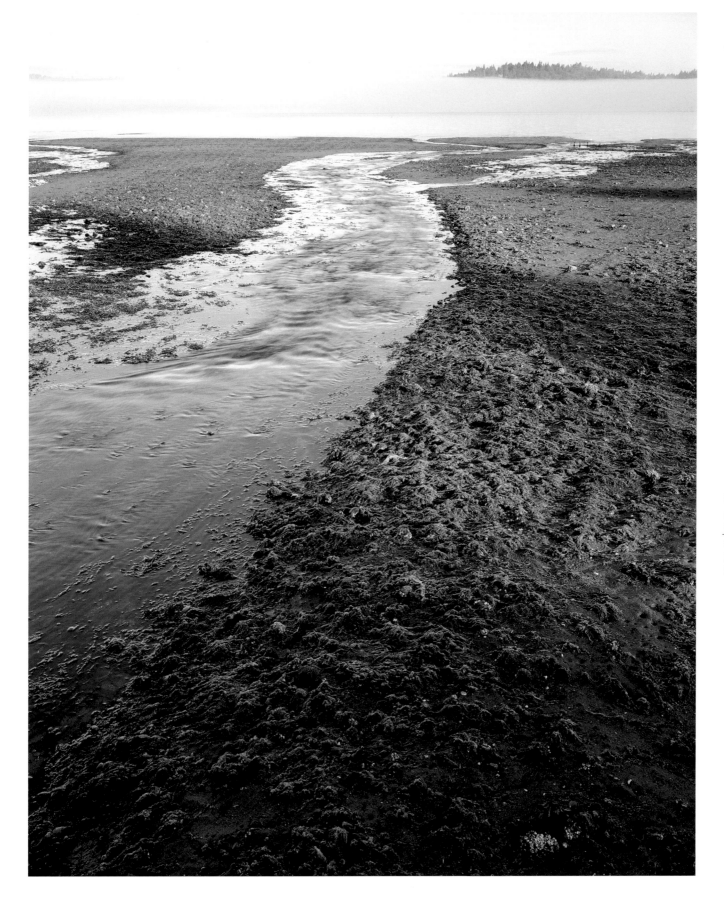

left: *Shinglemill Creek,
salmon-spawning stream
flowing through tidal
marsh into Colvos
Passage, Fern Cove
Sanctuary, Vashon Island*

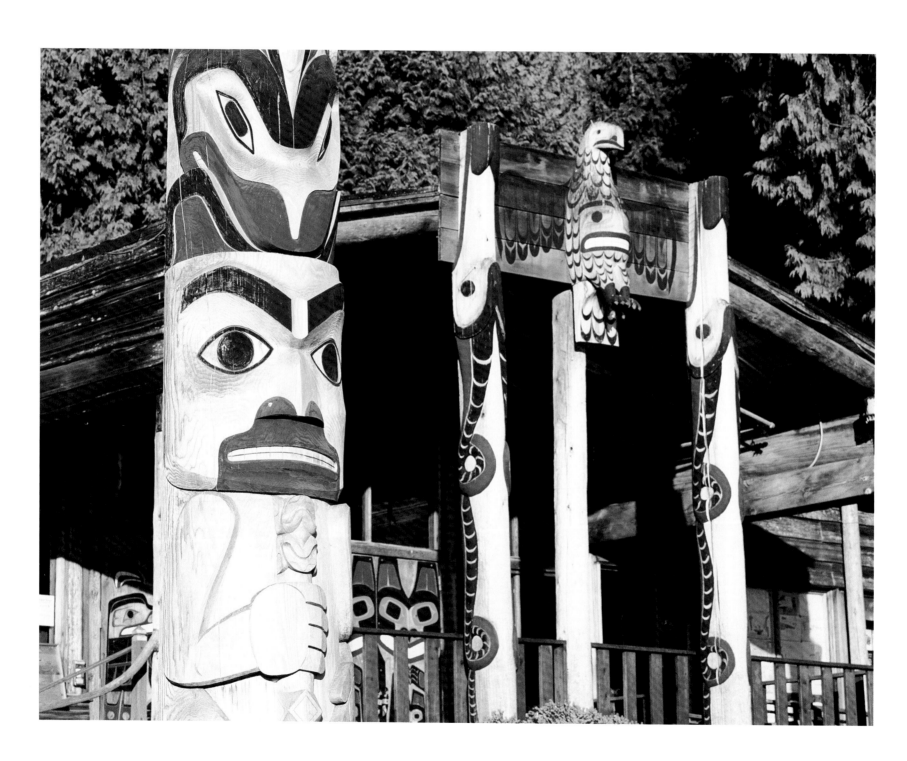

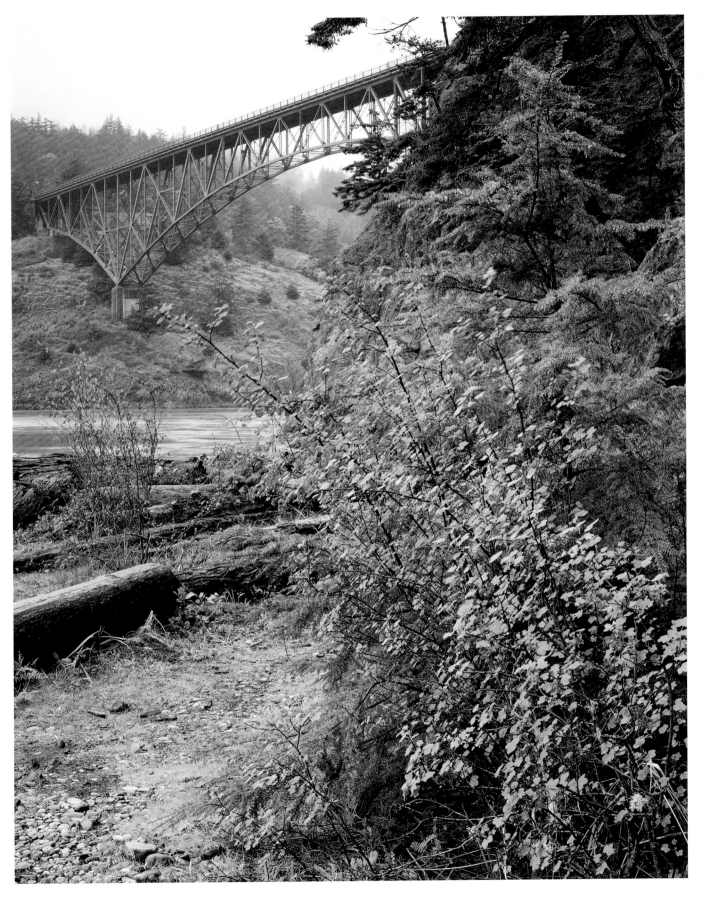

left: *Red flowering currant below Deception Pass Bridge in spring rain, Deception Pass State Park, Whidbey Island*

135

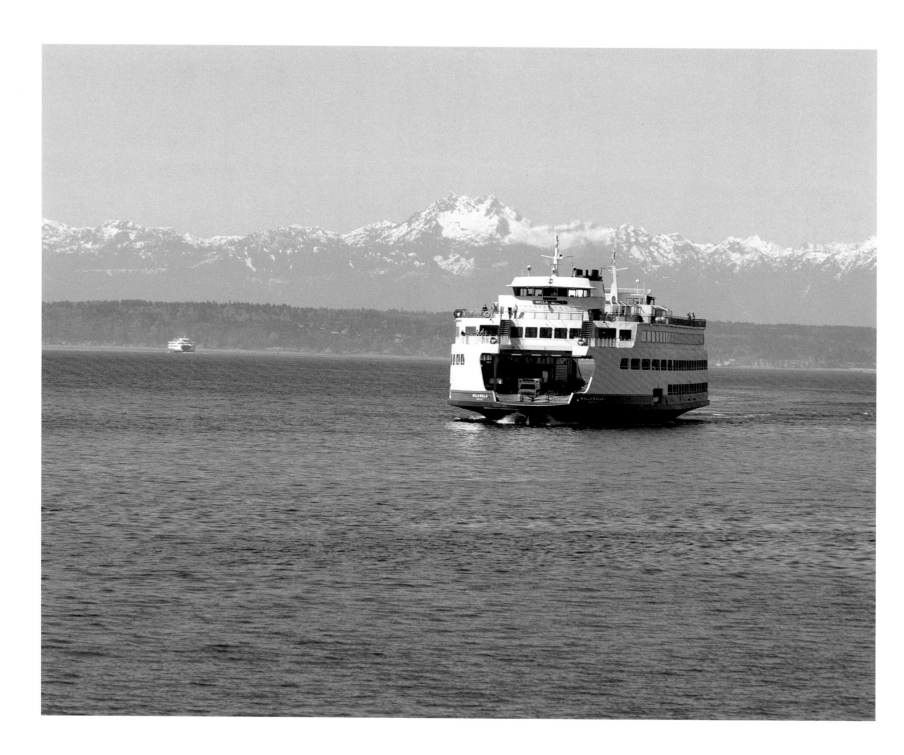

below: *Orcas, or killer whales,
often seen in Puget Sound and
throughout the San Juan Islands*

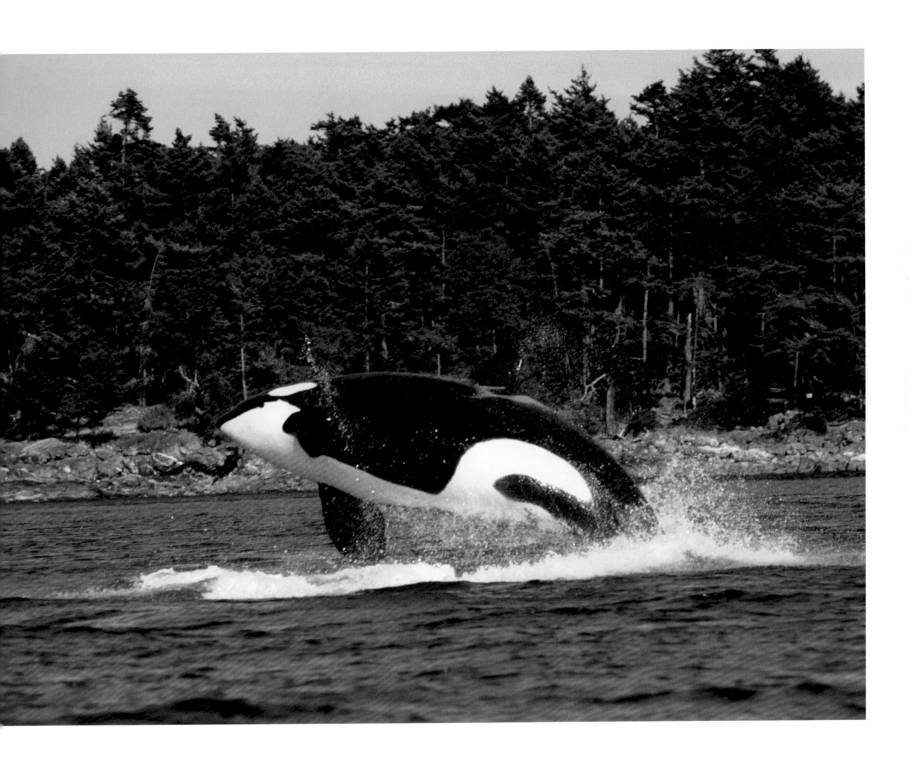

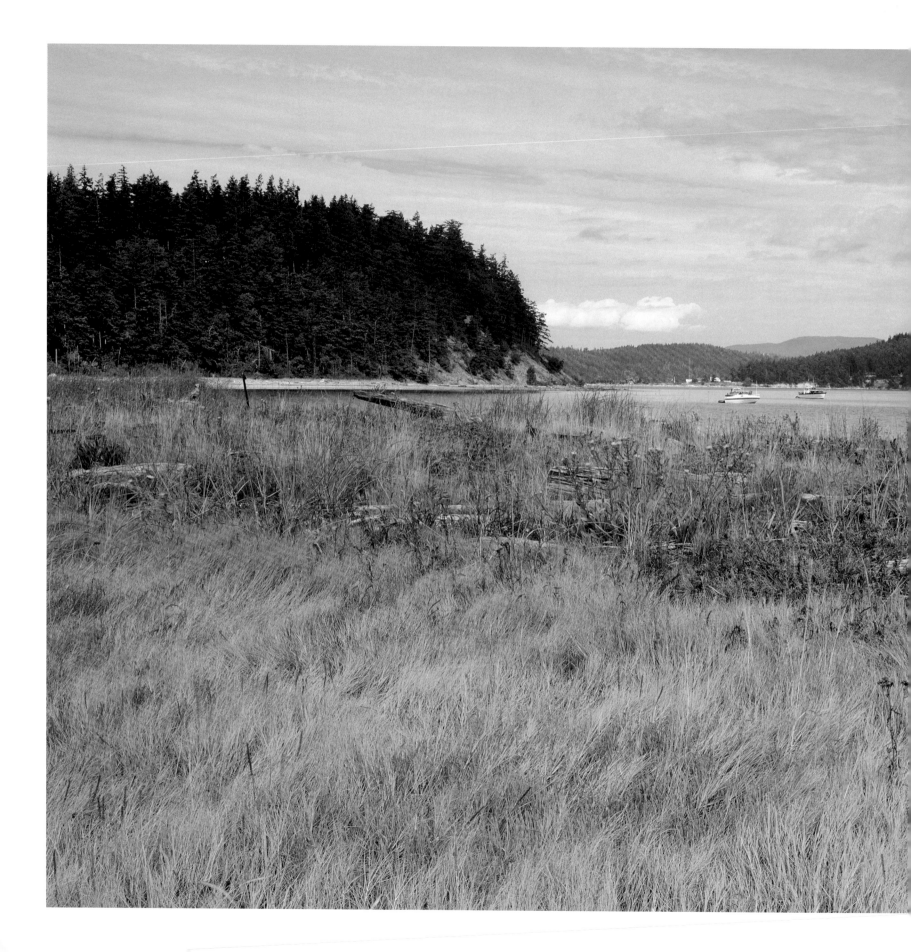

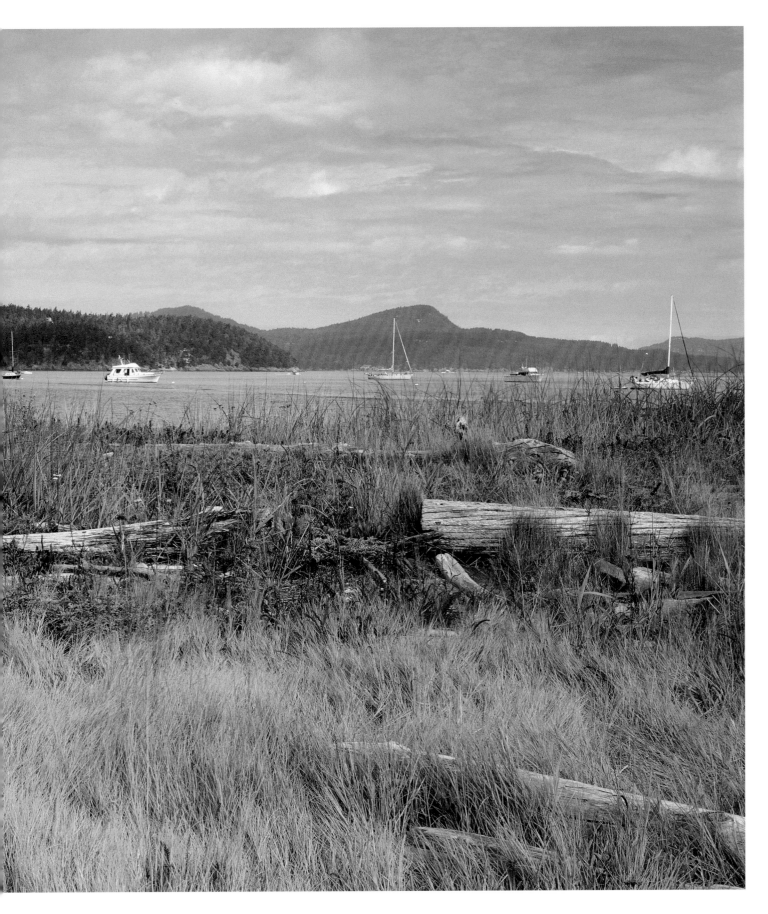

Wild
SEATTLE

left: *Sedges along salt-marsh lagoon, Spencer Spit State Park, Lopez Island, San Juan Islands*

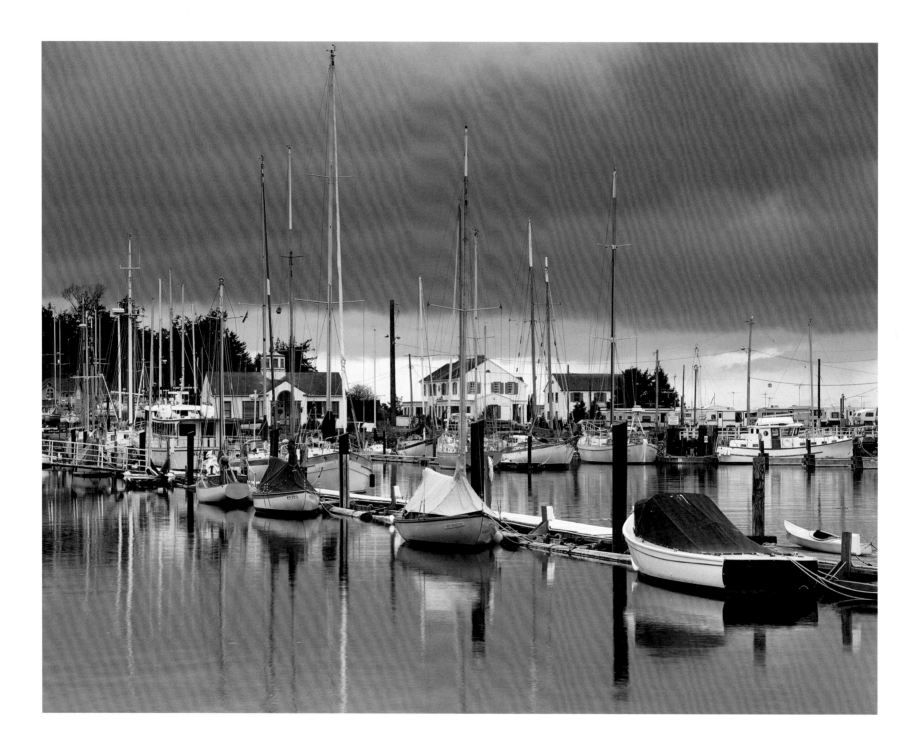

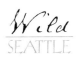

below: *Harbor seals, frequently spotted residents of Puget Sound*

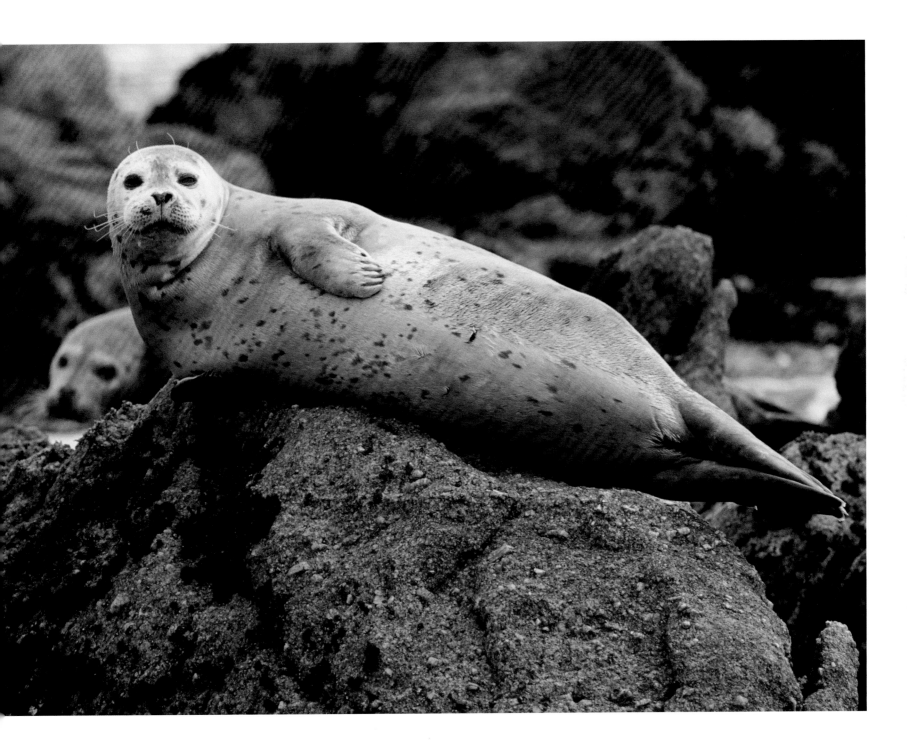

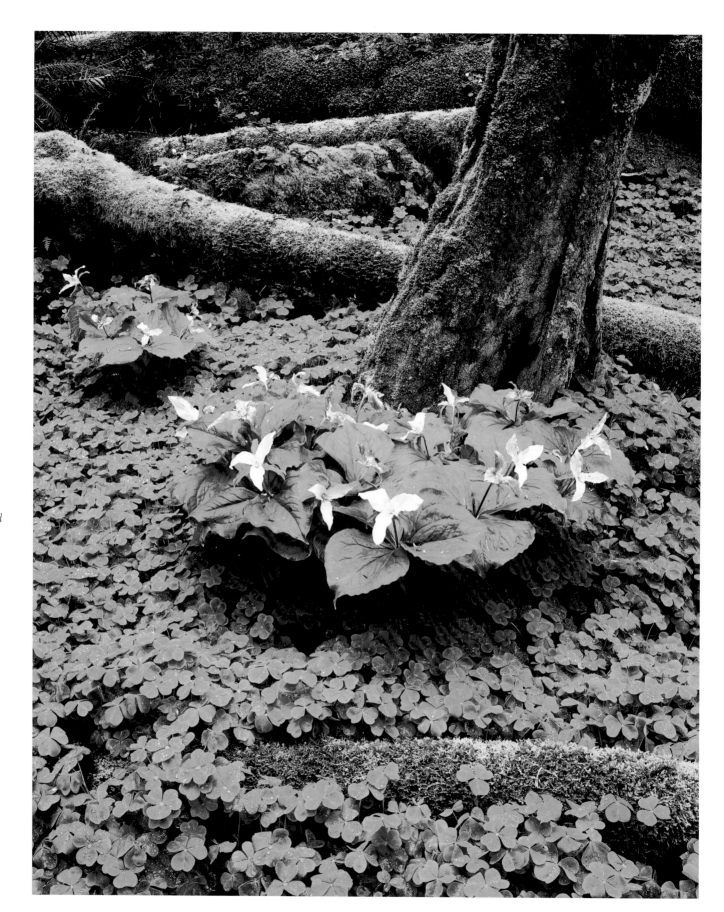

below: Sunset over Strait of Juan de Fuca and distant Olympic foothills, from Fort Ebey State Park, Whidbey Island

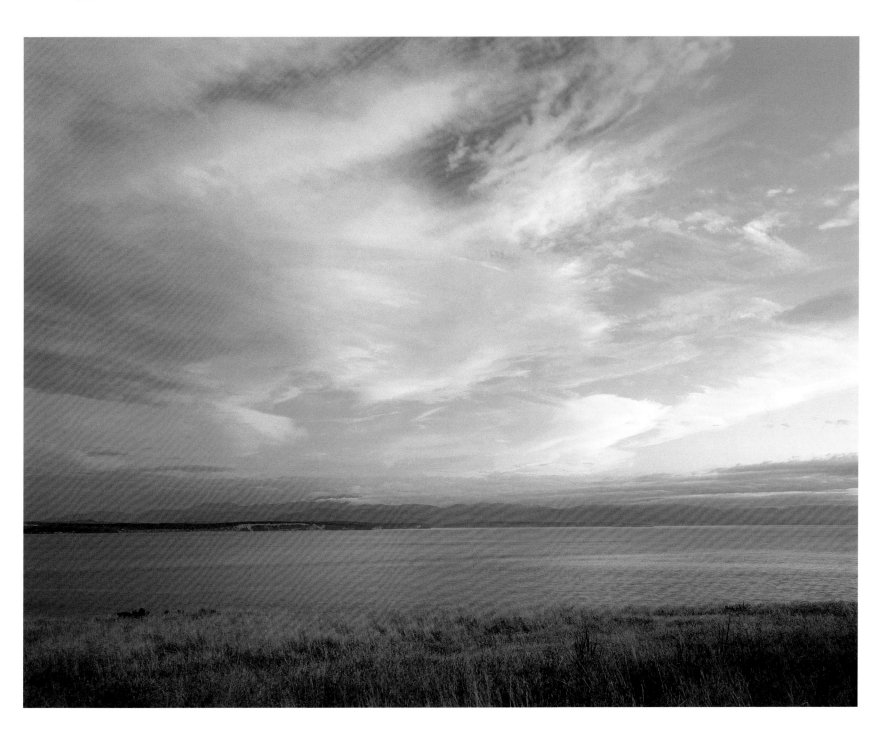

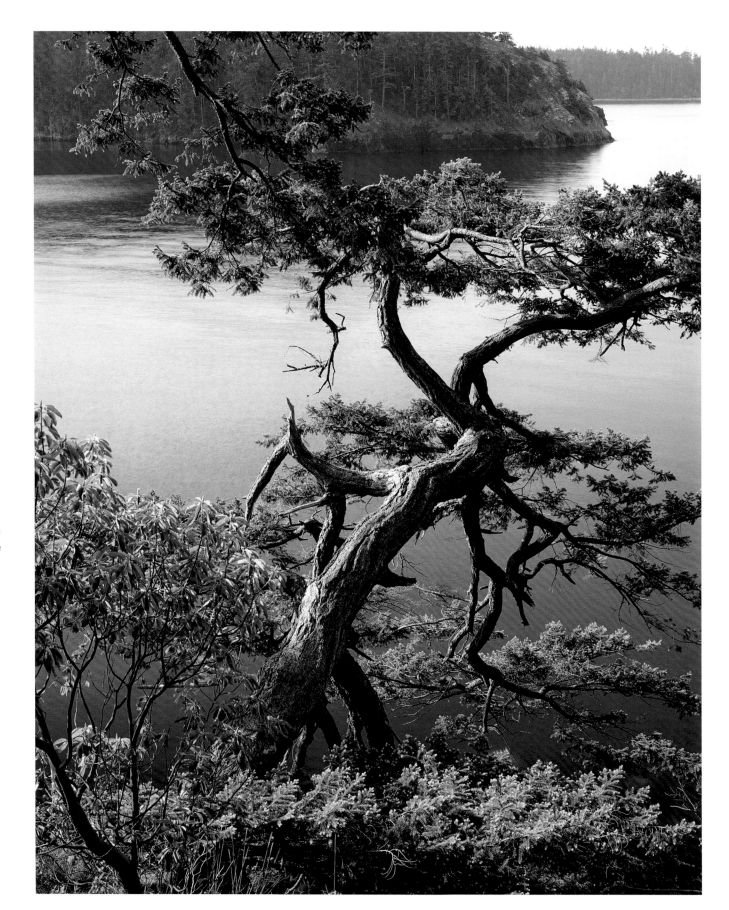

right: *Weather-sculpted Douglas fir on cliff above Bowman Bay, Deception Pass State Park, Fidalgo Island*

144

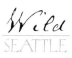

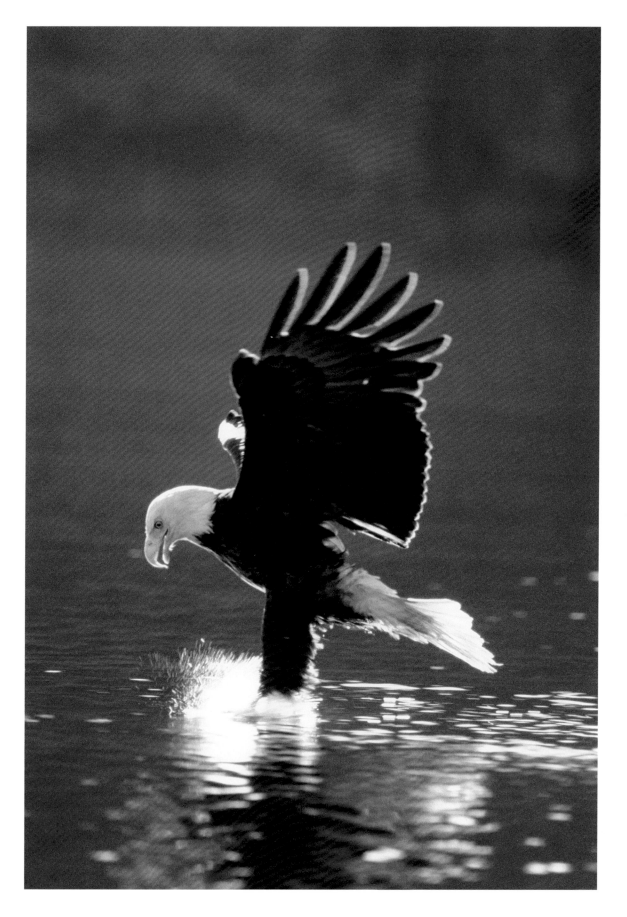

left: *Bald eagle fishing*

145

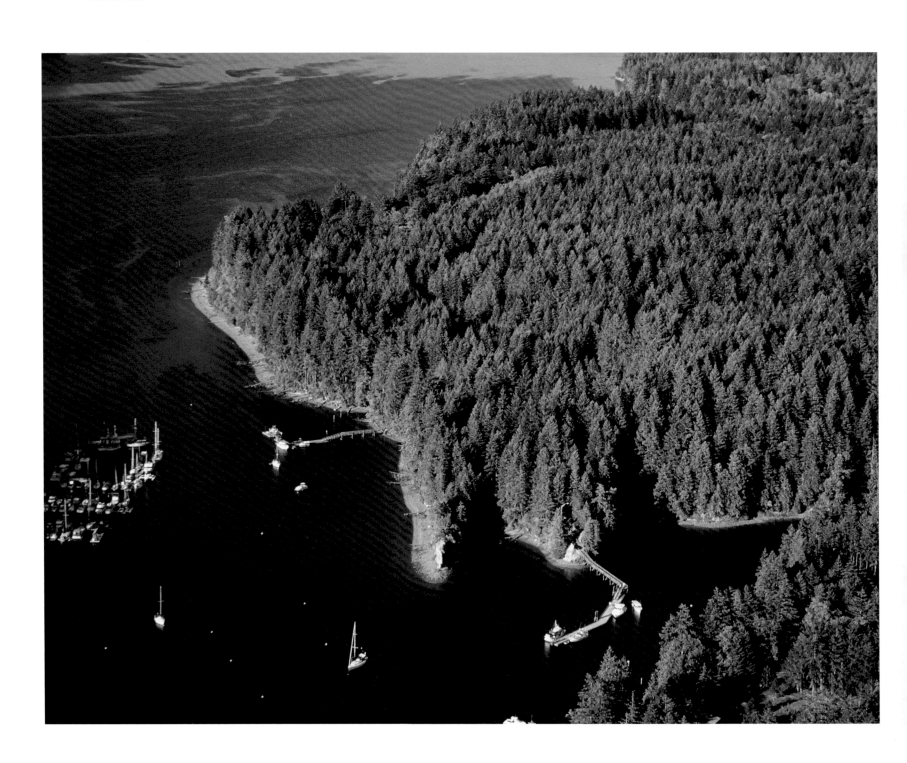

below: *Cutts Island Marine State Park, on Carr Inlet, South Puget Sound*

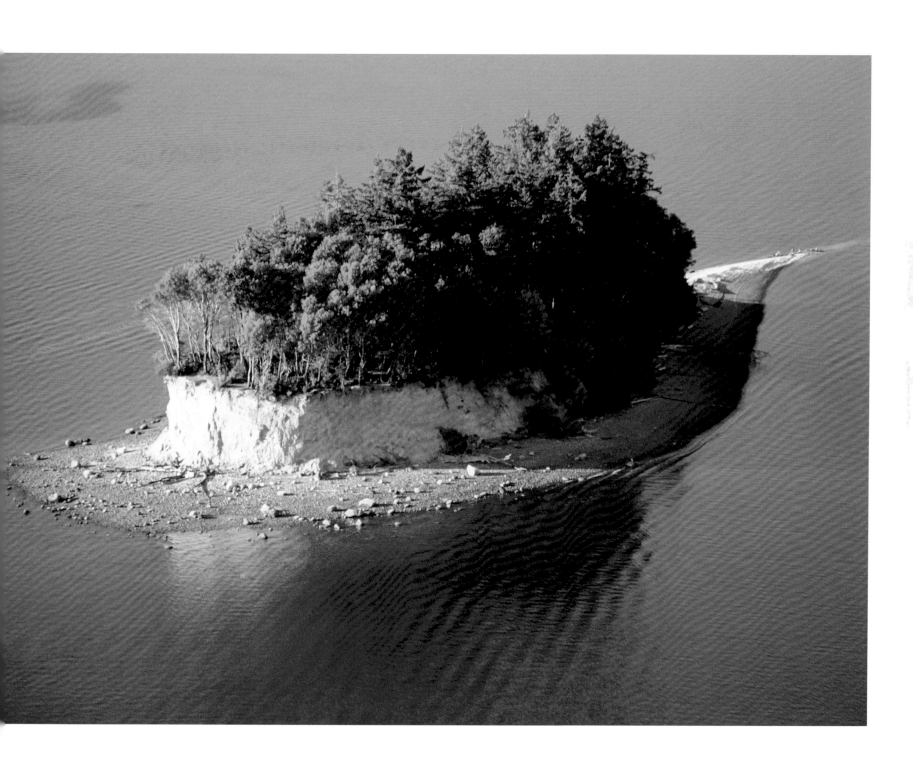

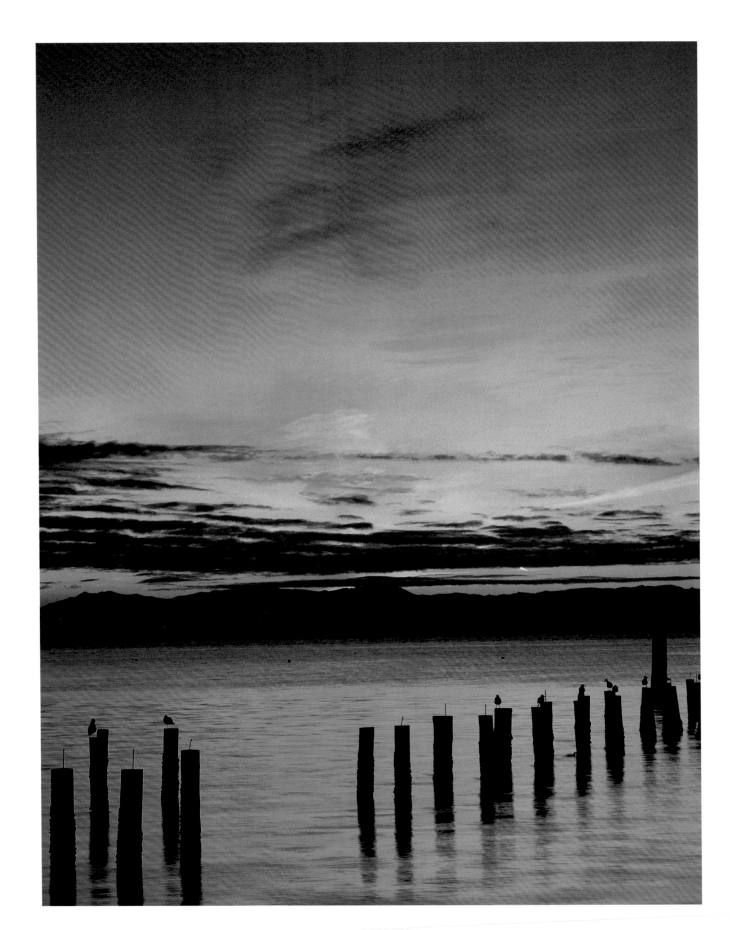

right: *Sunrise over East Passage of Puget Sound from Tramp Harbor, Vashon Island*

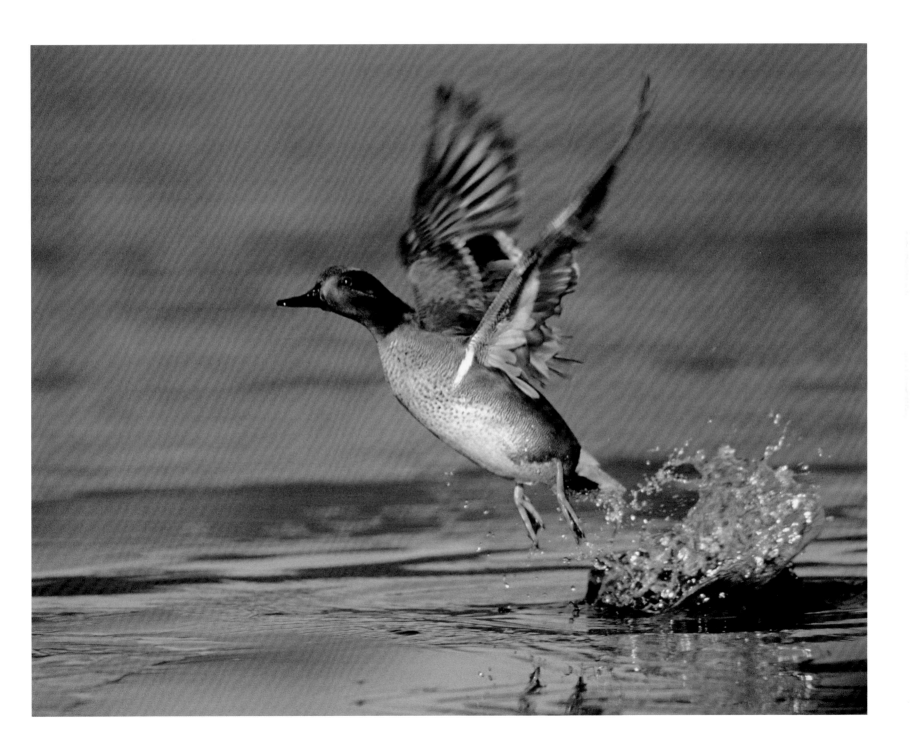

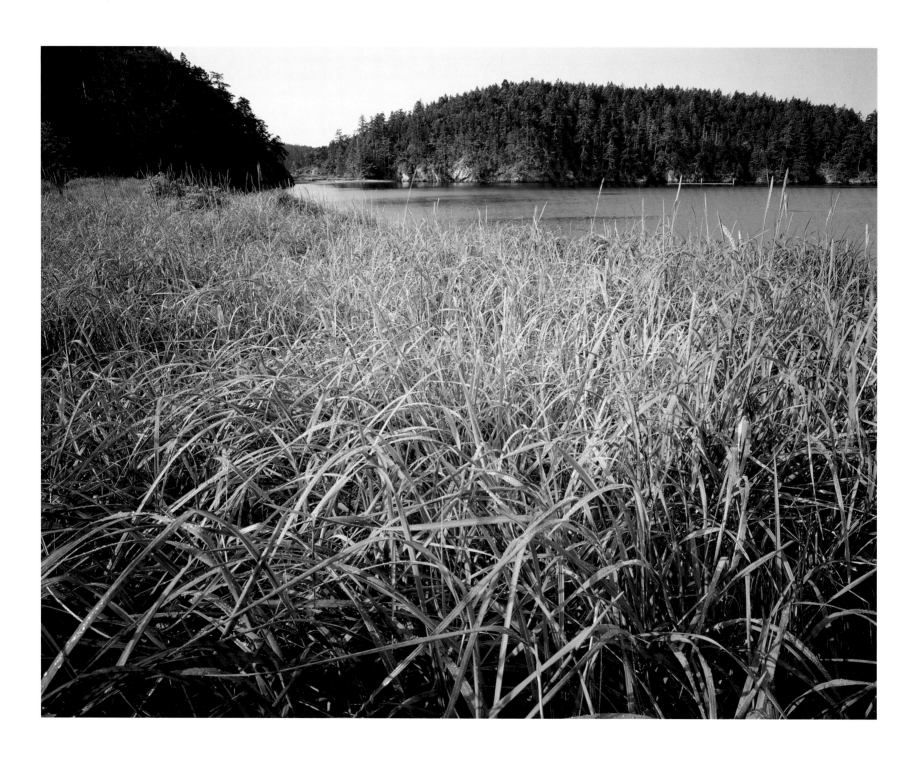

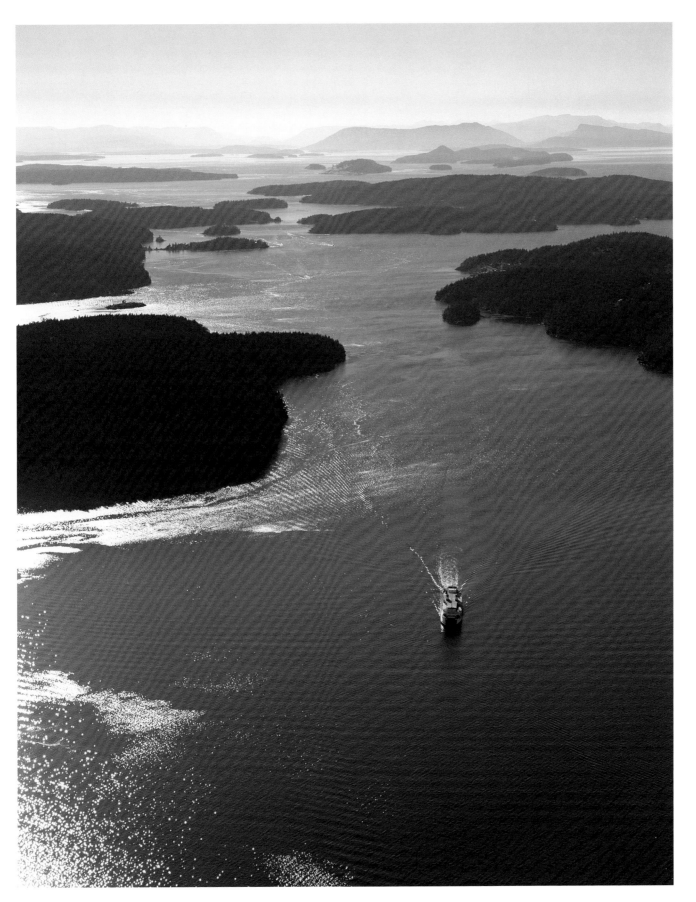

left: *Washington State ferry in Harney Channel with Wasp Islands in the distance*

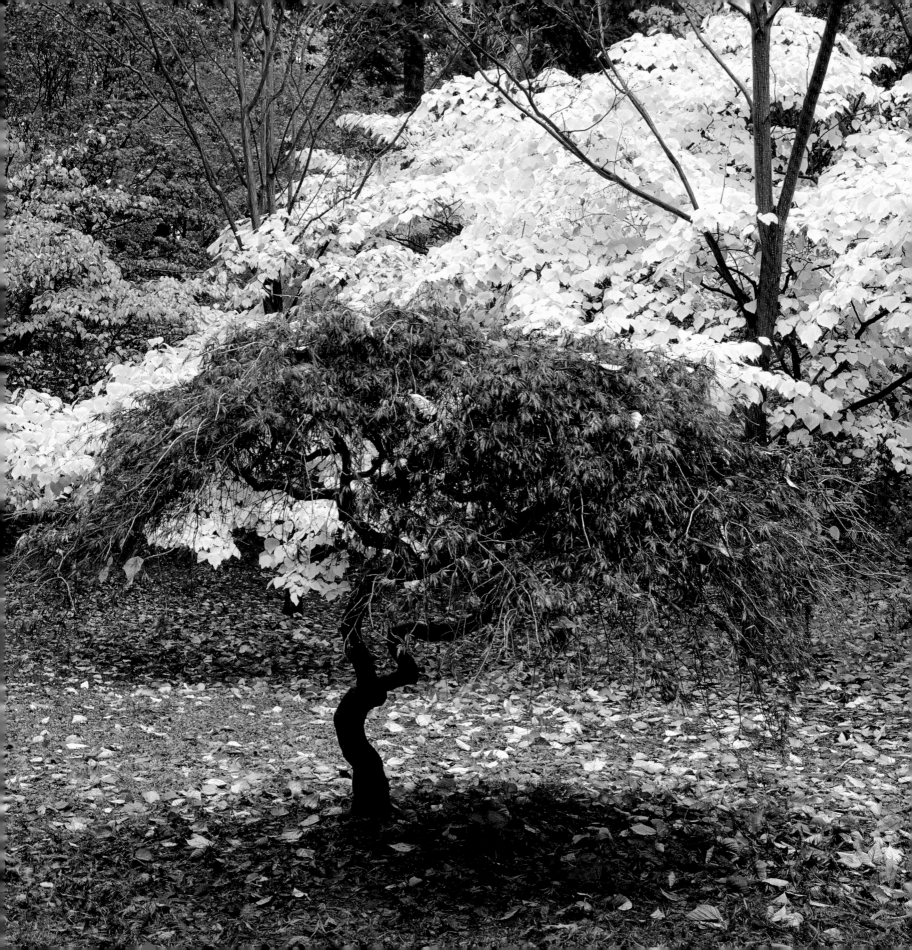

opposite: *Asiatic maples,*
Washington Park Arboretum
right: *Red-tailed hawk*

Afterword: The Long View

I DO NOT KNOW OF ANY PLACE WHERE THE NATURAL
ADVANTAGES FOR PARKS ARE BETTER THAN HERE.
THEY CAN BE MADE VERY ATTRACTIVE AND WILL, IN
TIME, BE ONE OF THE THINGS THAT WILL MAKE
SEATTLE KNOWN ALL OVER THE WORLD.

-JOHN CHARLES OLMSTED, 1903

Even more than a Microsoft millionaire or a vanilla latte, pervasive wildness is the essence of Seattle. We have changed much and built much, yet we've also taken care to preserve wildness at our door, down the block, and on the skyline. Denizens of Wild Seattle do not take these natural gifts for granted; we cherish these places and use them intensively. Protecting the green world amid cities and suburbs, on mountain ridges, and in deep, forested valleys has been the work of generations of conservation activists.

Wild
SEATTLE

153

Vistas of wilderness rise around Seattle. In an ineffable yet vital way, nearby mountain and forest wilderness areas imbue even our smallest urban parks with something of their aura. Our drinking water flows from wilderness snowfields. Salmon commuting in urban rivers and streams are ambassadors of wilderness, coming from and returning to wilder places in their timeless migration from freshwater to salt water and back. Northwest tribal people who live and work here remind us latecomers that they long ago set the pattern for living harmoniously with the natural world.

So, the "Emerald City" is not, after all, at the end of a yellow brick road in Oz, but here in the Evergreen State. The stunning greenness of Seattle's parks and open spaces inspires the city's official nickname. A commitment to green spaces is common to cities and towns all around Puget Sound.

It was improbable that the city of Seattle would have exercised park-saving foresight as early as it did. Seattle Parks Department historian Don Sherwood observed: "Seattle was so busy becoming a city—and so surrounded by wilderness—that the 'park concept' was slow to grow." Yet even before the first real population boom, the city protected a rich trove of urban parks. The vision was laid out by Olmsted Brothers, America's renowned landscape architecture firm, whose founder, Frederick Law Olmsted, gave us New York's Central Park and San Francisco's Golden Gate Park. Building on the legacy of Olmsted-designed parks—notably Seward Park, Woodland Park, Volunteer Park, the Washington Park Arboretum, and Green Lake—Seattle

exemplifies Frederick Law Olmsted's ideal: parks as "the lungs of the city."

Accidental good fortune has added to Seattle's wealth of parks as open spaces have been protected or reclaimed from development. When most of Fort Lawton, an artillery battery on Magnolia Bluff, was declared surplus in the late 1960s, it became Discovery Park, Seattle's largest at 534 acres. With two miles of tidal beaches, 250-foot sea cliffs, meadows, and thick forests laced with trails, it is a wildlife sanctuary, outdoor classroom, and widely loved and used green space. A similar history helped secure 137-acre Fort Ward State Park, a marine park along the southwest side of Bainbridge Island having 4,300 feet of scenic wooded shoreline on Rich Passage, the route of the Seattle-Bremerton ferry.

Park-minded citizens have mobilized when federal lands being declared surplus have been targeted by other interests. When most of Sand Point Naval Air Station was closed in the 1970s, some dreamed of its runways as an in-city airfield for Piper Cubs and Beechcrafts. Instead, the runway is gone, and Magnuson Park, our second-largest, protects a mile of Lake Washington shoreline.

Bridle Trails State Park, situated just east of Interstate 405 between Bellevue and Kirkland and just twenty minutes from Seattle's downtown, protects 482 acres of the mixed forest that once covered the Puget Sound lowlands. Some call it "the wilderness in the city," and its twenty-eight miles of forested trails make it a favorite of equestrians.

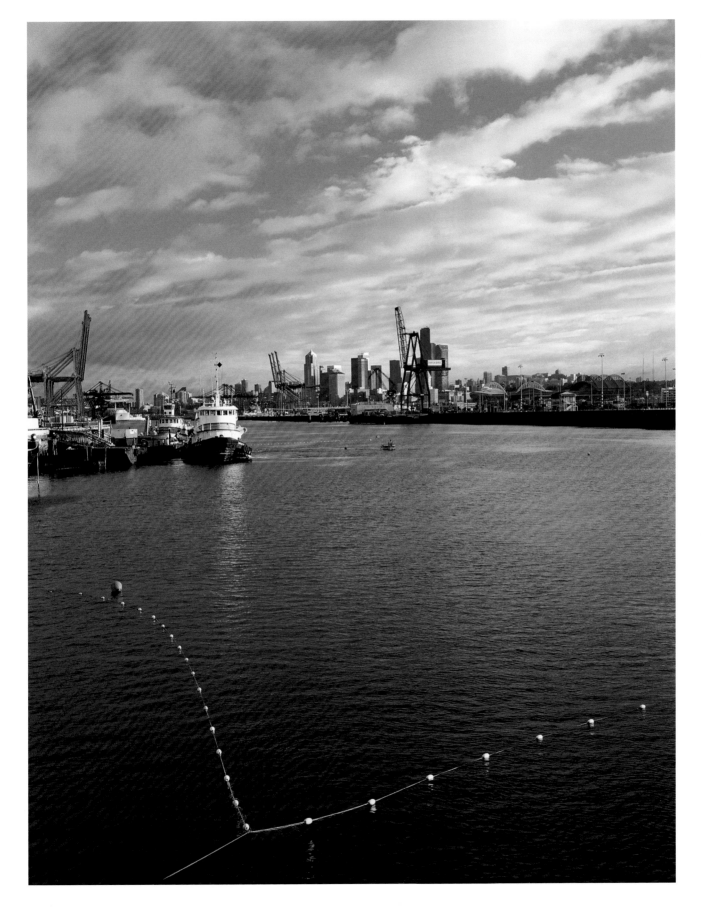

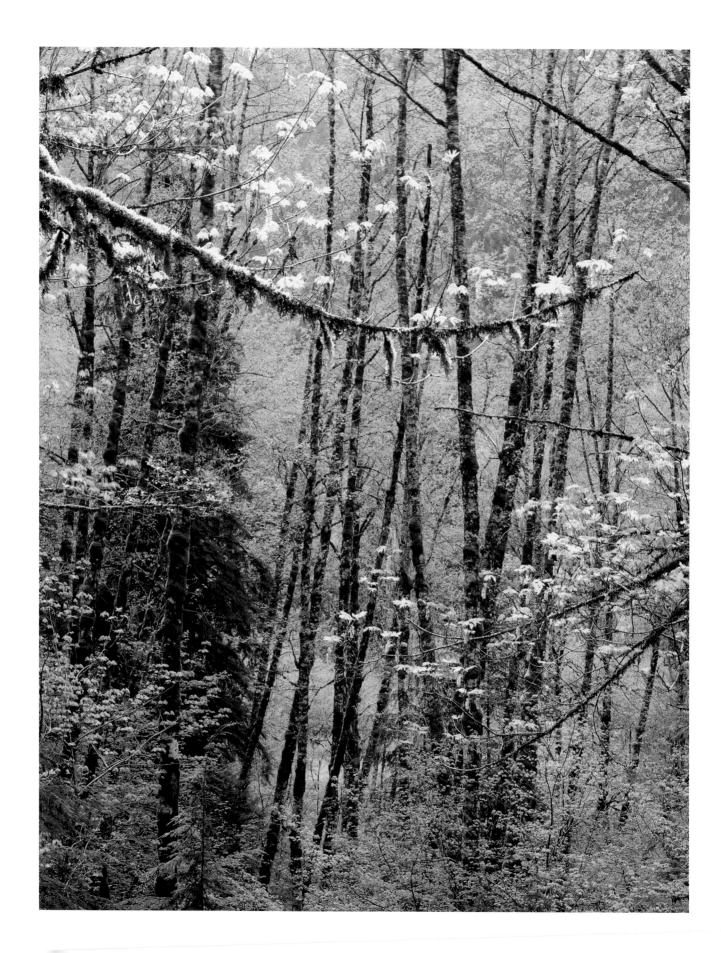

Asked if the park has changed, the ranger there for more than twenty years, Mary Welborn, replies, "Not much, and that is the beauty of it." When state budget cuts threatened to close the park in 2002, enthusiasts formed the Bridle Trails Park Foundation, raising funds to help.

Walking, jogging, and biking trails function as connective tissue linking wild places in the city and leading beyond to suburban and rural open spaces—and on, ultimately, to the wilderness forests and peaks of the Cascade Mountains. Here, too, happy accident has helped. In 1885 Thomas Burke and Daniel Gilman sought to link the Seattle docks to the Canadian transcontinental railroad. Their rails through the city were abandoned in 1971. Today, this and other old railroad rights-of-way are part of the Burke-Gilman/Sammamish River Trail, extending twenty-seven miles from Seattle's Ballard neighborhood west around Lake Union, through the University of Washington campus, north along Lake Washington, and east to King County's 640-acre Marymoor Park. A paved ribbon through nature, it delights thousands of commuter and recreational cyclists, skaters, joggers, and strollers.

Using an old rail line along the shore of Lake Sammamish, the East Lake Sammamish Trail will link Marymoor Park (and the Burke-Gilman Trail) with the waterfront in 512-acre Lake Sammamish State Park, and on to the Mountains-to-Sound Greenway. The greenway is an all-star success for Wild Seattle, a 100-mile network of open space and trails extending along the Interstate 90 corridor from Seattle's waterfront through the forests of the Cascade foothills, over Snoqualmie Pass (where it links to the Alpine Lakes Wilderness), and on to the desert of Central Washington. Sustaining the vision of the still-growing greenway and spurring public acquisition or exchange of more than 125,000 acres thus far, the Mountains-to-Sound Greenway Trust is a lively coalition of timber companies, environmental organizations, local businesses, and land management agencies. Trust leaders herald the greenway as "a scenic gateway to Washington's largest cities and a pathway to nature for growing city populations."

These urban-to-wilderness trail corridors have their wet, salty equivalent in the Washington Water Trails, a system of designated routes, campsites, and put-ins allowing kayakers and other users of human- and wind-powered, beachable watercraft to travel the length of Puget Sound and other waterways. These small craft share Lake Union, in the heart of Seattle, in a happy chaos of sailboats and motorboats, windsurfers, seaplanes (a scheduled airline takes off from there to the San Juan Islands and Canada), and floating communities of houseboats. Following one route, the Lakes-to-Locks Trail, boaters can traverse from Lake Washington and its quiet backwaters in Washington Park Arboretum through the Lake Washington Ship Canal to Lake Union and out to Puget Sound. The last leg takes them through the fascinating Hiram M. Chittenden Locks in Ballard, the largest locks in the Western Hemisphere outside Panama. Salmon go around the locks by fish ladder.

South of the city, Mount Rainier and its tendrils stitch the south Puget Sound region together. More than the manmade Space Needle, Mount Rainier is the icon of Wild Seattle, not simply a scenic beacon, but our own Parthenon rising above us, ever on our skyline. Flowing from its slopes, the White River and the Nisqually are pathways from Rainier, exemplars of icy mountain rivers rushing to the sound all along the west slope of the Cascades and the east slope of the Olympics. The White and Nisqually rise from glacial parents to carry finely ground rock—the very bone meal of Rainier—away in the timeless business of grinding a mountain down into a flat plain and nurturing the estuaries below.

In the estuary where the Nisqually idles into the sound, the Nisqually National Wildlife Refuge, established in 1974, protects 3,000 acres of salt and freshwater marshes, grasslands, and mixed forest habitats as resting and nesting areas for migratory waterfowl, songbirds, raptors, and shorebirds. It is a refuge for people, too.

From Olympia to Bellingham, from the east side of the Cascades to the west side of the Olympics fronting the Pacific, great wilderness areas ring Wild Seattle like a green necklace studded with the precious, glittering jewels of our glacial peaks—Mount Baker, Glacier Peak, Rainier, Olympus. The wilderness on these federal lands has been protected by the unrelenting work of generations of conservation-minded citizen-activists. Today, wilderness areas are thronged by outdoor enthusiasts who know little of how those places came to be preserved.

A single reality motivates activist campaigns to protect forest and wilderness: all of American history demonstrates that wilderness cannot preserve itself in the face of the insatiable appetites of man, if not for logs, then for playgrounds for the infernal combustion engine. The appetite for development and noisy mechanized inventions will increase everywhere, leaving no wilderness beyond the end of the road and the whine of engines unless a decision is made to protect specific areas within a specific boundary, and even then only if that decision is sustained. This work has been going on in the Puget Sound region for generations.

Pat and Polly—Pat Goldsworthy and Polly Dyer—are legendary visionaries and activists, our local John Muir and Rachel Carson, as it were, our exemplars of volunteer wilderness advocacy. Polly and Pat are the very best kind of leaders, recruiting and encouraging untold squadrons of wilderness activists over the decades since they began their efforts in the 1950s.

Pat Goldsworthy's lifetime avocation has been to protect the North Cascades reaching to the Canadian border, a stunning part of Wild Seattle's mountain playgrounds, America's Swiss Alps. In 1957, Pat and others banded together as the North Cascades Conservation Council to lead, with the Sierra Club, the ten-year campaign to establish North Cascades National Park.

Every time we turn on a light (and turn it off, for we are

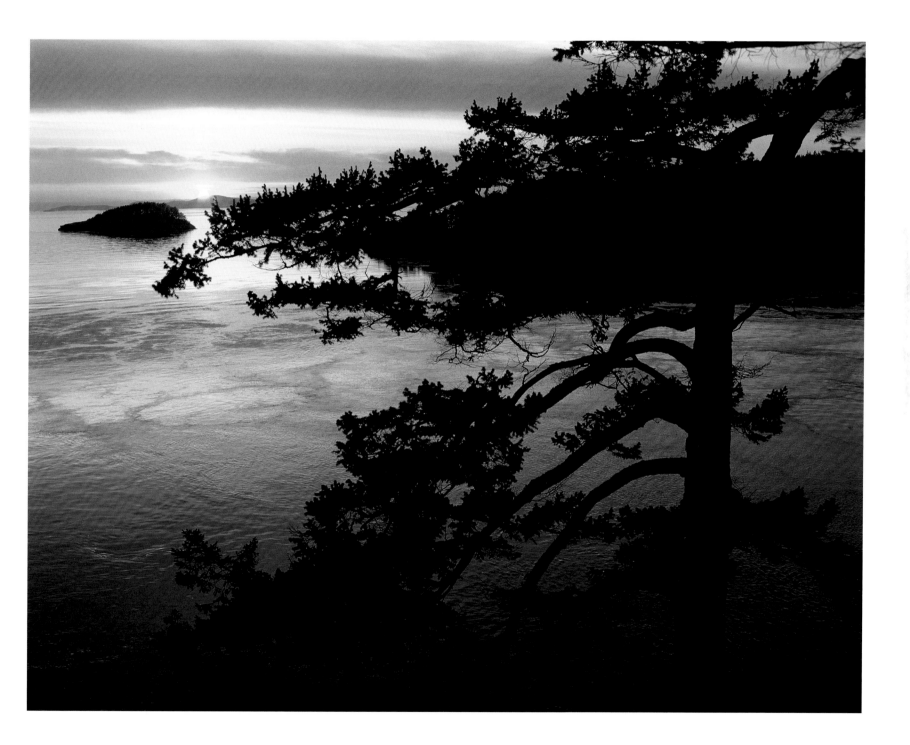

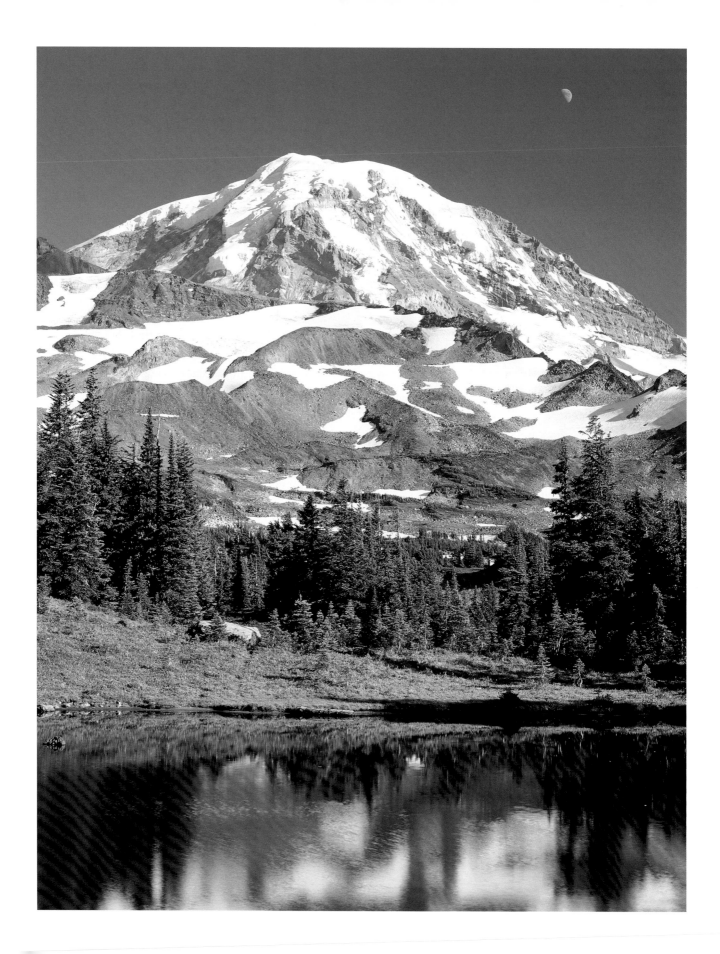

opposite: *Mount Rainier above*
alpine tarn

energy conscious), it is lit by power from North Cascade dams that harness the energy of the once-plunging Skagit River—dams built and operated by City Light, Seattle's municipal utility. Eternal vigilance is the price of wilderness. With the national park in place, new threats arose. One was the bad idea of raising a City Light dam to flood more mountain valleys in the heart of the wild park, another a scheme to build a nuclear plant along the Skagit River. Pat and the NCCC have always been there, leading successful campaigns to block these and other threats, enlisting new generations of leaders, modeling effective volunteer activism.

That is the pattern: old hands avidly welcoming and nurturing new recruits. The park and wilderness campaigns of today reflect a rich and powerful mix of the generations, melding deep experience with new energy and approaches. Conservation groups of every sort are at work in the Seattle region; the calendar of strategy meetings, workshops, trail maintenance trips, conferences, and—yes—fundraisers, is crowded year-round.

Since 1956, if it is an even-numbered year, there has probably been another Northwest Wilderness Conference, and, since 1964, Polly Dyer has organized it, the latest in April 2004. No one has better credentials, for Polly is Wild Seattle's indefatigable doyenne of wilderness-saving, herself a veteran of the eight-year campaign to pass the Wilderness Act of 1964. She has been up to her elbows in every Washington wilderness campaign for half a century—leader, mentor, den mother to the youngest and newest recruits, host to generations of itinerant wilderness workers camped in her spare bedroom. While she has a special attachment to the wild Olympics—as a leader of the activist group Olympic Park Associates—Polly's leadership shows up in literally dozens of protected wilderness areas all across the state.

In fact, Polly was in on nurturing one of the essential ideas in the Wilderness Act itself. In April 1956, the bill's draftsman, Howard Zahniser of The Wilderness Society, came west from Washington, D.C., for a wilderness conference, carrying his tenth draft for the bill with him and puzzling over tricky wording choices. The Olympics being Polly's first love, she was describing a then-unprotected stretch of wild Olympic coastline to Zahniser when she enthused, "Zahnie, it's just so . . . well, just so *untrammeled.*" That, he wrote later, convinced him that this uncommon word he wanted to use in defining ideal wilderness was not too far beyond common usage after all.

Today, the word *untrammeled* is in common usage among tens of thousands who know it from the eloquent opening section of the Wilderness Act, with the very specific meaning that wilderness areas, large or small, are places where as much as possible the forces of nature prevail, unrestrained and uninfluenced by man. Ideal wilderness, the law says, contrasts "with those areas where man and his own works dominate the landscape," providing wild sanctuaries "where the earth and its community of life are *untrammeled* by man, where man himself is a visitor who does not remain."

Pat's North Cascades, Polly's Olympics, and other gems in our necklace of wilderness provide the anchor for all that is wild about Wild Seattle. Glance at the map in this volume and you will see the national forest wilderness areas encircling Puget Sound. Not shown is the fact that 95 percent of the three great national parks is wilderness with a capital W.

Thanks to Polly, Pat, and legions of volunteer activists, these places have been set apart by the most permanent form of protection our society can command: by acts of Congress that promise their preservation as wilderness in perpetuity. "The wilderness that has come to us from the eternity of the past, we have the boldness to project into the eternity of the future," said Howard Zahniser. That promise is embodied in the 1964 Wilderness Act.

Fearing any temptation toward tyranny, our country's founders designed a political system in which acts of Congress are devilishly difficult to enact. And an act of Congress is required to add lands to the protection offered by the Wilderness Act. Securing such laws often requires tenacity in the form of decades-long grassroots lobbying campaigns. Once such a law is passed, wilderness-killing roads, off-road vehicles, logging, mining, and the like are excluded. Wilderness is preserved within a specific boundary fixed in the law itself, and the federal agency involved is commanded by Congress to administer the area "to preserve its wilderness character."

Wilderness advocates understand that the long, hard work to secure wilderness protection by law is well worth it.

Prior to the Wilderness Act, portions of the few wilderness areas then protected by purely administrative orders could all too easily be sliced out by agency decision for logging—by the stroke of a pen—and often were. Now, thanks to the Wilderness Act, the protective restrictions—and the boundary—of a statutory wilderness area can be changed only by another act of Congress. We are most possessive about our treasury of backyard wilderness. A bill proposing to undo one of our wilderness areas, or to cut chunks from its boundary, or to water down protective restrictions would arouse extraordinary public opposition and passionate activism. That is strong assurance that the promise of the Wilderness Act will be kept "to secure for the American people of this and future generations an enduring resource of wilderness."

The map and the numbers tell the story of what Pat and Polly and their colleagues—and the squadrons of citizens who have taken up their example and their work—have accomplished for Wild Seattle. When the Wilderness Act became law in 1964, it protected only three areas in Washington, totaling 583,000 acres. In a sequence of eight additional laws enacted over the four decades since, Congress has added more than six times as much land to Wilderness Act protection in our state.

All along the rim of Wild Seattle, our wilderness areas reflect the power of Sierra Club–style volunteer citizen conservation action using the Wilderness Act. More than 40 percent of the Mount Baker–Snoqualmie National Forest

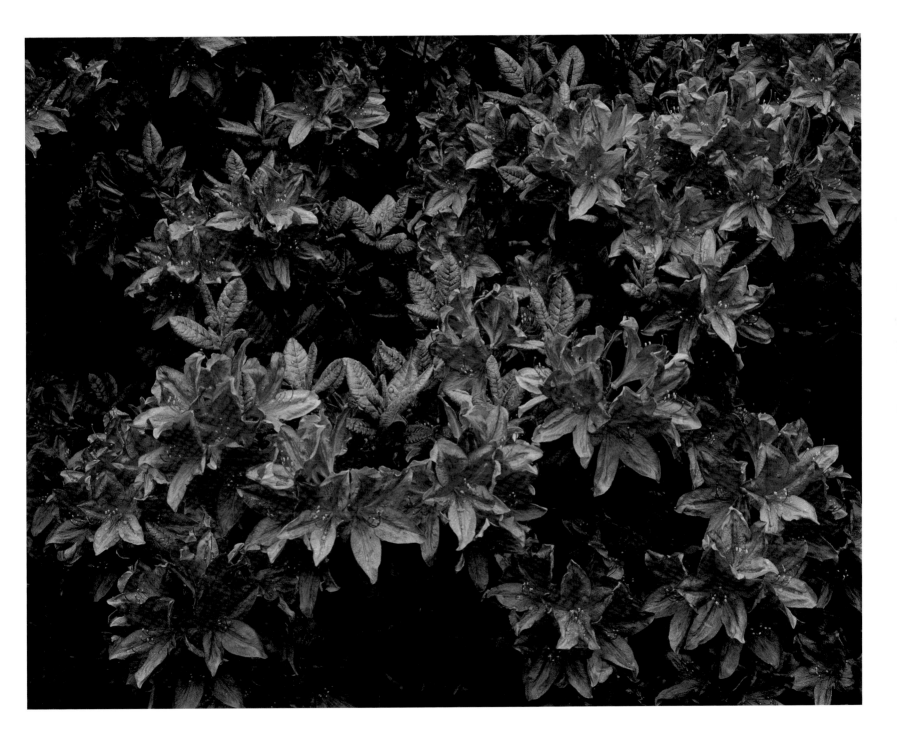

has this status. The names of these wilderness areas offer a veritable roll call of conservation history. Among them:

- The 570,573-acre Glacier Peak Wilderness north of Stevens Pass, designated by the Wilderness Act itself in 1964, expanded by Congress in 1968 and again in 1984

- The 100,356-acre Henry M. Jackson Wilderness designated in 1984, contiguous to the Glacier Peak Wilderness and extending protection south to within shouting distance of Highway 20 at Stevens Pass

- The 362,789-acre Alpine Lakes Wilderness between Stevens and Snoqualmie Passes, Seattle's "backyard wilderness" established in a hard-fought 1976 law

- Mount Rainier National Park wilderness, at 228,480 acres, protecting Wild Seattle's southern sentinel

Across the sound, the roll call continues:

- The 876,669-acre wilderness within Olympic National Park, designated in 1988, protecting what Washington's governor in 1889 called "the mystery which wraps the land encircled by the snow-capped Olympic range"

- A series of national forest wilderness areas on the eastern boundary of Olympic National Park, expanding the single unit of wilderness within the park to nearly 1,000,000 acres, protecting the wild Olympic skyline and slopes viewed from Seattle

The work to protect Seattle's backyard wilderness goes on, for serious gaps remain and inadequate wilderness boundaries must be expanded.

One glaring flaw is the legacy of our once-young nation's view of its public lands, so vast as to be literally given away to individuals and corporations to promote development. In a well-intentioned Civil War–era law, forty to fifty square miles of public land were deeded to the railroads as incentive for every mile of track they laid to create the great transcontinental railroads. The Great Northern Railway (over Stevens Pass) and the Northern Pacific (over Stampede Pass near Snoqualmie Pass) got their lands in a pattern of alternating mile-square sections extending back from each side of the track—something like 1.5 million acres in the Central Washington Cascades. Many of these sections have since been logged, leaving a giant's checkerboard of clear-cut scars woven together with a lacing of logging roads despoiling the intervening public lands.

The Sierra Club's Cascade Checkerboard Project is part of the answer for Wild Seattle, promoting complex U.S. Forest Service land exchanges that have already succeeded in blocking up much of the checkerboard with solid federal ownership in key parts of the Alpine Lakes Wilderness. The Sierra Club is also part of a dozen-member coalition that is currently urging the Forest Service and Congress to add 16,000 acres of ecologically crucial lands along the southernmost fringes of the Alpine Lakes Wilderness east of Snoqualmie Pass.

Many citizen organizations, including local Sierra Club groups, are working under the umbrella of the Wild Washington Campaign to press Congress to designate additional wilderness areas.

The Wild Skykomish Wilderness, shown on the map in this volume, will be the newest; it was nearing final approval by Congress in early 2004. The 106,000-acre "Wild Sky" in the upper Skykomish River basin will be the backyard wilderness for the rapidly growing city of Everett and Snohomish County. It is an essential piece of a single great

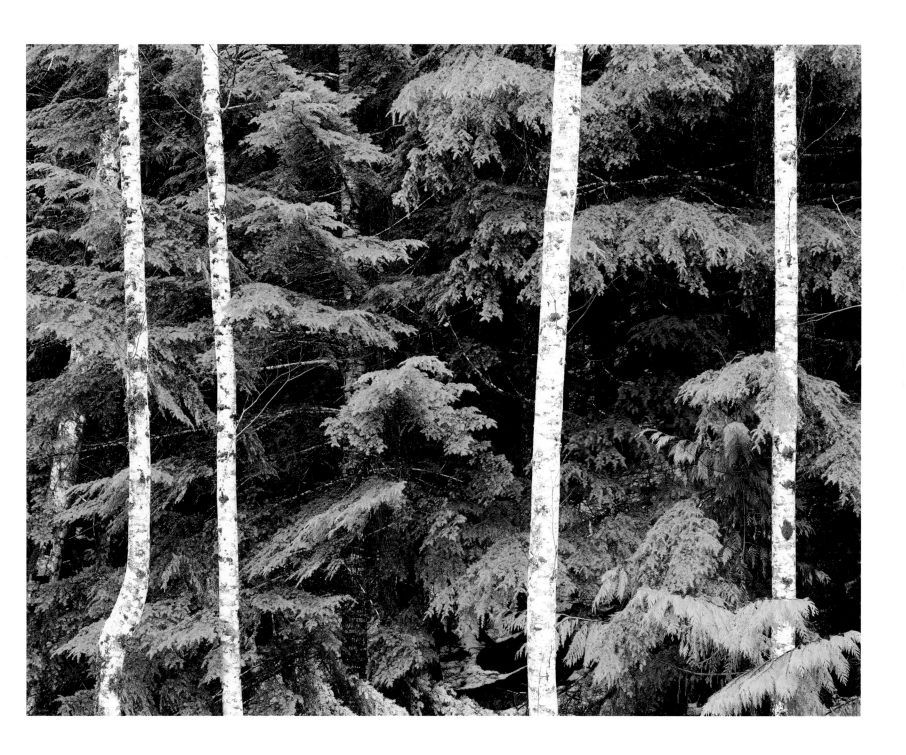

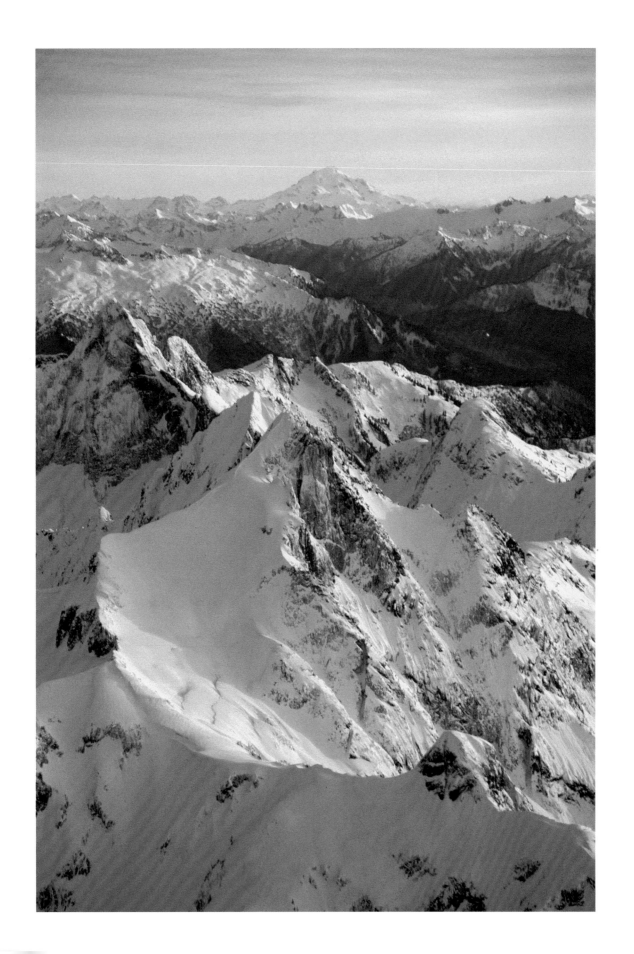

Cascade wilderness complex reaching from Washington Pass on Highway 20 far north of Seattle, south through the southern unit of North Cascades National Park (and contiguous national forest wilderness to the east of it) and the Glacier Peak and Henry M. Jackson Wilderness Areas, down to Highway 2 and Stevens Pass. With the Wild Sky protected, this complex will amount to more than 1,235,000 acres—the largest unbroken block of statutory wilderness in Washington. More additions are being sought by conservationists to protect threatened wildlands around the fringes of this Delaware-size wilderness complex.

A great value of the Wild Sky—and an example of a particular focus of ongoing wilderness campaigns around Wild Seattle—lies in extending statutory protection to lower-elevation lands below the high peaks. Bringing the boundaries of wilderness areas down to lower elevations diversifies protected ecosystems, protects fragile watersheds and salmon and steelhead spawning tributaries, and preserves year-round recreation opportunities in quiet forested valleys. And given relentless pressure from some logging interests and motorized recreation users, it is these low-elevation forested valleys that are now most at risk.

Writing of the Cascades in 1901, John Muir captured the essence of western Washington's forests: "Along the moist, balmy, foggy, west flank of the mountains [is] a forest kingdom unlike any other, in which limb meets limb, touching and overlapping in bright, lively, triumphant exuberance. . . . No ground has been better tilled for wheat than these Cascade Mountains for trees: They were ploughed by mighty glaciers, and harrowed and mellowed and outspread by the broad streams that flowed from the ice-ploughs as they were withdrawn at the close of the glacial period."

Deep river valleys penetrate the flanks of the Cascade and Olympic Ranges, offering easy routes for too many roads punched up seemingly every tributary and across seemingly every steep sidehill to slake the insatiable appetites of too many sawmills. Though clear-cut logging continues (and aggressively so on private lands), the pace that so grossly accelerated after World War II has sharply declined in the face of unacceptable damage to salmon streams, wildlife species and habitat, and scenic values. But the legacy lingers; from an airplane, the patchwork of clear-cuts makes obvious that this is a badly abused industrial forestry landscape in slow recovery. One artifact of this history is the starfish-like edges of wilderness areas in the Cascades and Olympics: inaccessible and treeless upper ridges got protection, while many intervening valleys, lusted after or already defiled by logging companies, did not.

Since the 1930s, national park advocates have urged an expansive boundary for Olympic National Park, warning that the boom-and-bust liquidation of old-growth forests being pressed with gluttonous savagery would likely leave the Olympics like "a squeezed lemon." In a Web posting in 2001, an enthusiastic visitor from Illinois called Olympic National Park a "paradise on earth," but ended his comments with a sorrowful personal recollection: "When I was thirteen, the forest was complete . . . but on my last visit, my heart sank. The forest was clear-cut right up to the park border itself! This was done within the past decade, and the newly planted forest has a long way to go to heal the ugly scars of clear-cutting."

Chainsaws whined and log trucks rolled along the eastern flank of the Olympic peaks above the long trench of Hood Canal, as in the national forest all around the park, with little care for wilderness values, scenic qualities, or

sensitive fish-spawning rivers with evocative Indian names—Big Quillcene, Dosewallips, Duckabush, Hamma Hamma, Skokomish. The story is changing as an increasingly urban and ecologically aware society demands greater priority for protection of the land and preservation of what remains of old-growth forest glories. Citizen campaigns now focus not only on designating more statutory wilderness, but also on building land-protecting partnerships with private-forest landowners, using innovative tools to expand protection into private lands beyond national parks and forests.

The art of coalition is simply smart politics; the political clout of the whole is greater than the sum of its parts. Many specialized conservation groups, each with its own focus and priorities, lend strength to common efforts.

Around Wild Seattle, specialization among conservation groups is now well advanced. There are Polly's Olympic Park Associates and Pat's North Cascades Conservation Council, the Seattle Parks Foundation, Northwest Energy Conservation Coalition, Washington Trails Association, and Friends of the San Juans, to name only a few. Larger groups with broader agendas add their own expertise and big numbers: the Sierra Club and its local groups, The Mountaineers (with branches all around Wild Seattle), Seattle Audubon, Tahoma Audubon, and The Wilderness Society.

Some nonprofit organizations specialize in particular conservation tools, such as purchasing private lands to protect natural areas. In 2002, the northwest office of the Trust for Public Land (TPL) helped the city of Burien, between Seattle and Tacoma, acquire one of the last undeveloped stretches of Puget Sound beach in the city. Mayor Wing Woo enthused, "There's not that much shoreline access to Puget Sound anymore," so Branson Beach "allows people to get to the water, see nature, and walk the beach."

The wild splendors of a small lagoon on Hood Canal were little known until a PTA leader at Seabeck Elementary School teamed up with fisheries biologist Ron Hirschi to organize an after-school program for kids to study fish in the nearby lagoon. Student Nick Holm, now a teenager, became so engaged in the effort that the lagoon is now known locally as Nick's Lagoon. In November 2002, when Nick's Lagoon was about to be subdivided into residential lots, TPL acquired the property and conveyed ownership to Kitsap County Parks and Recreation. "With streams from headwater to mouth, it is much like holding the entire Columbia River System in the palm of your hand. There is no other lagoon system in Hood Canal that offers this opportunity for environmental education," said Hirschi.

Similarly, The Nature Conservancy recently purchased 4,122 acres at the mouth of the Stillaguamish River near Camano Island—the largest private purchase of land for conservation in Snohomish County history. The property contains diked uplands and a vast expanse of estuarine wetlands, a critical staging area for tens of thousands of migratory shorebirds and more than 50,000 lesser snow geese, a distinct population that breeds on Wrangel Island off the Russian coast and migrates to this habitat for the winter. Local and specialized land trusts such as Skagit Farmland Trust and the Cascade Land Conservancy pursue similar efforts.

Special funding campaigns are now a particularly active part of the Wild Seattle conservation scene. Even with the progress in preserving wilderness areas on federal lands, there is precious little forest habitat left to link the wilderness in and contiguous to Mount Rainier National Park to the Alpine Lakes Wilderness. Picture Washington's Cascade Mountains looking like an hourglass; the area south of I-90

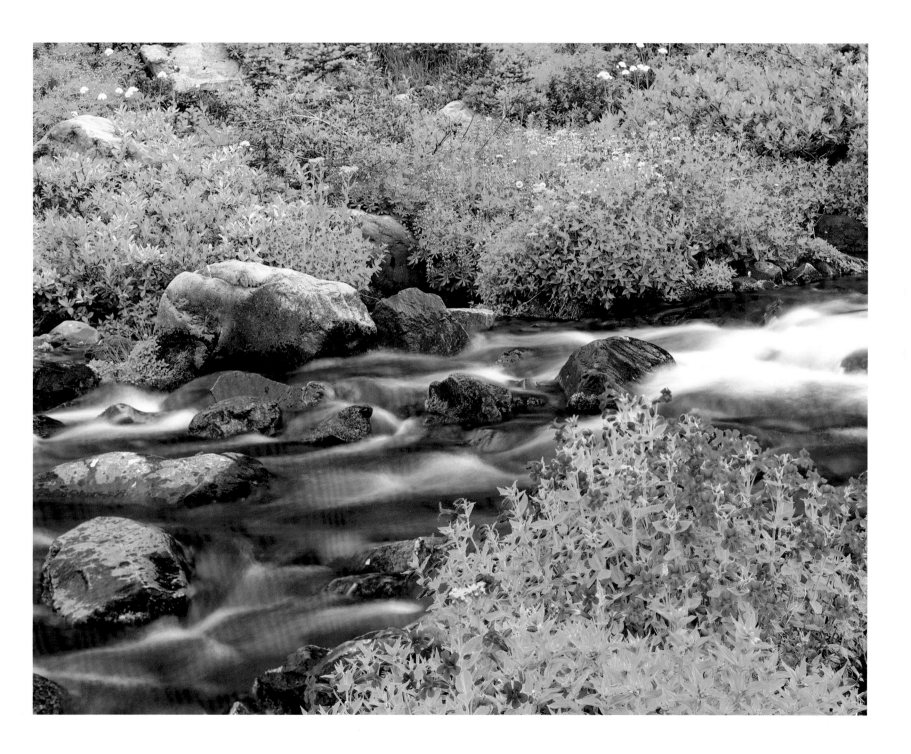

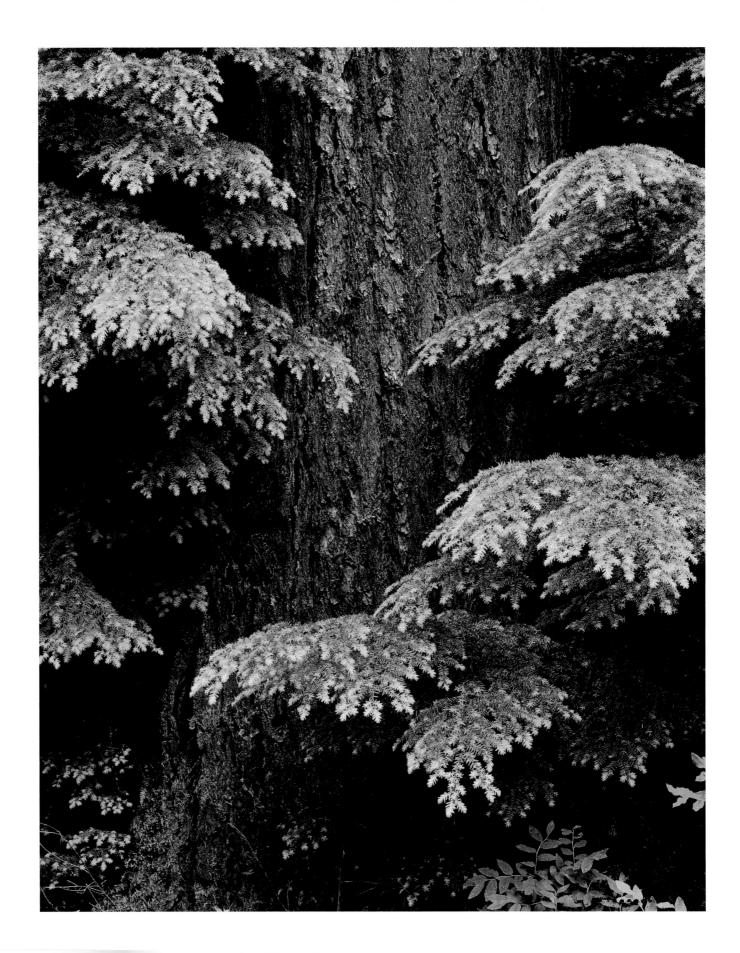

is the thinnest portion with the spottiest protection, creating a threatening bottleneck for wildlife species that need to roam between wild habitats to the north and south.

The Cascades Conservation Partnership is a temporary campaign for raising funds to purchase more than 75,000 acres of privately owned forests in this hourglass area, where old-growth forests are threatened with logging. The partnership's goal is to raise $25 million in private funds to help persuade the federal government to contribute at least $100 million, all to protect 26 miles of river, 15 lakes, over 45 miles of hiking trails, and 20 miles of mountain-biking trails just an hour's drive from Seattle. Through the fall of 2003, some 31,000 acres had been protected using $16 million in private donations and $45 million in public funds.

Conservationists have mobilized to protect not only forests and peaks, but also Puget Sound itself. On a sunny day, the bright glints off the water are deceptive. Life in the much-abused sound—like marine life in the oceans everywhere—is teetering on the edge of ecological collapse. Kathy Fletcher, a former Sierra Club board member and founder of People For Puget Sound, says: "The entire sound is a severely impaired marine ecosystem. Overfishing, hardening of shorelines, pollution, dredging and destruction of estuaries, all have done their part to make the fate of our marine life an open, urgent question."

Like the canary in the mine shaft, our marine icon, the orca (misnamed "killer whale"), symbolizes what is going so wrong. Orcas concentrate deadly bodyloads of PCBs from their prey, which have picked up PCBs from their prey. The source: toxic sludge at the bottom of Puget Sound harbors. Survival of wild salmon is jeopardized by massive loss of essential estuary habitat. The far less charismatic rockfish, a long-lived bottom dweller you know on your table as red snapper, is imperiled, much of its habitat destroyed by trawling—dragging weighted nets across the floor of the sound in the saltwater equivalent of forest clear-cutting.

With efforts spearheaded by People For Puget Sound, the fate of the marine environment is gaining increased priority from conservationists. The policies are complex and the politics daunting. Massive effort must go to cleaning up pollution. For salmon, the key is restoring estuaries that provide security habitat, including right in the heart of Puget Sound cities, while also clearing passage to upstream spawning grounds. For marine life to again flourish, Puget Sound must have a comprehensive system of large no-fishing marine reserves, something like a saltwater equivalent of wilderness areas. In the long run, such areas will particularly benefit fishermen, both commercial and recreational fishers, as we reverse the long downward spiral of marine life.

A quality shared by many wilderness advocates is a kind of gentle intensity. Passion fuels citizen action to save beloved wild landscapes, but wildness inculcates a soft-spokenness that has greater persuasive power than bombast and vitriol.

Wild Seattle had its own Ansel Adams, its own crusader who championed wilderness and wild trails with the power of his camera and his gently intense advocacy. Ira Spring, who died in 2003, marshaled his photography in more than sixty trail guidebooks, including the perennially popular "100 Hikes" series published by The Mountaineers, many with collaborator Harvey Manning. These are not simply trail guides; Ira consciously designed them as tools for recruiting more activists, fervently believing that those who are drawn onto forest trails will become advocates for protection. Near the end of his life, he told the Seattle *Post-Intelligencer:* "It takes thousands of people to make a dent in

convincing federal lawmakers and bureaucrats of the need to protect forest and park land for hiking and to provide money for trails."

As a Sierra Club lobbyist, I once accompanied Ira around the halls of Capitol Hill to meet with key senators and representatives. He had an unbeatable way of dramatizing the need to protect more wilderness areas and old-growth forests: he gave each legislator a copy of one of his "100 Hikes" books with scores of pages half ripped out and dangling—the pages describing trails threatened by logging and road building if not given statutory protection.

Today, Ira's work for trails continues, thanks to the Spring Family Trust for Trails, funded by his contribution of royalties from his books. With more than $300,000, the trust works with agencies and volunteers to help maintain trails, including the expensive work of replacing bridges washed out in storms. In tribute to Ira, in 2003, Seattle-based Recreational Equipment, Inc., added a grant of $50,000 to the trust.

REI has long set the pace as an enlightened, outdoor-oriented company actively helping to protect wildlands. As a co-op, REI distributes annual dividends to its members—after contributing part of its profits to support wilderness, trail, and other environmental efforts. These grants have often made a crucial difference in campaigns to protect wilderness, including helping citizen lobbyists get to Washington, D.C., to press the case for such legislation as the 1984 Washington State Wilderness Act, which designated more than 1 million acres of wilderness, both new areas and expansions of older ones. REI's CEO, Dennis Madsen, who can be encountered running and hiking the trails of Wild Seattle, says: "In serving our members, giving back to help see wild places protected and trails maintained makes the very best kind of business sense." Outside

Dennis's office hangs a huge framed display of copies of each of the twenty-two wilderness designation bills that protected 8 million acres of wilderness in 1984 alone, thanks in good measure to over $100,000 that REI provided to help sustain citizen lobbying campaigns in the states involved, including Washington. The display was presented by the Sierra Club, Wilderness Society, and other organizations to salute REI's path-breaking business leadership for wilderness, leadership now being emulated by many other outdoor-oriented businesses.

Vigilant citizen lobbying, in the halls of Congress and back home, is an essential part of the work to protect Wild Seattle. From Pat Goldsworthy's trips to Washington, D.C., in the fight for North Cascades National Park to twenty-first-century lobbying campaigns for more wilderness protection and land acquisition funding, the work goes on.

For the most part, elected officials who represent the environmentally conscious voters of Wild Seattle have been ready and effective in collaborating with citizen groups to help protect wild places. But the timber industry, though now diminished from its days as a mainstay of the Washington economy during the era when unsustainable clear-cut logging boomed on the federal lands, still swings considerable clout. So generating effective citizen support has always been the key ingredient in conservation campaigns, essential to blunt the logging lobby and other anti-wilderness interests.

The honor roll of members of Congress, governors, mayors, and local elected officials who have helped in these efforts is long and thoroughly bipartisan. One name stands out: former Republican governor and U.S. Senator Dan Evans. Evans's commitment to wilderness is founded in the long view: "We must leave to our twenty-first-century

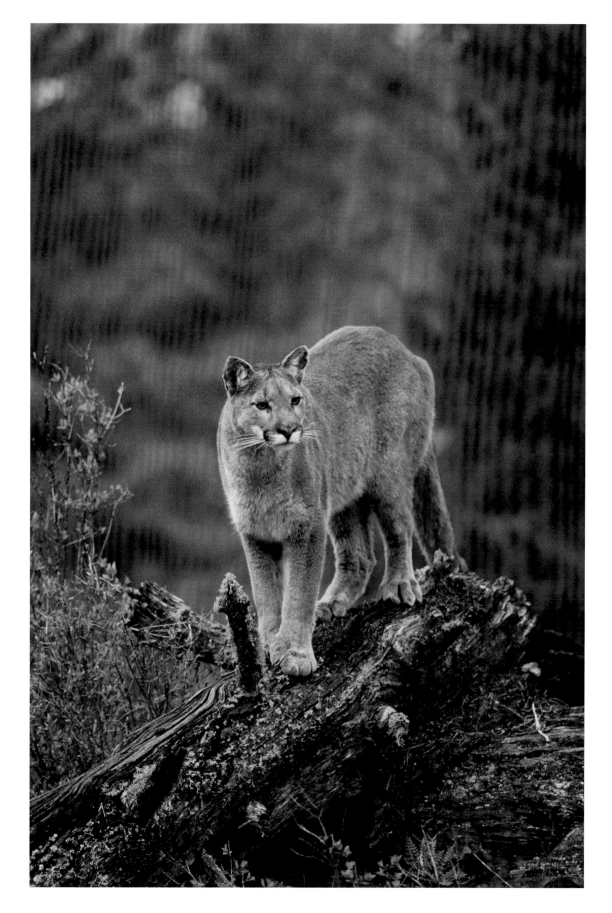

children two important legacies: all of the knowledge we possess on which they will build in ways we cannot yet foresee, and wilderness preserves or windows to the past where they can stand and say, 'This is how it was before man touched the Earth.'"

"Protecting wilderness for future generations," Evans has said, "is a fundamental—a truly conservative—American ideal we all share."

Wild Seattle remains a work in progress. Incessant, grinding development gnaws at the vulnerable edges of wild places large and small, urban and rural. As with so many places, the very quality of life in Wild Seattle is a siren drawing wildness toward ruin. Experience has taught conservationists that in national forests, the only sure protection from roads, logging, and the off-road vehicles John Muir might well have termed "wheeled locusts" is found not in inherently temporary administrative policies and plans, but in the security of a statutory wilderness boundary. As for state forests and private lands, such teeth as Washington's Forest Practices Act, the Growth Management Act, and local land use planning are all too easily compromised by the clout of big developers.

Writing forty years ago, U.S. Supreme Court Justice William O. Douglas observed that "we look backward to a time where there was more wilderness than the people of America needed. Today we look forward (and only a matter of a few years) to a time when all the wilderness now existing will not be enough." He added, "It would be wise right now to stop all new roadbuilding into wild lands, all damming of wild rivers, all logging of virgin forests. The Americans of 2000 A.D. will thank us if we take that course."

But the damming, road building, and logging did not stop. And Douglas could as easily have been writing about the perilous future of urban parks and suburban open space as about the wilderness farther afield. Knute Berger, publisher of the *Seattle Weekly*, writes, "Despite aggressive neighborhood planting, trees and urban wildlife habitat are still being lost to development. Suburban sprawl is chomping away, like an infestation of caterpillars."

Are places of supreme beauty such as Wild Seattle, with bountiful natural features and outstanding options for outdoor activities, just fatally attractive, doomed to disappear into the maw of human growth and appetite?

In 1949, in *A Sand County Almanac*, Aldo Leopold observed that the wild things wilderness lovers seek have eluded their grasp and they hope "by some necromancy of laws, appropriations, regional plans, reorganization of departments, and other forms of mass-wishing to make them stay put." Generations of denizens of Wild Seattle, the figurative children of Pat Goldsworthy, Polly Dyer, Ira Spring, and Dan Evans, have given much of themselves in working to make all that is wildest about Wild Seattle "stay put." Turn this page to find where you can learn more and contact organizations eager to sign you up to help keep more of Wild Seattle wild.

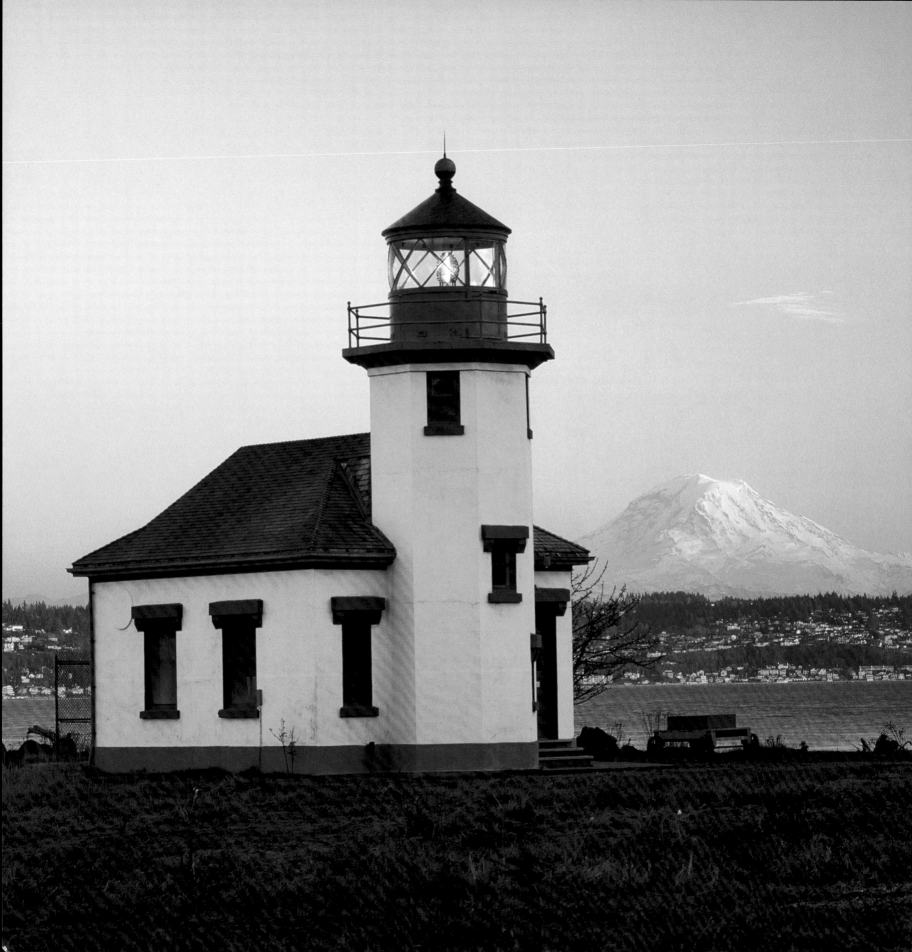

Bibliography

Barcott, Bruce, editor. "Interview with Poet David Wagoner," in *Northwest Passages: A Literary Anthology of the Pacific Northwest from Coyote Tales to Roadside Attractions.* Seattle: Sasquatch Books, 1994.

Baron, Nancy, John Acorn, John Alden, and Gary Ross. *Birds of the Pacific Northwest Coast.* Auburn, Wash.: Lone Pine Publishing, 1997.

Dietrich, William. *The Final Forest: A Battle for the Last Great Trees of the Pacific Northwest.* New York: Penguin, 1993.

Egan, Timothy. *The Good Rain: Across Time and Terrain in the Pacific Northwest.* New York: Random House, 1990.

El Hult, Ruby. *The Untamed Olympics: The Story of a Peninsula.* Port Angeles, Wash.: CP Publications, 1989.

Ewing, Susan. *Going Wild in Washington and Oregon: A Guide to Northwest Wildlife Viewing.* Alaska Northwest Books, 1993.

Fobes, Natalie, Tom Jay, Brad Matsen. *Reaching Home: Pacific Salmon, Pacific People.* Seattle: Alaska Northwest Books, 1994.

Karlinsey, Laura. *Seattle City Walks: Exploring Seattle Neighborhoods on Foot.* Seattle: Sasquatch Books, 2003.

Knibb, David. *Backyard Wilderness: The Alpine Lakes Story.* Seattle: The Mountaineers, 1982.

Kozloff, Eugene N. *Plants and Animals of the Pacific Northwest.* Seattle: University of Washington Press, 2003.

———. *Seashore Life of the Northern Pacific Coast.* Seattle: University of Washington Press, 2003.

Lichen, Patricia K., and Linda M. Feltner. *Passionate Slugs and Hollywood Frogs: An Uncommon Field Guide to Northwest Backyards.* Seattle: Sasquatch Books, 2001.

Manning, Harvey. *The Wild Cascades: Forgotten Parkland.* Foreword by William O. Douglas. San Francisco: Sierra Club Books, 1965.

———. *Washington Wilderness: The Unfinished Work.* Foreword by Dan Evans. Seattle: The Mountaineers, 1984.

Mathews, Daniel. *Cascade-Olympic Natural History.* Portland, Ore.: Raven Editions, 1999.

McDonald, Cathy, and Stephen Whitney. *Nature Walks in and Around Seattle: All-Season Exploring in Parks, Forests, and Wetlands.* Seattle: The Mountaineers, 1997.

McNulty, Tim, and Pat O'Hara. *Olympic National Park: Where the Mountain Meets the Sea.* Aspen, Colo.: Woodlands Press, 1984.

———. *Mount Rainier National Park: Realm of the Sleeping Giant.* Aspen, Colo.: Woodlands Press, 1985.

Muir, John. *Our National Parks.* Boston: Houghton Mifflin, 1901.

———. "An Ascent of Rainier," in *Steep Trails.* Boston: Houghton Mifflin, 1918.

National Audubon Society. *National Audubon Society Regional Guide to the Pacific Northwest.* New York: Knopf, 1998.

Pojar, Jim, and Andy MacKinnon, editor. *Plants of the Pacific Northwest Coast.* Auburn, Wash.: Lone Pine Publishing, 1994.

Rogers, Joel W. *Watertrail: The Hidden Path through Puget Sound.* Seattle: Sasquatch Books, 1998.

Saling, Ann. *The Great Northwest Nature Factbook: A Guide to the Region's Remarkable Plants, Animals, and Natural Features.* Seattle: Alaska Northwest Books, 1999.

Schofield, Janice. *Discovering Wild Plants: Alaska, British Columbia, the Northwest.* Seattle: Alaska Northwest Books, 1989.

Scigliano, Eric, and Tim Thompson. *Puget Sound: Sea Between the Mountains.* Portland: Graphic Arts Center Publishing, 2000.

Scott, Douglas W. *A Wilderness-Forever Future: A Short History of the National Wilderness Preservation System.* Washington, D.C.: Campaign for America's Wilderness, 2001.

Sherwood, Don. "Interpretive Essay on the History of Seattle's Parks and Playgrounds," July 13, 1979, www.ci.seattle.wa.us/seattle/leg/clerk/sherwood/sherwd.htm#history.

Spring, Vicki, Ira Spring, and Harvey Manning. *100 Hikes in Washington's Alpine Lakes.* Seattle: The Mountaineers, 2000.

Steelquist, Robert U. *Washington's Mountain Ranges.* Helena, Mont.: American Geographic Publishing, 1986.

Vancouver, George. *A Voyage of Discovery to the Northern Pacific Ocean and Round the World, 1791–1795.* London: C. J. and J. Robinson, 1798.

Whitebrook, Robert Ballard. *Coastal Exploration of Washington.* Palo Alto, Calif.: Pacific Books, 1959.

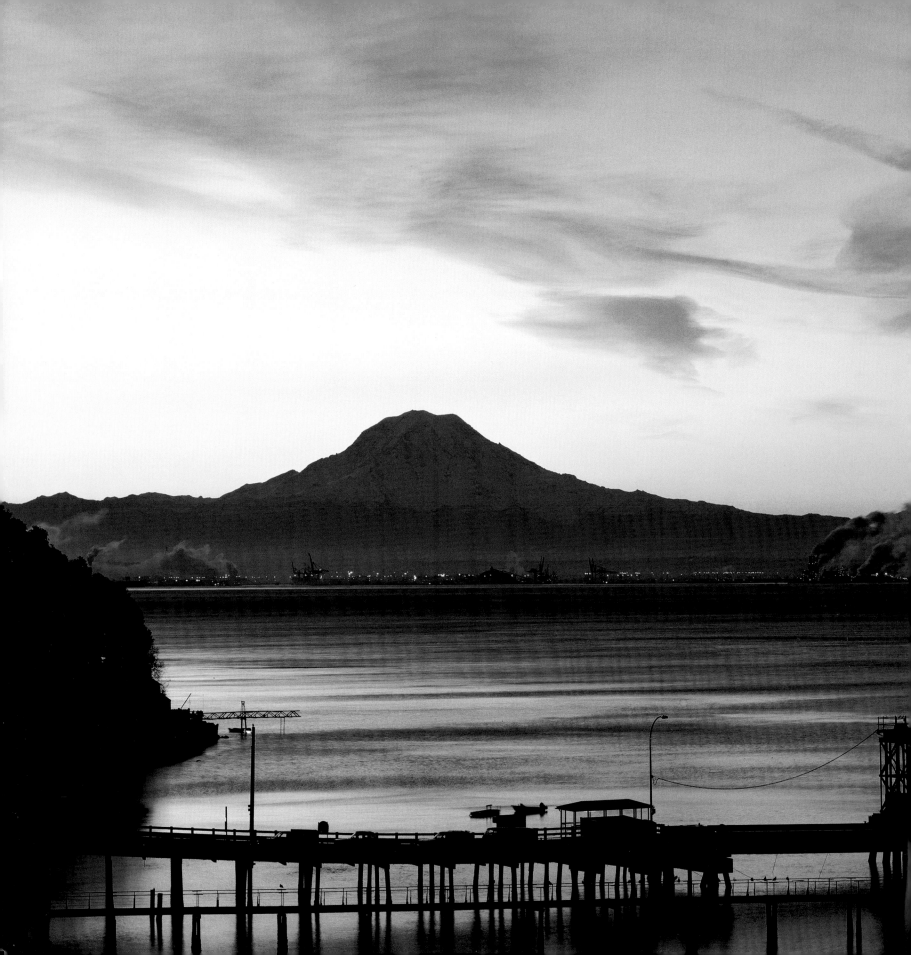

Agencies and Organizations

Alpine Lakes Protection Society
P.O. Box 27646
Seattle, WA 98165
www.alpinelakes.org

American Rivers
4005 20th Avenue West, Suite 221
Seattle, WA 98199
(206) 213-0330
www.amrivers.org

Bridle Trails Park Foundation
6619 132d Avenue NE, Suite 265
Kirkland, WA 98033
(425) 883-8501
www.bridletrails.org

Cascade Land Conservancy
615 Second Avenue, Suite 625
Seattle, WA 98104
(206) 292-5907
www.cascadeland.org

Friends of Discovery Park
P.O. Box 99662
Seattle, WA 98199
(206) 283-8643
www.discoveryparkfriends.org

Friends of the San Juans
P.O. Box 1344
Friday Harbor, WA 98250
(360) 378-2319

Friends of Seattle's Olmsted Parks
P.O. Box 9884
Seattle, WA 98109
(206) 332-9915
www.seattle.gov/friendsofolmstedparks
For an interactive map of Seattle's
Olmsted Parks: www.historylink.org/

Hood Canal Environmental Council
P.O. Box 87
Seabeck, WA 98380
www.hcec.ws

Issaquah Alps Trails Club
P.O. Box 351
Issaquah, WA, 98027
www.issaquahalps.org

King County Parks and Recreation
Division
201 South Jackson Street, Suite 700
Seattle, WA 98104
(206) 296-8687
www.metrokc.gov/parks

The Mountaineers
300 Third Avenue West
Seattle, WA 98119
(206) 284-6310
www.mountaineers.org

Mountains-to-Sound Greenway Trust
1011 Western Avenue, Suite 606
Seattle, WA 98104
(206) 382-5565
http://www.mtsgreenway.org

Mount Baker–Snoqualmie National
Forest
21905 64th Avenue West
Mountlake Terrace, WA 98043
(425) 775-9702, (800) 627-0062
www.fs.fed.us/r6/mbs

Mount Rainier National Park
Tahoma Woods, Star Route
Ashford, WA 98304
(360) 569-2211 Ext. 3314
www.nps.gov/mora

National Parks Conservation
Association
313-A First Avenue South
Seattle, WA 98104
(206) 903-1444
www.npca.org/across_the_nation/
npca_in_the_field/northwest

Nisqually National Wildlife Refuge
100 Brown Farm Road
Olympia, WA 98516
(360) 753-9467
http://nisqually.fws.gov

The Nature Conservancy
217 Pine Street, Suite 1100
Seattle, WA 98101
(206) 343-4344
www.tnc-washington.org

Nisqually River Council
P.O. Box 47775
Olympia, WA 98504
(360) 407-6783
www.nisquallyriver.org

North Cascades Conservation Council
P.O. Box 95980
Seattle, WA 98145
www.northcascades.org

North Cascades Institute
810 State Route 20
Sedro Woolley, WA 98284
(360) 856-5700, Ext. 209
www.ncascades.org

North Cascades National Park
810 State Route 20
Sedro Woolley, WA 98284
(360) 856-5700
www.nps.gov/noca

Northwest Ecosystem Alliance
3414-1/2 Fremont Avenue North
Seattle, WA 98103
(206) 675-9747
www.ecosystem.org

Northwest Energy Coalition
219 First Avenue South, Suite 100
Seattle, WA 98104
(206) 621-0094
www.nwenergy.org

Northwest Interpretive Association
909 First Avenue, Suite 630
Seattle, WA 98104
(206) 220-4140
Books, maps, links to national park and
forest websites:
http://nwpubliclands.com/bookstore

Olympic Forest Coalition
606 Lilly Road NE, Suite 115
Olympia, WA 98506
www.olympicforest.org

Olympic National Forest
1835 Black Lake Boulevard SW
Olympia, WA 98512
(360) 956-2402
www.fs.fed.us/r6/olympic

Olympic National Park
600 East Park Avenue
Port Angeles, WA 98362
(360) 565-3130
www.nps.gov/olym

Olympic Park Associates
2433 Del Campo Drive
Everett, WA 98208
www.drizzle.com/~rdpayne/opa

179

People For Puget Sound
911 Western Avenue, Suite 580
Seattle, WA 98104
(206) 382-7007
www.pugetsound.org

Preserve Our Islands
P.O. Box 845
Vashon Island, WA 98070
(206) 463-7296
www.preserveourislands.org

Puget Sound Action Team
Office of the Governor
P.O. Box 40900
Olympia, WA 98504
(800) 54-SOUND
www.psat.wa.gov

Save Lake Sammamish
1420 NW Gilman Boulevard
Issaquah, WA 98027
(425) 641-3008
www.scn.org/earth/savelake

Save Our Wild Salmon
424 Third Avenue West, Suite 100
Seattle, WA 98119
(206) 286-4455
www.wildsalmon.org

Seattle Audubon Society
8050 35th Avenue NE
Seattle, WA 98115
(206) 523-8243
www.seattleaudubon.org

Seattle Parks and Recreation
100 Dexter Ave North
Seattle, WA 98109
(206) 684-4075
www.cityofseattle.net/parks

Seattle Parks Foundation
860 Terry Avenue North, Suite 117
Seattle, WA 98109
(206) 332-9900
www.seattleparksfoundation.org

Sierra Club Cascade Chapter
180 Nickerson Street, Suite 202
Seattle, WA 98109
(206) 523-2147
www.cascade.sierraclub.org

Spring Family Trust for Trails
18819 Olympic View Drive
Edmonds, WA 98020
www.springtrailtrust.org/about.html

Tahoma Audubon Society
2917 Morrison Road West
University Place, WA 98466
(253) 565-9278
www.tahomaaudubon.org

Trust for Public Land
1011 Western Avenue, Suite 605
Seattle, WA 98104
(206) 587-2447
www.tpl.org

U.S. Geological Survey
David A. Johnston Cascades Volcano
Observatory
1300 SE Cardinal Court, Building 10,
Suite 100
Vancouver, WA 98683
(360) 993-8900
Geological and volcanism information
for Cascade Range: http://
vulcan.wr.usgs.gov/Volcanoes/
Cascades/volcanoes_cascade_range.html

Washington Environmental Council
615 Second Ave, Suite 380
Seattle, WA 98104
(206) 622-8103
www.wecprotects.org

Washington Kayak Club
P.O. Box 24264
Seattle, WA 98124
(206) 433-1983
www.washingtonkayakclub.org

Washington State Parks and Recreation
Commission
P.O. Box 42650
Olympia, WA 98504
(360) 902-8844
www.parks.wa.gov

Washington Trails Association
1305 Fourth Avenue, Suite 512
Seattle, WA 98101
(206) 625-1367
www.wta.org

Washington Water Trails Association
4649 Sunnyside Avenue North,
Suite 305
Seattle, WA 98103
(206) 545-9161
www.wwta.org

Washington Wilderness Coalition
4649 Sunnyside Avenue North,
Suite 520
Seattle, WA 98103
(206) 633-1992
www.wawild.org

The Whale Museum
P.O. Box 945
Friday Harbor, WA 98250
(360) 378-4710
www.whalemuseum.com

The Wilderness Society
1424 Fourth Avenue, Suite 816
Seattle, WA 98101
(206) 624-6430
www.tws.org/wherewework/washington

Wild Washington Campaign
4649 Sunnyside Avenue North,
Suite 520
Seattle, WA 98103
(206) 633-1992, Ext. 105
www.wildwashington.org